FLUID

FLUID

A FASHION REVOLUTION

HARRIS REED

with JOSH YOUNG

ABRAMS, NEW YORK

For all the queer kids bullied on the playground who dream of being heard and seen and valued, know that all your dreams are valid. I hope this book helps you realize your authentic self.

TABLE
OF
CONTENTS

I

WHAT IS FLUIDITY?

"Fluid" is a wonderful word. If something is fluid, it has no fixed shape. It's able to move, flow, change, and ebb, and to do so smoothly, effortlessly, and gracefully.

Gender fluidity takes its cue from these varied definitions of the word. The term refers to change over time in a person's gender expression, gender identity, or both. This change might be in expression but not in identity, or conversely in identity but not in expression— or any other possible combination of the two.

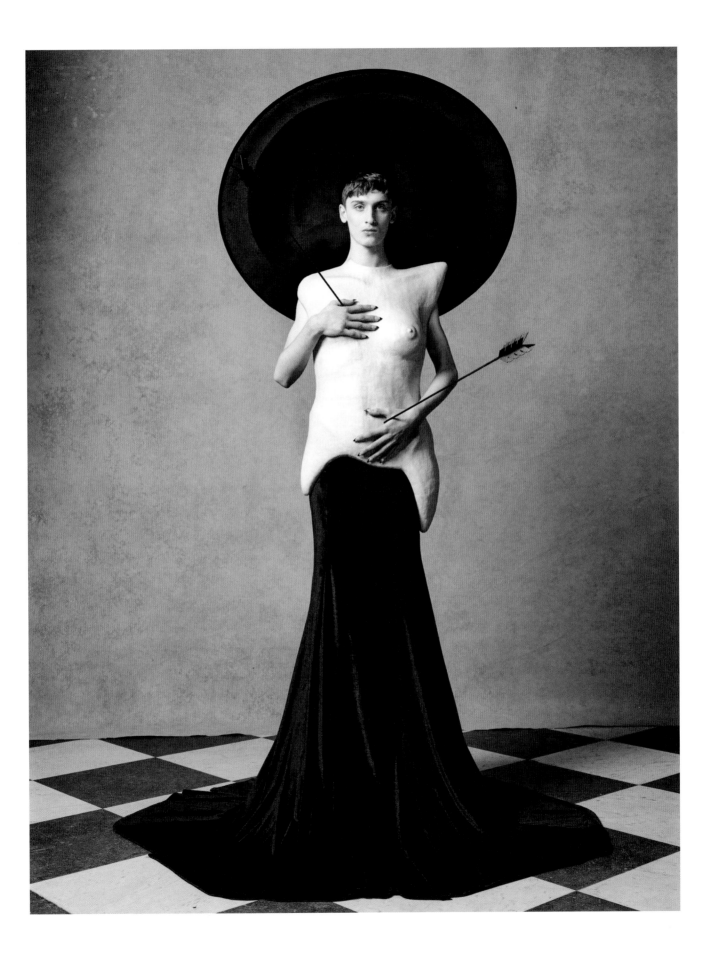

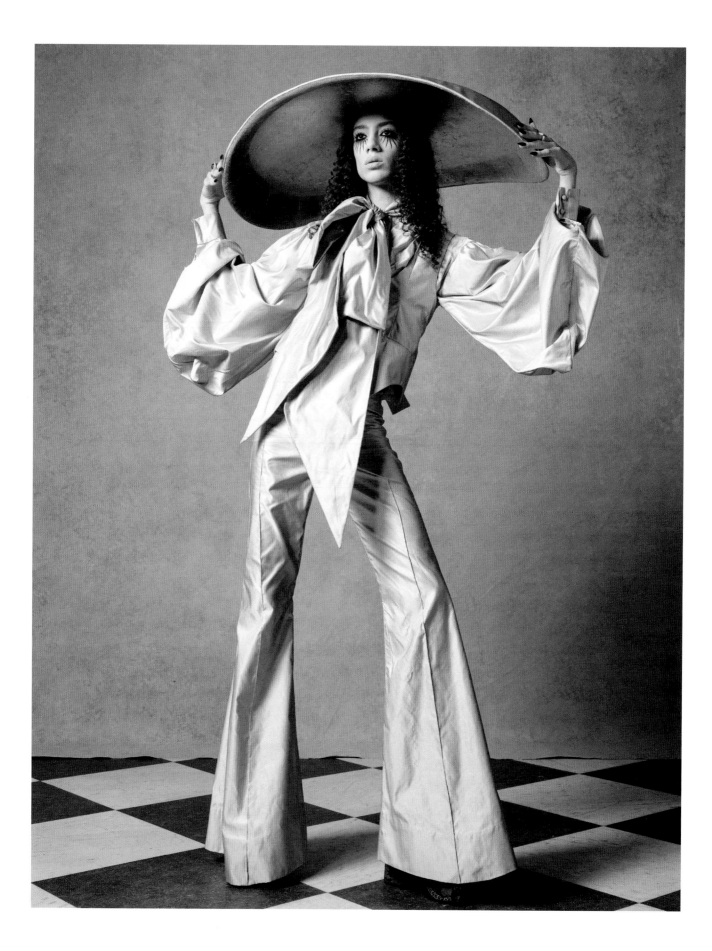

For me, fluidity encompasses both gender expression and gender identity. It can be one or the other, or it can be neither. That's what is so exciting about fluidity.

At its core, fluidity is an exploration of who you are. This can be scary, like going into the dark basement of your house when you were a little kid or being afraid of looking behind a bookcase because a monster might jump out and scare you. But exploration can also be very liberating.

I dove into the process of exploring my gender when I was all of nine years old, by necessity, not by choice. I didn't feel like I fit into one gender or the other, so dressing myself became quite a great challenge. This was often true when clothes shopping with my mom. My mom saw how upset shopping made me, and it was becoming clear to her that what I wanted to wear was going to challenge the norms of what each gender wore. Because none of the boys' trousers ever made me feel like my true self, my mom took me to the preteen (then called tween) department for girls, which is where my eyes sparkled at what I saw, and I felt for the first time that I was starting to find my fashion salvation. The jeans were accented with rhinestones, and the trousers were boot cut and flared. Nothing about this felt boyish. Many shirts were made from flowy chiffon, which both felt and looked freeing and limitless—there was an appeal to this freedom. Discovering that world opened the door to an evolution and exploration

into myself that ultimately illuminated who I am. It might sound crazy, but a blouse can sometimes do that.

I began to see how the light I shone on myself could change colors every day. Seeing that allowed me to build a safe haven, whether I knew it or not, to feel like I actually had found a place to be uniquely myself. The light was malleable, and for me, that was the key to everything inside me that was coming to the surface for the first time. I began shining this light on facets of my internal self that I wanted to play with so they could be immediately seen by others on the outside—and I found this light, this freedom, this bolt of electricity inside myself through the clothes I chose to put on my back.

That's what my fluid journey has always been centered around, and why fashion is a perfect medium for fluidity. The clothes we wear signal who we are to the world—whether we want to dazzle or just blend in. With intention, what you wear can reflect the way you want to be seen by the world. Just because you are a man wearing a suit in the day doesn't mean you can't be a man wearing a dress at night. And these identities and expressions can be ever-evolving, because the exploration of gender is limitless.

Quite simply, fluidity offers an alternate way of being. By crossing the lines of men's and women's fashions and by merging the masculine with the feminine, fluidity seeks to eradicate that line altogether. The notion that clothing as an

PREVIOUS This is my full embodiment of the gender-fluid torso shot by Marc Hibbert for my collection "Sixty Years a Queen."
OPPOSITE The true essence of the renaissance from "Sixty Years a Queen"
FOLLOWING Me with my muse Trey Gaskin, who wears my graduate collection that was created during the COVID-19 pandemic, shot by Elliott Morgan at the Standard hotel in London for *Grazia* magazine

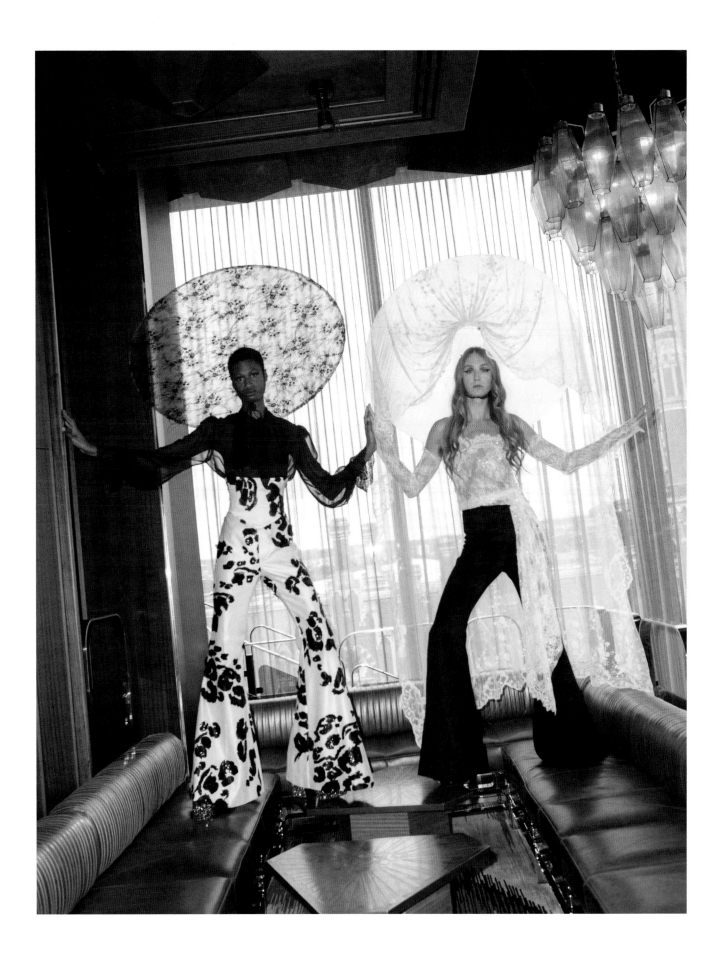

expression of our personality belongs to one gender or another is a social construct that needs to be ripped apart seam by seam and unraveled until we can rebuild it into something that is for everyone. Dismantling that construct is one of the biggest drivers of my work, and fluidity strives to dismantle and reconstruct something new that people might not have thought was possible.

I didn't hear the word "fluidity" and immediately attach myself to it. If I'm being honest, I came around accidentally by saying it over many times. People constantly asking me what I was trying to be or do or make became overwhelming. All I wanted to do was create a statement that felt true to myself, but I couldn't quite define what that truth was. Initially, I would say, "It's the new queer scene, it's gender-bending, it's unisex, it's natural, it's for everyone."

I just couldn't find the right words. It was like trying to put together a jigsaw puzzle with oddly shaped pieces that didn't seem to fit together, though I knew that when they did, they would somehow express the vision I was looking for and trying to express. I thought about my goals, what I wanted my work in its purest state to represent—curiosity, empathy, and optimism, and most importantly, a safe haven for anyone who feels like an outcast. This is fluidity. What else would it be?

Obviously, I didn't invent the term or its application to fashion. But once I said that word out loud, everything I was doing, everything I stood for, and everything I wanted to put out in the world merged into one ideal. I woke up at five a.m. one morning and changed my Instagram bio to "fighting for the beauty of fluidity." This was my calling!

This concept has been a work in progress for a while. In 2019, more than half of Gen Z shopped outside the department of their sex, searching for fluidity in their own way. This led to a boom in gender-neutral or unisex clothing. Clothing companies rushed to capture a slice of this new market, but many of them had no fucking clue what they were doing. Many designers' unisex looks were just bland, gray hoodies and baggy trousers with no consideration of body and form, nor of what the wearer truly wanted.

Fluidity in fashion is not just a section in a department store. Fluidity isn't created by an entrance light flashing UNISEX in some ugly bubble font wedged between the hyper-stereotypical men's section with straight-leg jeans and flannels and the women's section with lingerie and skirts. Fluidity is a way of being, a way of expressing yourself authentically, and a way of holding yourself in the purest and highest regard. It's not rooted in gender, and certainly not in unisex clothes.

I see fluidity as a pendulum. Sometimes the pendulum must swing far left, like putting a man in a ball gown skirt in *Vogue*, to show that boundaries can be broken. Of course, that garment isn't wearable every day, but that radical pendulum swing affects how we think about wearing our clothes in everyday life. It's pushing the boundaries in your own way.

I certainly don't expect every man walking down the street to be wearing a dress . . . though that would be fabulous, and a world I would very much like to live in! Obviously, that would be incredible, but I'm a realist, or at least I try to be. In my work, I create statement garments in the hopes that they

swing the pendulum *just* enough, to a place where men feel empowered to wear clothes that are considered to have more feminine attributes and where women will wear clothes with more male attributes.

There are two different aspects to the pendulum. There's the pendulum effect where we push the limits to reach a place where it is the norm to wear anything you want, to be who you want to be, and to be truly fluid. Those are the big strides forward, like Harry Styles wearing a dress in *Vogue* and Sam Smith being the fashion icon they are.

Then there are the pendulum's subtler movements. These happen when a suburban dad wears statement clothes, like fuchsia socks with a matching pocket square, or a husband dares to try on his wife's flowy blazer. Maybe then, young kids seeing their dads wearing what makes them comfortable helps them choose to do the same and feel safe doing that.

But despite these risks, when someone dares to test their own limits, their family, friends, and colleagues all see them in these unconventional clothes, or something that doesn't conform to their gender, and the idea of fluidity begins to normalize—for society and maybe even for themselves. That's how we keep the pendulum swinging.

Swinging this pendulum, pushing boundaries, helps normalize things doing so—and moves people closer to who they truly are. These risks can help people express their truest selves, not only in how they dress but in how they live their lives. It is not about checking a box. If anything, it's about shattering that box into a million pieces until there is nothing left of it other than the true individual

standing proud, hammer in hand and confidence in their heart.

Still, being realists, we should acknowledge the sexist and homophobic influences that make these choices daring and even life-threatening in some extreme circumstances. The fact is, there is much more ridicule when men adopt women's wear than when women adopt menswear. If a woman is wearing a suit, she is unlikely to be called out, but if a man wears a billowing blouse, the reaction can be overwhelming—violent, even.

Straight men often get freaked out with the idea of changing their exterior presence a bit because they don't want to be seen in a different way than they have been taught all their lives from family, religion, and the media. The great irony of this thinking is that by not wanting to appear a certain way, these men rob themselves of expressing other unique and nuanced parts of their personalities. Clothing can be the best way to express a feeling, a mood, or a way of being, and through doing that, you can discover a truer part of yourself. Maybe a man is embracing a bit more of his femininity by wearing more free-flowing clothes instead of rigidly tailored suits. He can still be straight and enjoy dressing up and have fun doing it. Clothes can be a gateway to knowing himself more deeply—and letting the world know more about him, too. By this happening, the pendulum effect kicks in.

But I want to dispel any preconceived notions that if you are fluid in the way you dress, you must be nonbinary or queer. That's not the case; fluidity is for everyone. Everyone can shine different lights on themselves, moving along their pendulum. Your version of fluidity doesn't have to

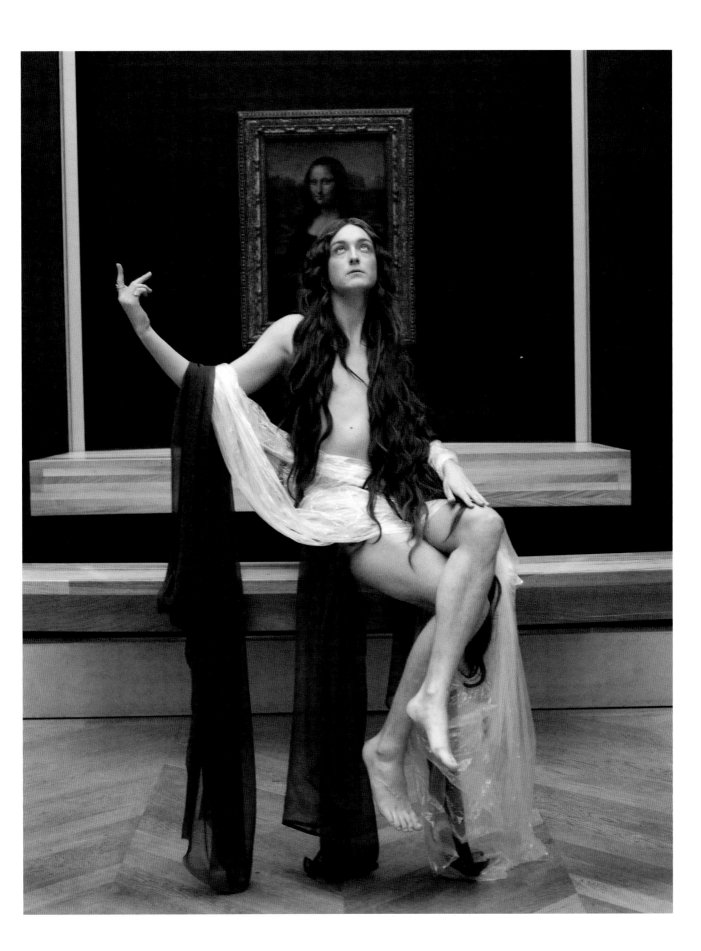

PREVIOUS Me dressed up as a queer Mona Lisa for a short film at the Louvre by my friend Ariana Papademetropoulos
ABOVE Creating "Sixty Years a Queen," shot by Buster Grey-Jung in my Standard hotel room studio
OPPOSITE A shot of my beautiful fluid model Tobias backstage at my "Sixty Years a Queen" show

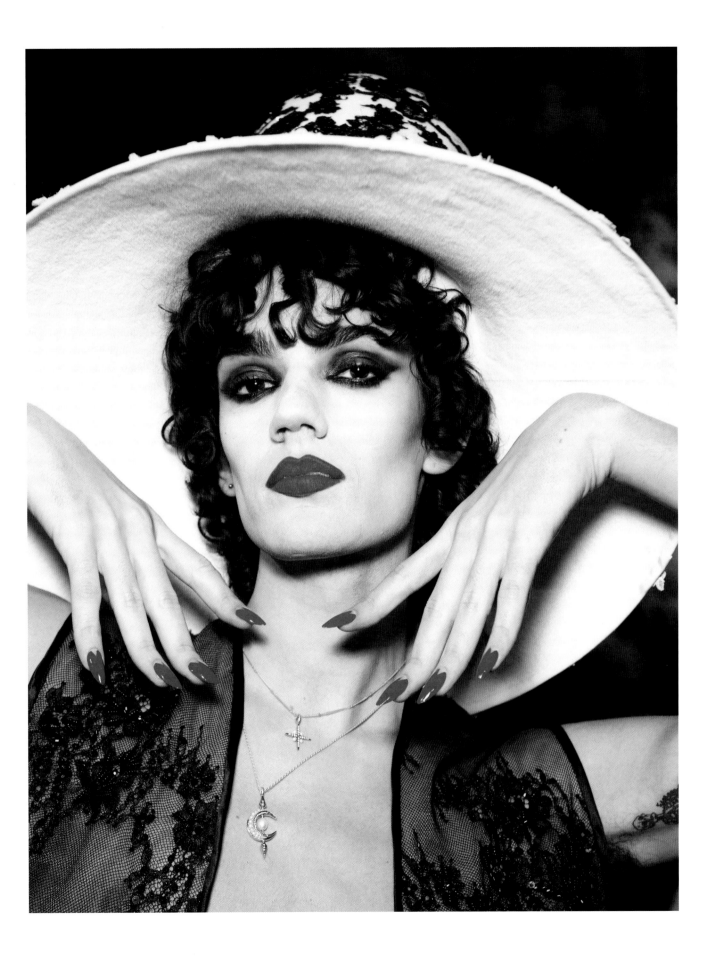

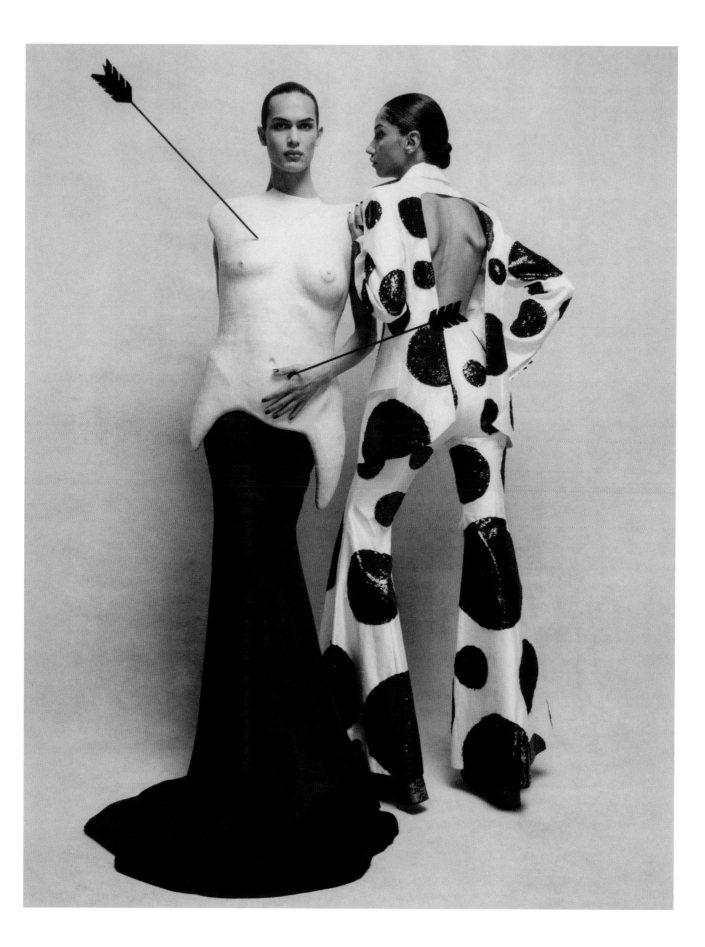

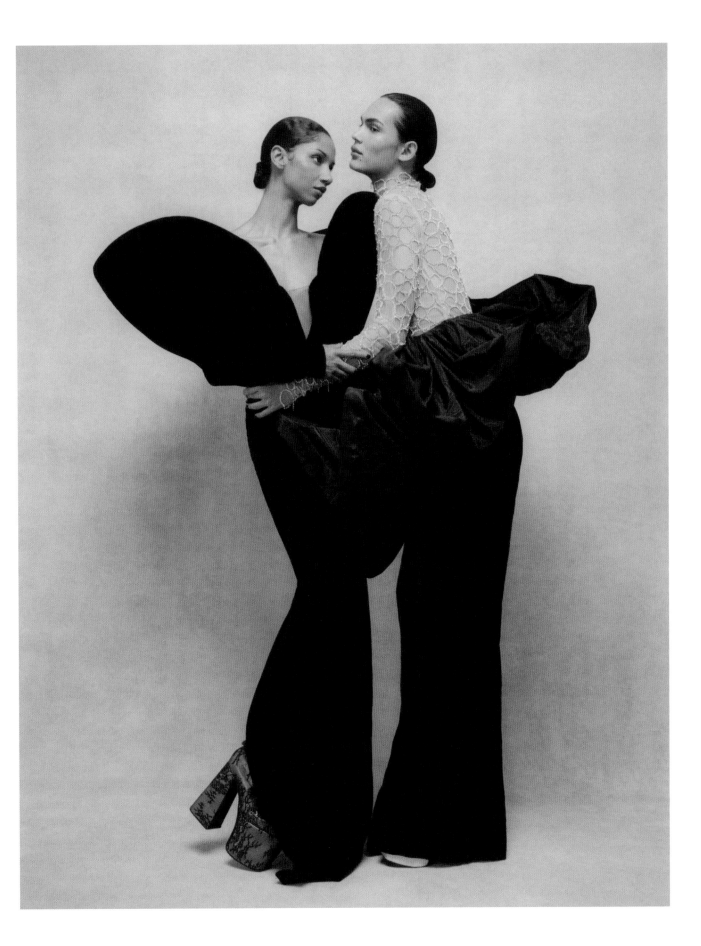

be my version, and your version doesn't have to be anyone else's.

Gender-fluid fashion is undefined and lacking a single, established construct. It can mean different things to different people. A truly gender-fluid outfit isn't an outfit at all. It's more a state of being, an authentic expression of one's self.

Instagram posts, TikTok videos, and newspaper editorials that talk about fluidity as only being avant-garde and extreme are off base. The whole point is not to force what doesn't feel natural. Do the things that appeal to your genuine curiosity within yourself. Think about what you're searching for, exploring, expanding about yourself—that is fluidity.

To apply this to a fashion perspective, try this: Go into your friend's closet or your partner's closet and grab what feels natural and right to you. Don't force it if it doesn't feel right, but push yourself and maybe gravitate toward different colors, fabrics, and textures. Free yourself of any constructs of what you think you should wear. Or go on Pinterest and explore rock icons like Mick Jagger, David Bowie, or Jimi Hendrix, all of whom pushed fashion and weren't scared to wear feminine silhouettes at times. Check out how famous women from Katharine Hepburn to Julia Roberts to Angelina Jolie wear men's suits and look every bit as striking as they do in a gown. Start following people on Instagram who are fashion fluid, like Sam Smith, Harry Styles, and Jaden Smith, or maybe even Olly Alexander, who are all putting their own mark on gender expression and fluidity. If you are ever nervous about being judged or don't live in a space where you can be seen following too

many queer icons, start a Finsta account to interact with other like-minded people. Find some way to bring fluidity into your daily life.

Fashion is at the forefront of fluidity because it moves quicker than any industry I know, even technology. Overnight, styles can change— new shapes, colors, and motifs emerge. We can go from Y2K hot pants and leg warmers to Tom Ford suits and harsh tailoring, or from everything being in some shade of black to bright colors being the order of the day, all within a matter of minutes.

People also have a visceral reaction to fashion. As a society, we are obsessed with what people wear, how they wear it, and what statements they make by wearing it. There is a visual, risk-taking aspect to fashion, whether that's on the red carpet or at the grocery store, that someone will judge you because of what you are wearing. People use fashion to say something, or explore something, or be something.

To me, fashion is the ultimate tool for expressing fluidity. I make fabulous clothing for editorial purposes because it's important to be able to put my clothing in front of people who wouldn't normally see them. I love nothing more than to move beyond the pages of fashion magazines, far from fashion's safe bubble of queer acceptance, and be featured in more mainstream magazines, because that gets my message out into the world. I also feel it's important to be able to have my clothes represented on an array of models. I make all my clothes with fluid expression in mind, rather than for an audience that simply wants to be fashionable. If you want only beautiful clothes, seek out somebody else, but if you want clothing with meaning, come to me.

I don't just want my clothes to be beautiful—I want them to have a message.

As much as I talk about de-gendering, fluid fashion does come from blending menswear and women's wear to create colors, textures, patterns, and layers that deconstruct the very binary the clothes began in. To that point, real gender-fluid fashion isn't really about fashion at all, but about the ways we observe the world through the prism of clothing and represent ourselves as a canvas for curiosity, empathy, and optimism. If nothing more and nothing less, that's fluidity.

PREVIOUS SPREAD Two of my favorite models, Joaquin and Aiden, modeling my archive for *Elle* magazine, shot by Silvana Trevale

FOLLOWING, LEFT Harry Styles wearing a completely crystalled take on men's tailoring, styled by my guardian angel Harry Lambert and shot by Samuel Bradley for the *Guardian Weekend*'s cover

FOLLOWING, RIGHT Me on the cover of *Harper's Bazaar*, a moment that cemented myself as a fluid designer to be reckoned with, and got us a great deal of backlash for exposed nipples on what many couldn't tell was a boy or a girl

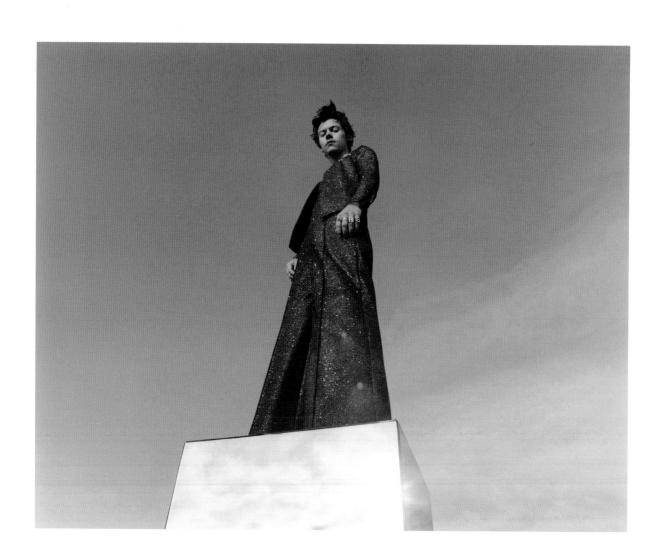

www.harpersbazaar.com/uk

Harper's BAZAAR

APRIL
2022
£6

COLLECTORS' EDITION FOR THE V&A

Harris Reed:
the face of
fluid fashion

2

WHY
I
DESIGN

Remember that department store I went to with my mother as a teenager? One floor was for boys, one floor was for girls. Tween clothing was on one side of each section, with teen clothing on the other. Its gender division boxed me in from the second I set my young, queer feet into that rigid space. Even the interiors and the music were curated to define me as M or F. The boys' department had wooden tables and skateboards used as wall art, with Blink-182 playing; the girls' department had glossy mannequins and bright pink chandeliers, with Alanis Morissette blasting from the speakers.

Fashion. Beauty. Business.

Even Bigger

Walmart had a strong fourth quarter and full year as the world's largest retailer adapts its business model.

Page 2

Karl's Last

A bearded Bearbrick figurine in the likeness of the late Karl Lagerfeld was the designer's very last project.

Page 3

Getting Better

MAGIC and Project in Las Vegas were busier than last August and retailers were pleased with the brands on show.

Pages 19 to 21

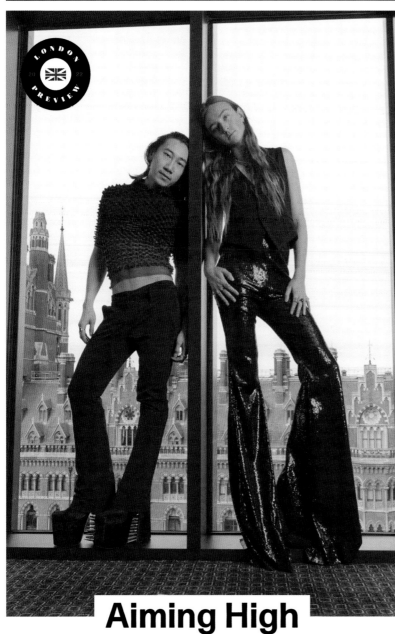

Aiming High

A new generation of designers is taking over London Fashion Week and keeping the event relevant. Two of the season's brightest young stars are Harris Reed and Chet Lo, fellow Central Saint Martins graduates, best friends, and one another's biggest cheerleaders. *For more on London Fashion Week, which kicks off today, see pages 6 to 12.*

PHOTOGRAPH BY **FRANCISCO GOMEZ DE VILLABOA**

BUSINESS

Gucci in Q4 Puts Kering in Bullish Mood

● Revenues at the conglomerate rose 35.2 percent in 2021.

BY **MILES SOCHA**

PARIS – After a worrisome wobble in the third quarter of 2021, Gucci showed signs of improvement in the fourth quarter, giving parent Kering confidence there is plenty of potential to expand its star brand further in upscale product segments, and in promising growth areas like men's.

"We have a very strong pipeline for this year again, and this will support the growth of Gucci," said François-Henri Pinault, chairman and chief executive officer of Kering, sounding the first of many bullish notes as the French group reported a 31.9 percent jump in revenues in the fourth quarter, a 25 percent improvement over 2019.

The luxury titan also talked up Saint Laurent as luxury's next mega brand, with the potential to drive further upscale, eventually expand into fizzy categories like fine jewelry, and

CONTINUED ON PAGE 18

FASHION

The New Guards Who Are Taking Over London

● London Fashion Week is staying relevant thanks to a wave of designers like Harris Reed and Chet Lo, who are rewriting the rulebook.

BY **NATALIE THEODOSI**

LONDON – Post-lockdown and post-Brexit, the London fashion scene feels forever changed.

Most of London Fashion Week's anchors are gone, picking Paris – or even the metaverse – over the more intimate, low-budget catwalks of the British capital.

So what will become of the London fashion scene, without Jonathan Anderson, Victoria Beckham, Burberry, Christopher Kane, or Mary Katrantzou headlining its fashion week schedule? Will any industry professionals of note even show up this week?

While the schedule, which runs from Feb. 18 to 22, is indeed much thinner and attendance numbers lower, London remains part of the conversation – because there are new sheriffs in town and they mean business.

CONTINUED ON PAGE 4

Those archetypes will always exist—though I hope not forever. Take Zara, one of the most popular stores among Gen Z. At the massive store on Regent Street in London, its men's department is confined to the basement, while the women's department occupies the top four floors. In fact, many stores are divided in this binary way. There's no common space among genders—it's all separated into hyperfeminine and hypermasculine spaces, like cages for one to be shoved into, unable to wander freely.

As a little boy, you might fear shopping in the girls' department, with its Marie Antoinette paintings and pink wallpaper. Bullies would be quick to box you in or call you names. I can certainly say my childhood shopping experiences that were trying to put me in a box stayed with me and helped stimulate my interest in what I could do differently if I were a fashion designer. As I learned more about this craft, I began to question why dressing within my gender was such an inflexible rule.

When I was having trouble reading at an early age, my parents seized upon my interest and bought me a subscription to *Women's Wear Daily* magazine—a little unconventional, but thankfully so are my parents. From the first issue, I was hooked. Seeing the way people presented themselves, particularly pictures of popular icons going out, was exhilarating, to say the least. Clothes by Givenchy's creative director at the time, Riccardo Tisci, and Celine's then creative director, Phoebe Philo, weren't just costumes in some movie; they were real—and "real" people wore them. I hung on every word and every image. The magazine became my safe haven, my place for escapism and wonder, like comic books were for some kids. It taught me a great deal about designing and style, as well as the inner workings of the fashion industry. As this was before magazines had an online presence, it was a window into a world that I didn't even know existed, let alone one that I could be a part of someday.

Looking back, I now see as a twenty-six-year-old gender fluid fashion designer with long red hair that I was quite obsessed with the psychology of fashion. I was always hyperaware of my surroundings and of what people were saying, first at my conservative elementary school in Arizona and then after a move to Los Angeles for middle school, to escape the bullying at my first school.

In LA, I attended Topanga Mountain School, the complete opposite of my Arizona elementary school in every way. It had started as a homeschool program by a group of parents who were concerned about bullying. The place was like a hippie commune for kids, a group of thirty misfits and weirdos. We journaled and sat in groups and talked about our feelings and fears of being different. When I started, most of the kids thought I was a girl, and many of my classmates I thought were girls turned out to be boys. We were in a space where we could have open conversations about sexuality, feelings, and adversities. Most importantly, we were heard, respected, and not made fun of for being different and allowed to explore who we truly were.

Looking back, I cannot express my gratitude enough to the privilege of being in this kind of environment during such a formative time. It allowed us to be queer, to be different, to pursue

unconventional ways of expressing ourselves. The atmosphere allowed me to start to come into myself and push my own understanding of my identity through what I put on my back. Kids dressed without judgment in torn jeans, baggy dresses, and leotards. Rather than making you an outcast, experimenting with clothes made you more celebrated. Our school actually held an opposite-gender-dressing day, which was my first eye-opening experience of such an encouraging freedom to play with gender in our clothes. I could play dress-up, not to the extreme degree that I would have liked, but it was a start.

Years later, in 2016, I enrolled in fashion school at Central Saint Martins, the premier London arts institution whose alumni include fashion pioneers Alexander McQueen and John Galliano. Back then, I did not feel represented in society whatsoever. I couldn't find anything to wear that reflected who I was at my core. I'd look in department store windows and see nothing that spoke to my identity, my personality, my needs, my wants, my desires. Even then I had to dig pretty deep on social media for something that was me. Fashion's ethos was still very much "men are like this, women are like that."

I felt like my pleas for gender crossover were shouts into a void. Whether I knew it or not, I found myself, in some small way, filling that void by designing my own creations. But every time I sketched something, my teachers would ask me, "Who is your customer? Who is this for?" And I'd always give them back the same sassy answer: "I hope they don't exist yet because my customer is the next generation. Why do my designs need to be for someone who already exists? They should be for whoever comes next and however they want to dress."

In the first collection I designed as a student at Central Saint Martins, I made outfits that *I* would wear. One outfit had black matador pants, a black lace ruffle running down the front of the shirt that looked like something a Victorian prince would wear, and a frontless jacket; another was bright pink metallic pants and a matching top with detachable sleeves. These were inspired by a story I imagined about an eighteenth-century aristocratic boy who has been thrown out of his home because he was gay and now lived backstage in the Royal Opera House, where he played dress-up with costumes—something of a metaphor for my own story, if you will.

I also created a pink moiré (a pattern with a sheen) outfit with a puffed-sleeve blouse and an oversized lace and black velvet cravat. I made it while I was eating chicken nuggets on the floor of my dormitory. Hence, it had a bit of grease on it, as well as a cigarette burn on one of the sleeves left by someone at a party in London hosted by Donatella Versace that I snuck into when I was nineteen.

As if I'm living in a dream, that outfit is now a part of London's Victoria and Albert Museum's permanent collection, something that will live on long after I do and will be able to be visited for

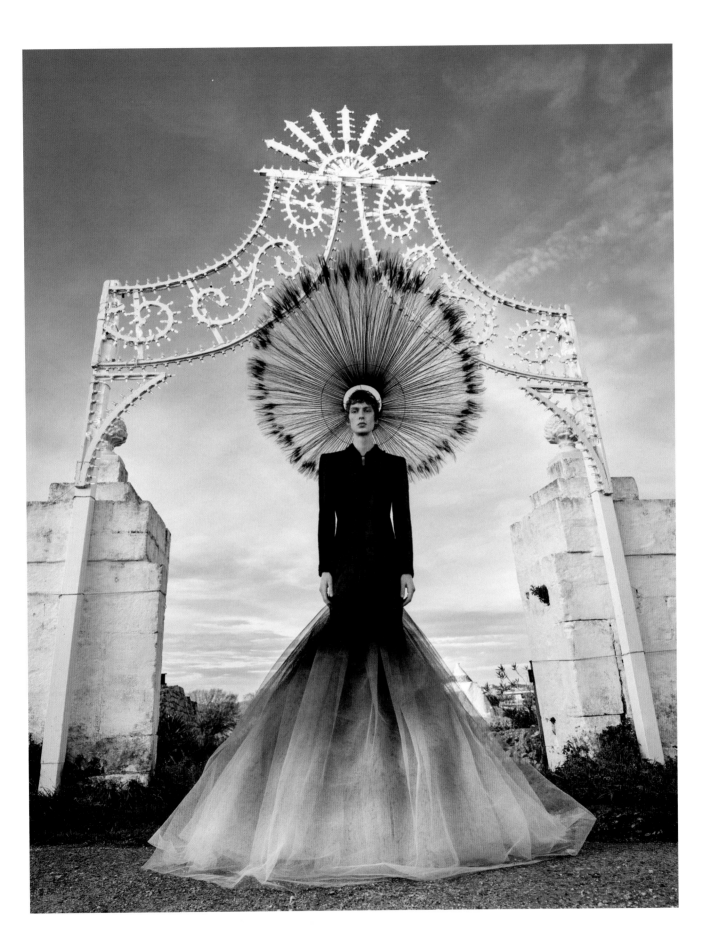

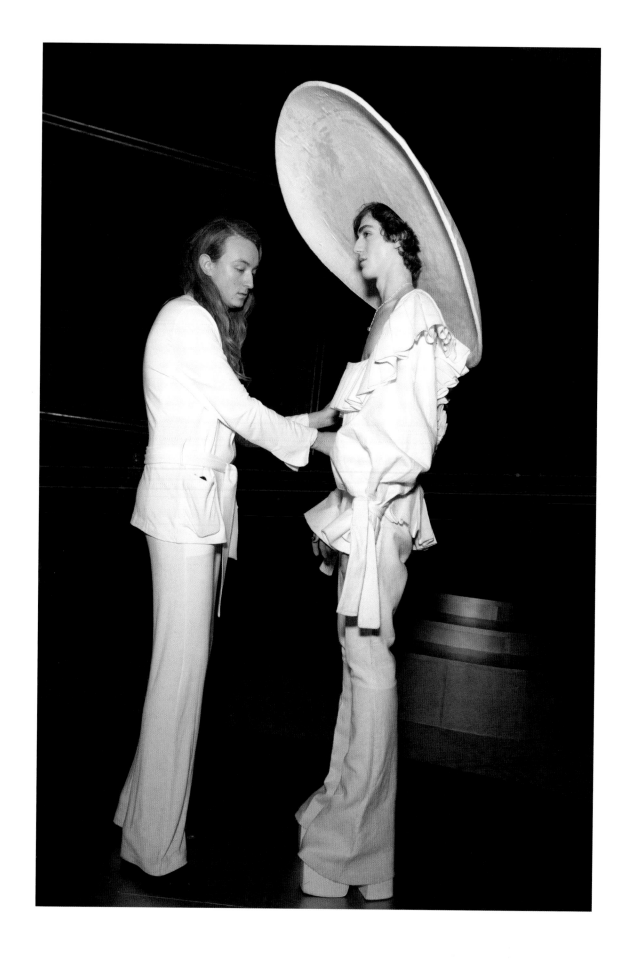

generations to come. Isn't it funny that that queer kid who dreamed of big hats and billowy sleeves ended up with something in a legendary museum?

My big break came when the highly regarded stylist Harry Lambert messaged me on Instagram about designing for some of his clients. Harry then commissioned me to make garments for Harry Styles's tour. The first outfit I designed, a silk crepe de chine blouson shirt with puffed and ruffled sleeves and a frilly collar, went viral on social media. Pinch me, pinch me, fuck!

For young Harris, trying to find himself, unsure of who he was or what he stood for, these breaks were huge. Several of my teachers were calling my work "costume," and I began to question if I needed to move my work to be more masculine or more feminine and fit into something that already existed in the binary fashion world—and thus give up on my fluid fantasy altogether. So when Harry Lambert endorsed my work, I finally felt like maybe I could project my own message through clothes.

My work for Harry Styles opened doors, to say the least. When I applied for an internship at Gucci one morning, I received a reply that afternoon telling me that they were sending a plane ticket for me to fly to Milan in the morning to meet with Alessandro Michele, one of the most important designers in fashion, who had become Gucci's creative director in 2015. From the bureau in my dorm room, I dug out the only piece of Gucci I owned, which was a beige women's blouse that I had bought at a thrift shop worn by Gucci employees.

I arrived at Gucci headquarters in Milan and was blown away. Its overload of colors, textures, and sounds made it like a fashion Disneyland. Alessandro's office transported me into another dimension. It had furniture that looked like it was from Marie Antoinette's bedroom. There were thousands of textile samples covering the floor, and the room had the most beautiful smell, a musky, gorgeous, warm scent. "So, *this* is what a real fashion designer's office feels like," I thought to myself.

Alessandro was sitting on the couch, sipping tea. I sat across from him. He told me that when I emailed the day before for the internship, he had coincidentally seen an article on me in *Dazed*, a British culture magazine, as well as a photo of Harry Styles and me together on Harry's Instagram page.

"So it's meant to be," he said.

I gave a nod of total agreement.

"Will you walk my next show with me, for me and the brand, in Arles?" he asked, referring to Gucci's upcoming cruise wear show in southern France.

"Yes . . ." I managed. "And I would also love to work for you."

He stood up. "Okay, we'll talk about that," he said. "But for now, come with me."

He took me through Gucci offices. Just the way people walked took my breath away. At the end of a corridor, he opened a large door to what looked like an aircraft hangar. Inside were hundreds of bags, sunglasses, shoes, and purses, all lined up alongside a long white runway.

He tapped his phone and MGMT's "Kids" started blasting from the surround sound speakers, and I walked down the runway. As I turned at the end and flipped my hair, I remember catching a glimpse of myself in a large mirror and seeing the biggest smile of my life on my face.

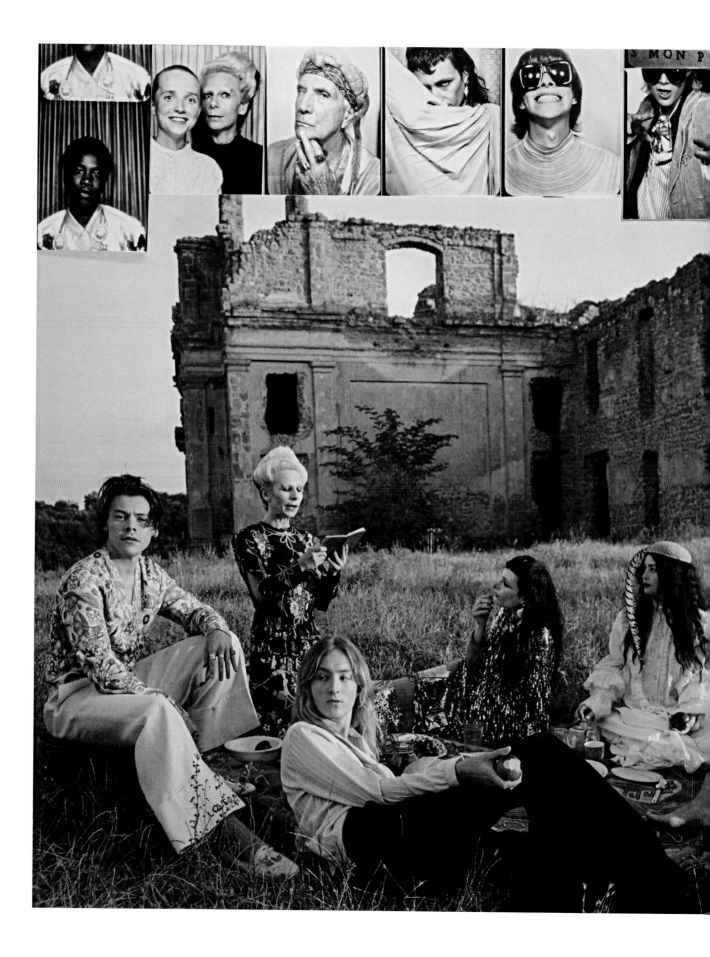

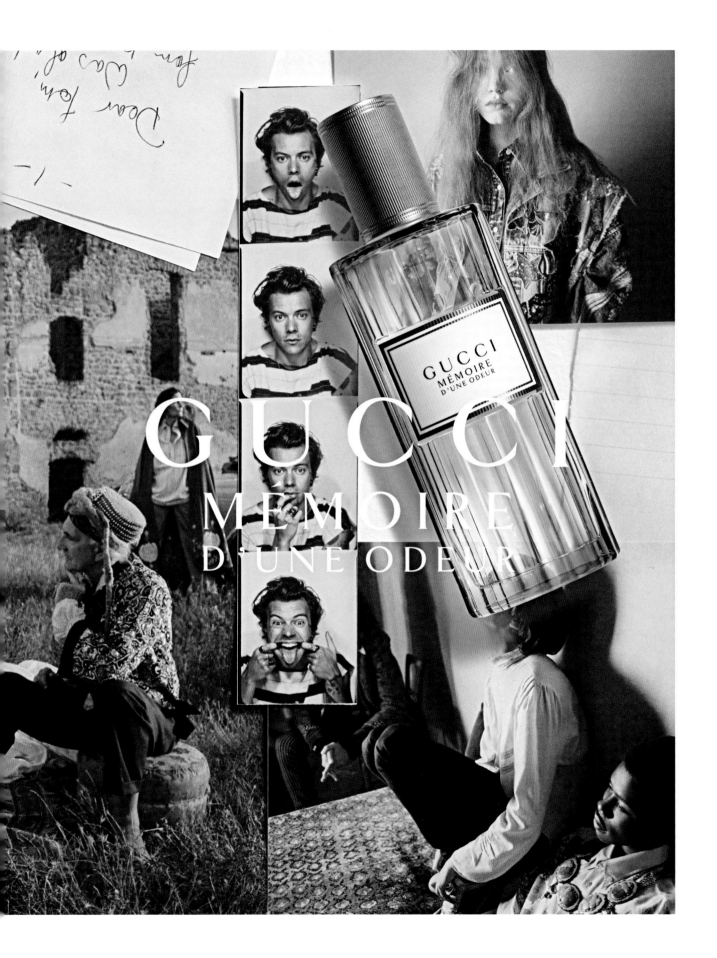

Alessandro offered me a spot in the campaign for Gucci Mémoire d'une Odeur Eau de Parfum, its first-ever genderless fragrance, with Harry Styles, who was by then a good friend and client. Talk about serendipitous! We shot the ad under the stars on the outskirts of Rome next to Roman ruins. I felt like I had landed on another planet.

Immediately after the shoot, I went to Rome for my interview with the head of women's wear at Gucci. I got the internship and spent nine incredible months there working for Alessandro. He focused on clothes that are expressive, nonconformist, romantic, and intellectual, and he feminized Gucci's menswear, essentially declaring that you can be more masculine by showing your femininity and vice versa. The fashion world saw this as liberating and lauded its message of inclusivity.

Being at Gucci opened my eyes to the fact that fashion is not just about commercial concerns and growing a business (even though they are very good at that); it's also about standing for something and really embracing the weirdos. Watching the way Alessandro worked, the way he used trans, nonbinary, and models of color, was quite radical, especially as the social mores in Italy are still very much conservative.

Even as the creative director of the company, Alessandro showed that you can make money and grow a brand that stands for something. He is a complete artisan and a showman, which is fun to watch, but the main aspect I wanted to emulate was his deep belief in his work. While he's able to create clothes with commercial viability, from what I saw, that's not his sole motivation.

He designs because he believes in what his clothes can say. Living a truth through design became my modus operandi.

I want my designs to stimulate conversation, to create a sense of identity, and to offer confidence, to showcase the wearer's true self. I want these designs to change the way we buy, change the way we wear, and change the way we see one another. My designs are less concerned with where you wear them and more about the responses they elicit. I want people to see my designs and think, "Wow, holy shit, this is really interesting!" or "That is insane! Who would wear this?!" But as much as I want my clothes to turn heads, they must also blur the preconceived notions that people have about gender and sexuality. I've seen how fashion is revolutionary and has a leading role in pushing the world to a more expressive and accepting place.

My greatest challenge is our extremely gendered society—but even that is changing . . . though not as fast as I would like. We are now seeing some of the biggest celebrities in the world wearing gender-fluid clothes on magazine covers and runways. Continuing this will help retailers and brands reconsider working in strict binaries—otherwise they're going to be left behind the times. No modern-day business wants to feel left out; they all want to be relevant and cool and a part of what's happening. They want to be the future. I want to make them see that the systems the fashion industry has in place with how clothing is merchandised, as male or female, is antiquated and that there is a new paradigm.

My work pushes gender fluidity from the fringes into the mainstream. When the mainstream

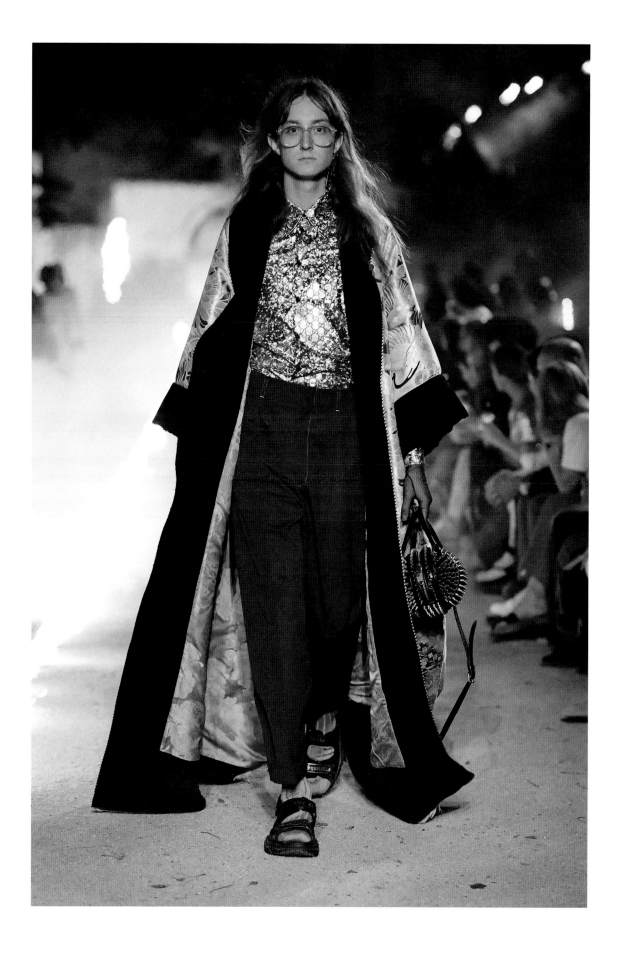

embraces gender inclusiveness and gender expression, in whatever way that looks like individually, it creates a safer space for people. It's a space that gives a new generation of creatives in all crafts—be it dance, art, music, writing, or film—the safety to grow and flourish. In a couple of years, we might even see people in other areas, such as finance, moving out of the mainstream with their style. There is space for fluidity there, maybe not at this moment in time, but if we could get there, it would open up so many incredible doors that all lead to self-expression and challenging the status quo. And the Harris Reed customer certainly challenges the status quo.

So, who is my customer? They're somebody who wants the attention on them, who wants to create a stir. They're someone who wants to be unique and rock a demi-couture gown and feel fabulous. They're a multi-hyphenate, a performer in their own right, crossing genres and even worlds.

I design for the risk-taker, the person who has lived a little bit, someone who is comfortable in the bold, bright, and avant-garde. Most of Harris Reed is not the first step someone will take on their fluid journey. It's a destination, an extreme end on the fluidity pendulum, fluidity at its maximum, and not for someone who is just starting to experiment with a little color or a slightly different drape on their trousers.

My customer is rethinking norms. Rethinking our norms is a great responsibility and priority. To be unapologetically ourselves, sometimes we need to rewrite a few of the rules or just burn them to the ground, tough as that may be.

A central theme in my life has been chasing my dreams no matter how weird they might seem or impossible to achieve. Far too many young people with a dream have been told they can't do something because of who they are and how they present themselves, but I want to show that you can succeed without taking a prescribed path. There may be prerequisite classes in school to reach a degree, but there are no prerequisites to forging a new path. When you discover your place in the world, you become an individual who can tap into your full potential. Corny as that may sound, fashion can actually help you do that. Fashion can help change the world.

Being of Gen Z, when I see what's going on in countries where there is gay purging, I feel a sense of anger and frustration for my community and an obligation to try to somehow infuse that into my work. I can't say that this sense of responsibility directly results in a flamboyantly over-the-top dress, but it does go hand in hand with how far I am willing to push my design process and make a statement with my work because I feel so fueled by the horrible things the world does to some people, especially to queer communities. That pushes me to go further and to be more authentic to who I am.

And so, I try to connect my designs to the current social and political issues as much as possible, to make them push the pendulum as far as possible, like putting a man in a skirt. There are

PAGES 36–37 My Gucci Mémoire d'une Odeur campaign for their first-ever gender-fluid fragrance alongside my first client, Harry Styles, my dear friend Ariana Papademetropoulos, and experimental musician Zumi Rosow

PREVIOUS On set for Gucci with my angels Ariana Papademetropoulos and Zumi Roscow

OPPOSITE Me walking my first-ever runway show, for Gucci—quite a magical night in Arles, France. I came out of a fourteenth-century tomb and walked alongside a half meter of flames, and the first people I saw when my eyes cleared were Sir Elton John and A$AP Rocky.

places in the world where being queer puts your life at risk; in places where queerness is accepted and celebrated, I want people to express that freedom. The work I create is built from assessing the responsibility that fashion must spark conversation in relation to societal injustices, yet all the while staying true to an ethos that strives for a vision of gender fluidity and inclusivity of race and of body and of mind. I call it "Romanticism Gone Nonbinary," and I believe that clothes are not merely garments; they are a nexus of art, philosophy, and history that can be used to help shape our world.

Look at Lil Nas X. He is constantly advancing the pendulum of change. A gay African American singer, he incorporates his heritage, identity, and sexuality into his music, videos, and fashion sense. (I mean, he actually makes out with men in his music videos—while wearing Versace and, yes, Harris Reed.) He doesn't do this for the shock factor. He does it to expand culture, to make people confront things about themselves. But without the sequined jackets, the platform boots, and the fake leather neon pink skorts he wears, he wouldn't have the same impact. They are meant to be thought-provoking, dynamic, startling, and avant-garde because *that* is what keeps fashion moving.

The way Nas expresses himself onstage in front of thousands of people and in videos seen by millions creates waves among people who do and who don't understand what he's pushing for. His dynamic fashion choices, full of crystals, textures, and provocative silhouettes, push conversation into new territory.

And when fashion is over-the-top for an audience of millions, in Nas's case, there's a tidal effect—whether people understand or celebrate what he's doing, he's pushing conventions and conversations forward. He shows that fashion doesn't shape culture; it *is* culture.

The world is an extraordinary place, but it is also an incredibly judgmental and mean place at times, a place afraid of change, one that is constantly challenged and outraged in its deep frustration of "understanding" and "labeling," whether in your gender, your job, your sexuality, or just your purpose. I design in hopes of removing stigmas in order to show how anyone can use fashion to live a life exactly as they are in a world that isn't quite ready for them.

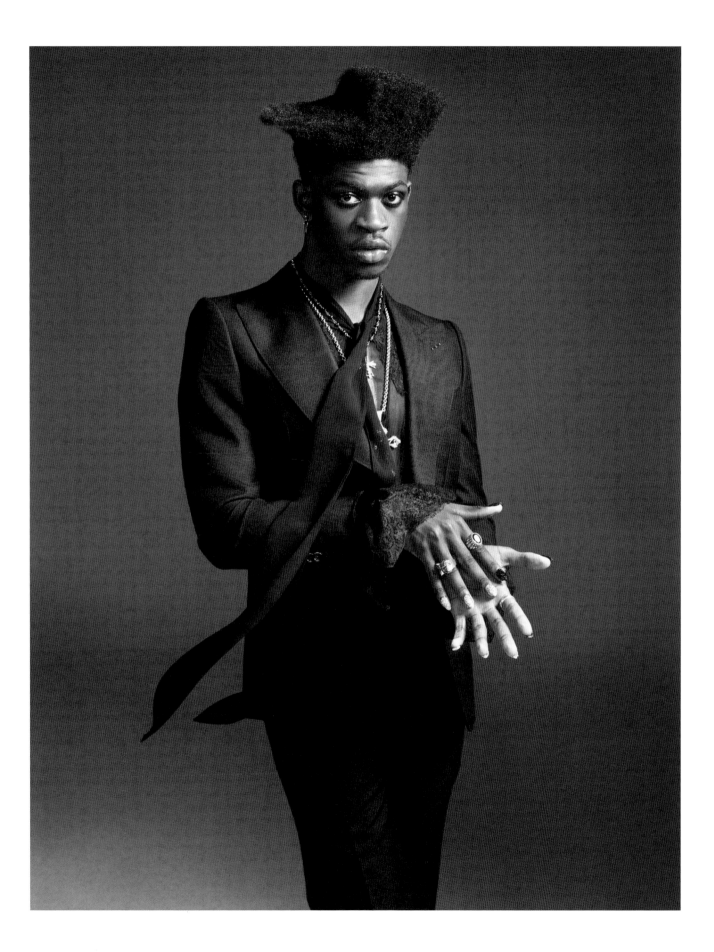

PREVIOUS Lil Nas X wearing a Harris Reed pussy-bow blouse, which later became one of my signature pieces at Nina Ricci
OPPOSITE Lil Nas X at the MTV Music Awards, wearing a signature Harris Reed feathered halo hat
and crinoline skirt with my "queer in your face" take on it
FOLLOWING One of my early muses, Momo, modeling backstage at my "Sixty Years a Queen" show

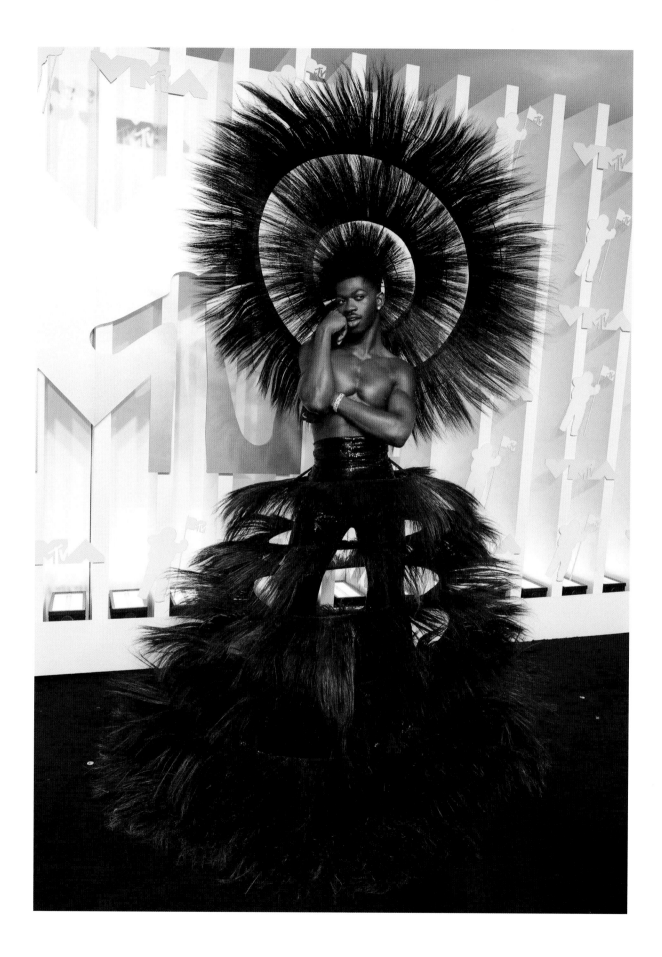

IDENTITY

I remember when I first understood how society labels our identities. I was still in elementary school, and my parents were called in for an urgent parent-teacher conference to discuss a problem: me. My teacher explained that she had had numerous complaints from other parents about "the gay kid." These parents wanted their kids removed from my class because they didn't want them "catching the gay," whatever that means. If that wasn't bad enough, my teacher had the audacity to caution my parents in a "friend-to-friend" tone: "You do know gays go to hell."

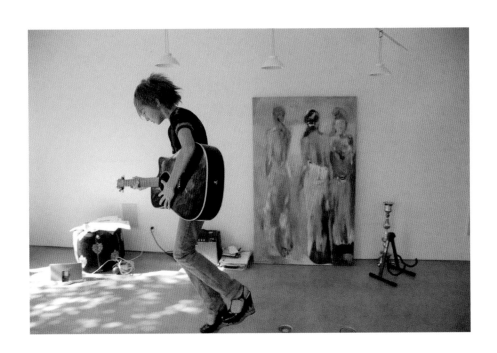

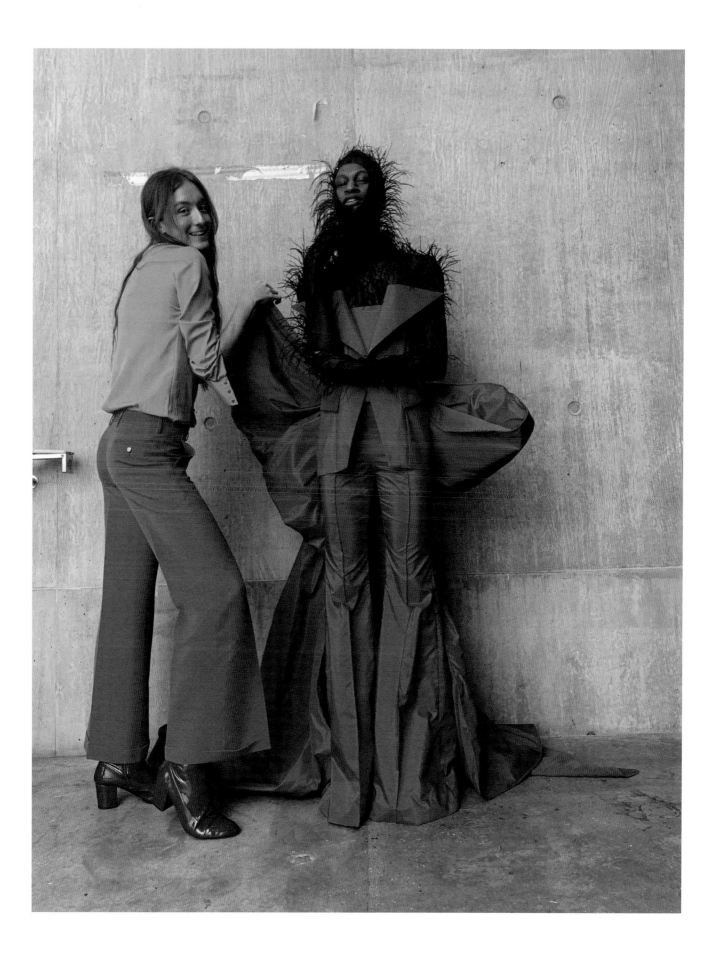

There I was, a nine-year-old—nine!—being told who I was by adults, before I even knew who I was myself. Being labeled gay came with the ominous warning of a one-way ticket to hell—all while I was a dyslexic child with ADHD who was still trying to figure out how to spell my middle name!

It took me a while to understand that I didn't have to assume the identity assigned to me, and if anything, I should challenge it. I could be whoever I wanted to be, even if the world wasn't ready for me. I looked at images of David Bowie as Ziggy Stardust, in awe of his skintight outfits and knee-high boots that veered way into the feminine form of absolute expression. I remember reading somewhere that his producer, Ken Scott, said that Bowie would "take bits and pieces from all over the place, put them in a melting pot and they'd come out being him." I thought, *That's exactly what I want to do!*

But the question remained, how was I to show my identity in a way that was, well, me?

Then, one day while shopping with my mother, I spotted a pink Lacoste shirt and pulled it off the rack. The salesman was an older queer African American man. He looked very pleased with my choice. "Yes, you can wear that one," he said enthusiastically. "If you love it, wear it and don't care what people say!"

I tried the shirt on. It was me. My mom bought it for me without hesitating. She told me to wear it well. I felt like I had taken a big step toward showing the world who I was.

I wore the shirt to school the next day as a symbol of change, whether I knew it or not.

Wearing a color that had been deemed feminine by society was part of my transformation that was to come. As I walked across the playground, heads turned. Guys were pointing, laughing, and calling me names. Girls flashed me odd looks of confusion and surprise. It was truly a fantastic moment, like a beam of light from the heavens hitting me straight in the face, truly a fuck-it-this-is-who-I-am moment—and if you don't like it, that's your problem, babe.

Mind you, I was scared, but I had an underlying feeling that I would just have to be scared until I wasn't. But it was dangerous to do so in my very conservative, heteronormative town. The community was also devoutly Christian, a place where marriage could only be between a man and a woman, where you were either male or female, and where men certainly did not wear pink, let alone dream about being anything out of the binary that was set in front of them.

Even though this seems like a small moment, it felt absolutely massive. Everyone was so concerned about declaring their opinions of me, but I was more interested in reclaiming the noise and confusion, owning the uncomfortable air that everyone felt, and using it to rewrite my own narrative. It was a moment of self-discovery, a moment of coming into my own, and a moment when I gained some power over my identity.

Nevertheless, confusion over who I was and my fears of being accepted because I was a boy who wanted to wear "girls" clothes remained through my teen years as I embarked on this identity renaissance, constantly searching for an environment where I could explore being my true self.

The breakthrough came when I moved to London in 2015. I remember getting off the Tube and seeing an individual walking down Liverpool Street in a wedding dress and platform boots with full-face makeup and a beard. I watched as this person passed a clean-shaven man with his hair cut over his ears and off the collar who was wearing a dark blue suit and carrying a briefcase. Neither one batted an eyelash at each other as they crossed paths.

What a space of true exploration! All in that one moment, I felt like I was living in the future. For the first time, I felt a world of new possibilities, where being different was possible, achievable, and even acceptable. When I started fashion school at Central Saint Martins the following week, I found myself surrounded by cool new dormmates who had shaved eyebrows and extreme looks—not to mention that so many were openly nonbinary, transgender, bisexual, and polyamorous, the list goes on and on. They all seemed so authentically themselves, in every bone in their bodies. By comparison, I felt *basic* with my short platinum hair, skinny AllSaints jeans, bomber jacket, and leather Doc Martens. I regarded myself as a gay man who was very far out of the closet because my peers had seen me as *only* my sexual orientation for so long. But I was finding out that my identity had many shades and colors and that I could fall on that spectrum wherever I wanted and however I measured myself.

And so, in the halls of school and under the disco ball on sweaty dance floors, I began to see my identity in a new light. I frequented Metropolis in East London, which was a strip club most nights, but on Fridays it was a gay club with a little bit of stripping (but only among friends) and a free-for-all of self-expression. At that time, I was more of a spectator who was processing people's body language and self-expression—all the way from their eyebrows down to their footwear. That started me on a deeper journey of self-exploration. I wanted to arrive at a place where my inner self matched my outward expression, where I wasn't just showing my fluidity; I was living, breathing, and being it.

Much of that exploration happens not only in the clothes we wear but the words we use. Those of us who identified as nonbinary, or gender neutral, began using the gender-neutral pronouns they/them instead of he/him or she/her. And while the use of they/them pronouns is now most commonly thought of as a contemporary practice for nonbinary and gender-nonconforming individuals, the use of "they" as a singular pronoun can be traced to some of our earliest literature.

One of the earliest recorded uses of "they" as a gender-neutral personal pronoun was in the fourteenth-century French poem "William and the Werewolf." Geoffrey Chaucer used "they" in the singular in *The Canterbury Tales*, which was published in 1387. William Shakespeare used they/them pronouns in *Hamlet* in 1599, and Jane Austen did the same in her landmark 1813 novel *Pride and Prejudice*.

IDENTITY

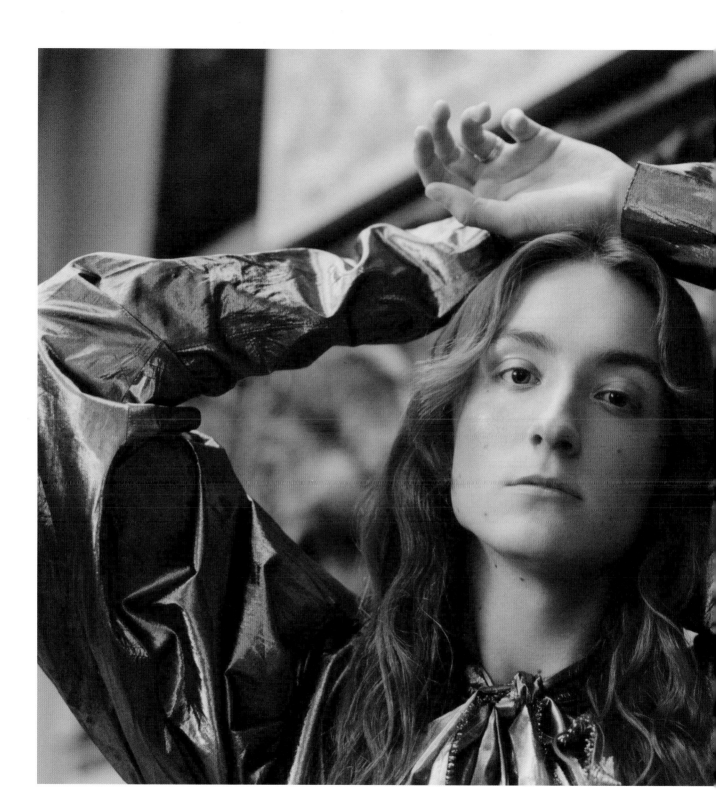

ABOVE A photo of me in Sir John Soane's Museum in London for a profile in the *Evening Standard*'s *ES Magazine* that put my brand on the map and showed the array of what I could do. (Fun fact: I'm wearing a look that is now part of the permanent collection in the V&A Museum.)

FOLLOWING Embracing Sam Smith after they performed at my "Sixty Years a Queen" show, a truly emotional moment. Sam agreed to perform off a DM (and a dream), and it all came full circle when I embraced them on the stage.

These writers' uses of "they/them" pronouns weren't necessarily to define people outside the gender binary, but it does show how far back the thought took hold that "they" could be used in the singular, as it is today. Through more contemporary writing, the singular use of "they" has been a device used when gender is unknown, needs to be concealed, or is irrelevant. Still, it wasn't until 2019 that *Merriam-Webster* added it in the singular use to its dictionary and chose "they" as its word of the year. The *Oxford English Dictionary* and dictionary.com also recognize the singular "they" as grammatically correct.

Around the time that I was discovering a more open world in the East End of London, several celebrities began changing their pronouns, which I believe had a real effect on a younger generation, giving them permission to explore their own identities. Two of the boldest names were Sam Smith, in 2019, and Demi Lovato, in 2021. They served as very public examples—millions saw them reckon with feeling that they did not match their gender assigned at birth. Coming forward and saying so publicly was empowering.

Coming from a Disney family actor, Demi's declaration provoked a predictable backlash and an avalanche of disgust from staunchly conservative media and unenlightened people, but it also opened a door. They inspired many people who heard what they said and instilled hope in them that they aren't freaks for not identifying as either male or female. I should note that Demi has recently gone back to identifying as she/her—which further highlights gender's fluidity as an aspect of our identities that constantly evolves.

Of course, Sam Smith going public had great impact. Sam's audience of billions around the world includes those in countries where being gay is illegal. Seeing a pop star of Sam's caliber openly celebrate their gender nonconformity may have given others courage to do the same.

With Sam, it's not just kids who are listening to them and hearing their message. It extends to their parents, who listen to Sam's music, too, and even grandparents. A cross-generational dialogue might begin with the fifty-year-old mom and the eighty-year-old grandmother asking, "What does that mean?" It can possibly help pave the way for talks about gender and self-expression for people who may be unsure how to begin.

Or take Laverne Cox, who starred on *Orange Is the New Black*, becoming the first transgender person to be nominated for an Emmy Award in an acting category back in 2014. The amazing Billy Porter won a Tony for his performance in *Kinky Boots* in 2013 and was the first male to be featured on the cover of *Allure* magazine. Porter opened up the conversation about what it really means to identify as a man, and he did that by delving into his feminine side—especially in fashion. As he said, it was "not about masculinity; that's about humanity."

Notable figures using their platforms to speak out about themselves—their identities, their struggles, their joys—is how we create progress. That level of visibility instills hope and materially affects the dialogue around gender identity. When any one person makes strides forward in revealing aspects of their identity, everyone is moved forward with them. When others stand with us as exemplars

PREVIOUS Wearing a crystal Gucci jockstrap, for a cover shoot for *Gay Times* magazine by Laura Allard-Fleischl—
my first time being widely recognized by the queer community

FOLLOWING, LEFT Me photographed by Piczo for a profile in *The New Yorker*, chest out, fully made up,
in platforms and a giant crinoline cage, grasping on to my dream.

FOLLOWING, RIGHT Feeling like a fluid Victorian doll in Vivienne Westwood couture on the cover of *10* magazine,
shot by the incredible Rob Rusling

of diversity, the message of choosing and celebrating your identity becomes even more powerful. As we begin to harness that power, we can begin achieving critical mass acceptance.

I actually came full circle on the topic of my own pronouns. After being born he/him and switching to they/them, I returned to he/him, because being gender fluid doesn't mean that you have to be nonbinary. Pronouns don't have anything to do with fluidity, because fluidity is a pendulum, and you are truly the most fluid when you allow yourself to swing freely. And so I made that pronoun change for myself because I had grown concerned that the concept of gender fluidity, rather than being liberating, was becoming its own limiting categorization.

But things really began to feel off when companies began approaching me to partner on certain projects. The executives would say, "You're gender fluid, so obviously you are a they/them. You wear makeup and dresses, right?" It became so tokenistic that it led me to think that I didn't want to be a token representative of any one thing. From my perspective, being they/them was not something that best represented who I was, and I felt like it would limit how I developed as a human.

Gender fluidity and they/them pronouns were being presented as boxes to check, and checking boxes is not for me on my personal journey. Boxes run counter to fluidity. Yet the strange thing was, when I switched back to masculine pronouns, some people were more certain that because I am fluid, I should be referred to as they/them. That reaction only reenforced my feeling that I don't owe anyone fucking anything—I'm just me. And you are just you. Recognizing that is the beginning of discovering your identity.

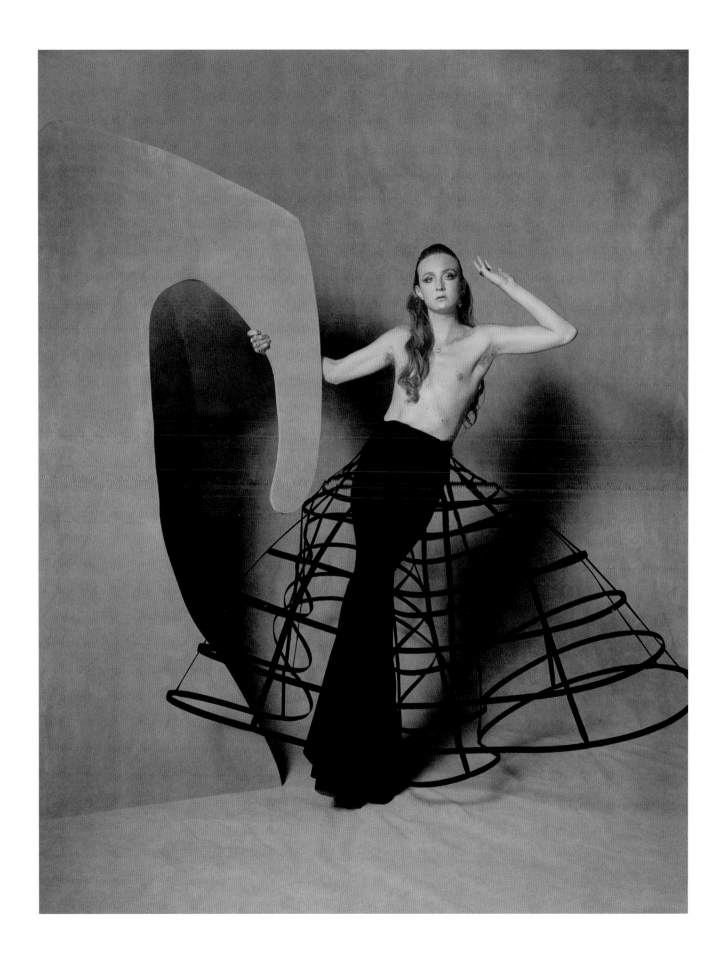

10

BOLD
&
Beautiful

HISTORICAL INFLUENCES ON FLUID FASHION

The roots of fluid fashion can be traced back centuries, when the clothes of noblemen contained distinctly feminine accents like ruffled vests and lace cuffs. While many of these looks went out of style over the centuries, elements of them endured and were brought back into style by modern designers and fashion icons challenging the norms.

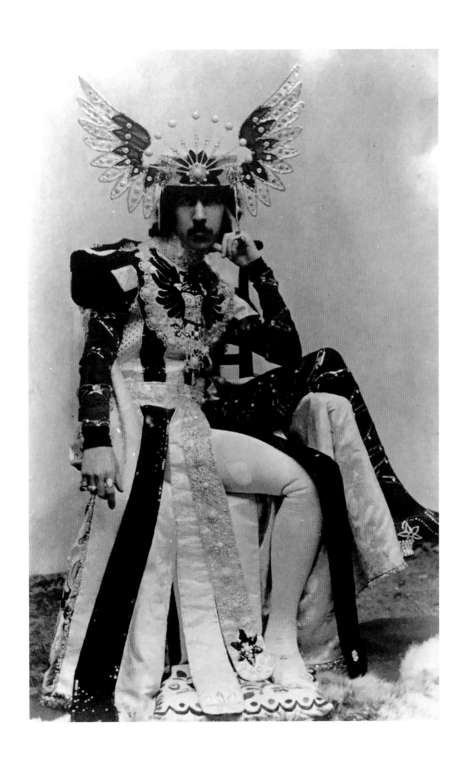

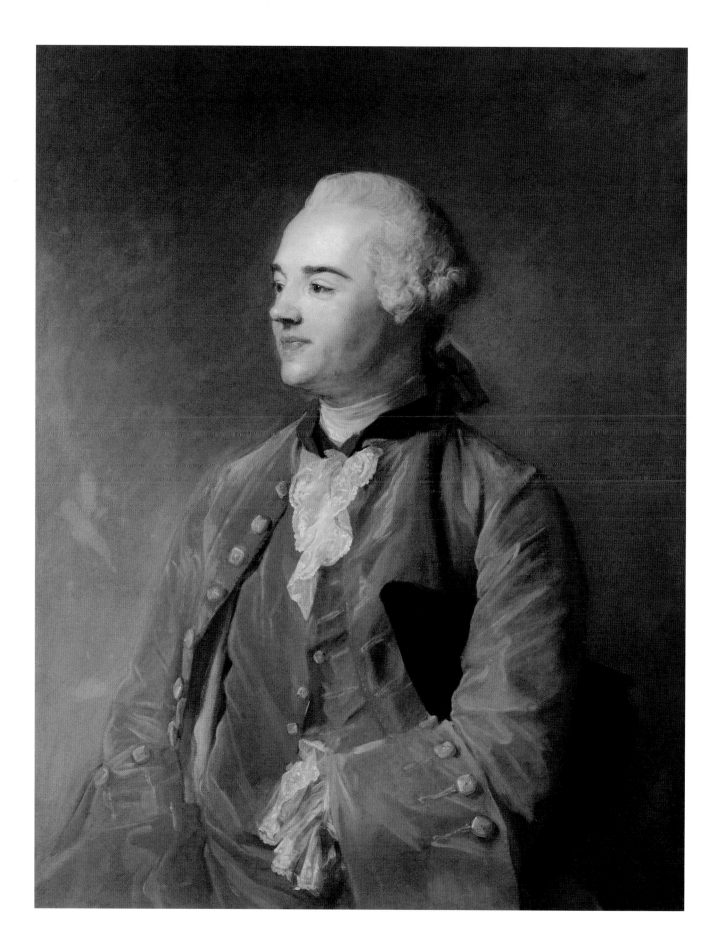

Togas and tunics were worn in ancient Rome by both men and women but were actually most favored by men. Kilts, the knee-length, skirtlike garments with pleats in the rear, were the original dress of men in the Scottish Highlands in the sixteenth century and continue to be worn for celebrations in modern times. Yet, in 1984, when Jean Paul Gaultier introduced kilt-like skirts in his men's line, people in the mainstream were gobsmacked.

In the seventeenth century, heels were considered quite fashionable among aristocratic men. As heels were a way to assert one's wealth and power, it's not uncommon to see a portrait of King Louis XIV wearing heels. In fact, in 1670, he passed an edict that only nobility could wear heels—the higher and redder the heel, the more powerful the wearer. How about that, Christian Louboutin!

The heel became a staple of what we regard now as the cowboy boot, which had its roots in the Persian army and then underwent many iterations. Flamenco dancers wore boots with a rounded heel, called the Cuban heel. By the 1960s, the Cuban heel adorned the tight-fitting, high-ankle, sharp-toed boot. John Lennon and Paul McCartney first saw a pair of these boots in the Chelsea neighborhood of London and ordered several pairs—thus they became the Chelsea boot, the staple of many men's wardrobes today.

One of my inspirations for fluidity in fashion comes from looking at images from the sixteenth, seventeenth, and eighteenth centuries in the National Portrait Gallery and the Victoria and Albert Museum in London and discovering a time in history when a man wearing pink and jewels and frills was respected by the court and society at large. There were times in history when flamboyance in men was very much in.

Noble, affluent men dressed in clothes with embroideries and embellishments and in colors that we would deem effeminate today. These ornately adorned clothes were the uniform for royalty. And yet in our lifetimes, at least before the gender tolerance shift of the last couple of years, a man dressing in such an ostentatious style would find himself ridiculed, or worse.

One painting that spoke to me was a portrait of Jacques Cazotte, an eighteenth-century French writer, hanging in the National Gallery. In the painting, Cazotte, in a powdered white wig, is wearing a rose-colored silk jacket with flared sleeves adorned with gold buttons, a matching vest, and white lace spilling out of his collar. In Cazotte's day, pink was favored by both men and women, and lace on a garment carried the instant connation not of femininity but of affluence. However, by the end of the eighteenth century, men's clothes for the elite had taken a somber turn and headed in a dreary, itchy, woolly direction. It became a time when to be masculine was to lose traces of femininity altogether.

A design of mine was featured next to another painting of Cazotte wearing a similar garment in the spring 2022 *Fashioning Masculini-*

In partnership with

GUCCI

With support from

AMERICAN EXPRESS

Fashioning
Masculinities
The Art of Menswear

V&A

ties: The Art of Menswear show at the Victoria and Albert Museum—the largest menswear exhibition in British history. The exhibit marked another leap forward for fluidity as it explored the role of menswear in conveying power, artistry, and gender identity.

While studying at Central Saint Martins, I discovered the life of Henry Paget in the library's archives. We didn't study the history of fashion dating back to his era, but I loved the idea of finding precedents and inspiration in places where no one else was looking.

Paget was regarded by many as the most eccentric aristocrat of the late nineteenth century. He was often adorned in furs and bejeweled headgear. At twenty-three, he became the fifth Marquess of Anglesey. He defied all societal expectations by divorcing his wife and spending all his family's money on clothes and lavish parties. He even converted his family's chapel into a theater with seats for two hundred of the local villagers and starred in self-produced Oscar Wilde plays—at a time when Wilde was being persecuted on the grounds of homosexual activity!

Paget was shamelessly himself in a time when that was not encouraged. His fluidly opulent outlook on life became the driving force for my 2020 collection "Thriving in Our Outrage."

Women wearing suits was another big step in fluidity's evolution. A big step came in 1966 when Yves Saint Laurent designed Le Smoking, which was essentially a tuxedo for women. The lines of the suit were narrowed, and the jacket was longer than it would have been for a man's version. Le Smoking provoked reactions in the fashion community and sent tongues wagging when women wore it in public, as people felt it was a demonization of femininity. One story goes that New York City socialite Nan Kempner showed up at the snooty restaurant La Côte Basque in Le Smoking and was turned away for inappropriate attire. Never one to shrink from a challenge, Nan simply took off the trousers and let the blazer hang down on her hips as a short dress.

"For a woman, the tuxedo is an indispensable garment in which she will always feel in style, for it is a stylish garment and not a fashionable garment," Saint Laurent said at the time. "Fashions fade, style is eternal."

Though it took a while to catch on, it became the precursor to the women's power suit that became popular in the 1980s. Trousers and blazers became the norm for women in the workplace. Later, designers like Ralph Lauren and Giorgio Armani began making stylish suits for all occasions, and in the 1990s, actresses such as Julia Roberts began wearing them on red carpets. All of this helped to lay the foundation for the idea that clothes can be a bit more fluid *and* part of the mainstream.

The most recent history I've drawn on in my designs is the 1970s and the Studio 54 era. I keep a series of pictures from this era pinned to the wall in my studio, depicting everyone's colorful and bold fashions. The clothes were about peacocking and making an entrance, the iconic example being Bianca Jagger on that white horse (though we now know she hopped on once inside the nightclub). People wanted to look a certain way to make them feel a certain way and to make others think about

what they were seeing—which is what fluidity is truly all about.

Rock icons amped gender mash-ups beginning in the 1970s. Queen's Freddie Mercury often performed in a sequined jumpsuit. Mick Jagger wore shirts that were modeled on flowy women's blouses. David Bowie wore high-heeled boots onstage—and had no trouble bounding around.

No matter the time period, I am drawn to the visual. This can mean paintings in a museum, images on Pinterest, or pictures in a coffee table book. The smallest detail in someone's clothes can trigger a design idea, a philosophy, and a new identity. It could be a ruffled cuff from a fifteenth-century Flemish painting, a bit of a cage sticking out of a crinoline dress from the 1800s, or sequins jumping off a 1970s disco blazer. Seeing these images pulls me into that time period and prompts me to reimagine those elements today.

My goal is to further and deepen my understanding of what I'm looking at, why people wore certain clothes or accents at a particular time. As we do this, my team and I start covering the entire studio with photos, sketches, and mood boards. I then use those details to drive a specific design for a jacket lapel or a style of skirt. And then the fun of bringing those pieces of the past to life begins.

PREVIOUS, LEFT My guiding light and brand director, Phoebe Briggs, took this shot of me in the London Metro next to the poster for the V&A's "Fashioning Masculinities: The Art of Menswear" show.

PREVIOUS, RIGHT The official poster for the V&A's "Fashioning Masculinities" show, featuring my look

OPPOSITE Pure inspiration: David Bowie during his Ziggy Stardust days

FOLLOWING SPREAD An image of me in the V&A Museum, next to the historical antecedent for this fluid outfit

PAGE 80 Snippets of my mood board: a mélange of inspirational images from Salvador Dalí to Sir Elton John to fashion designer Charles James

PAGE 81 A model wearing—what else?—full Harris Reed

PAGES 82–83 These images of Freddie Mercury were an inspiration for my collection "All the World's a Stage," because they are the embodiment of performing and how performance can enhance an alter ego.

PAGES 84–85 Thanking Olly Alexander after he performed at my V&A fashion retrospective

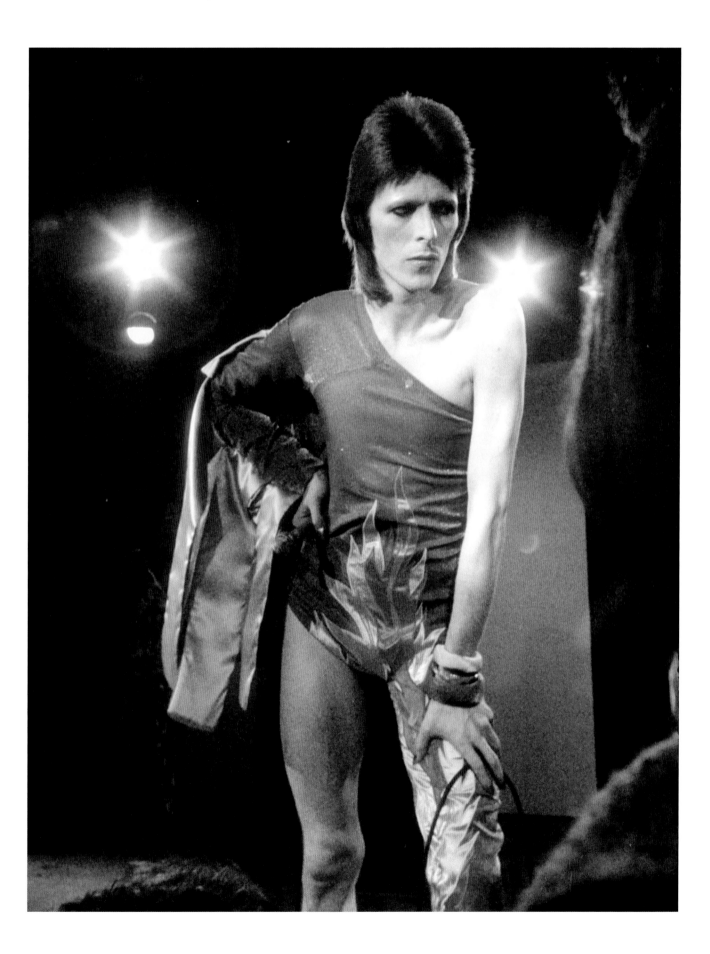

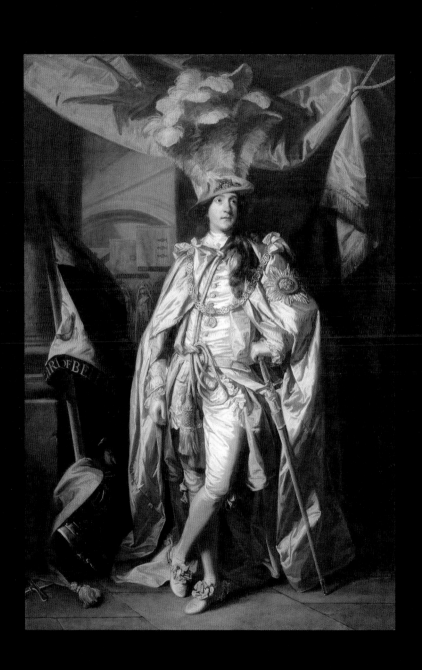

HARRIS REED

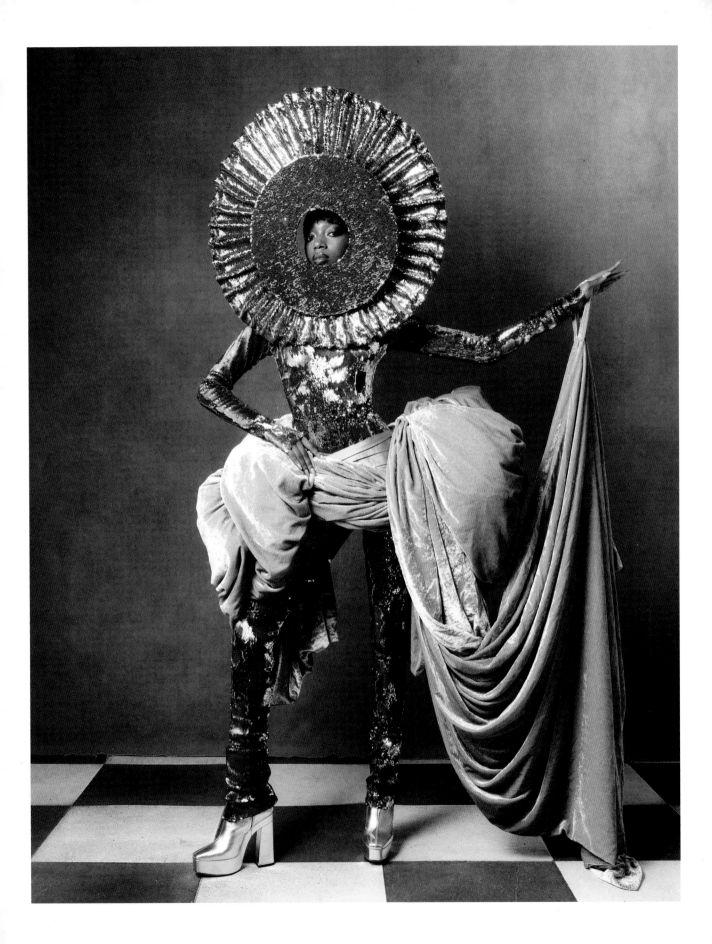

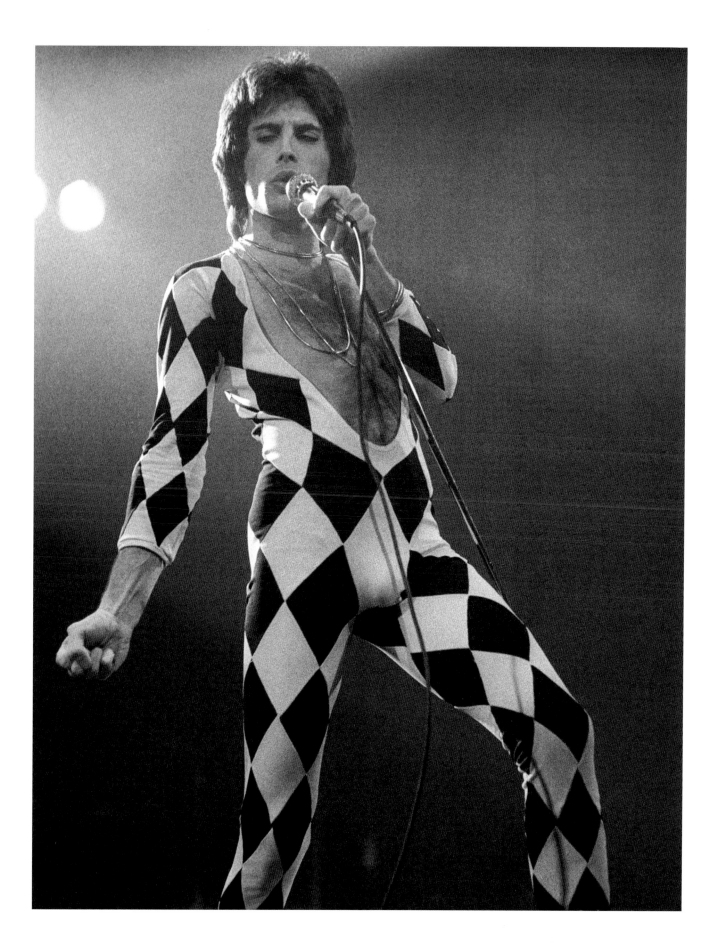

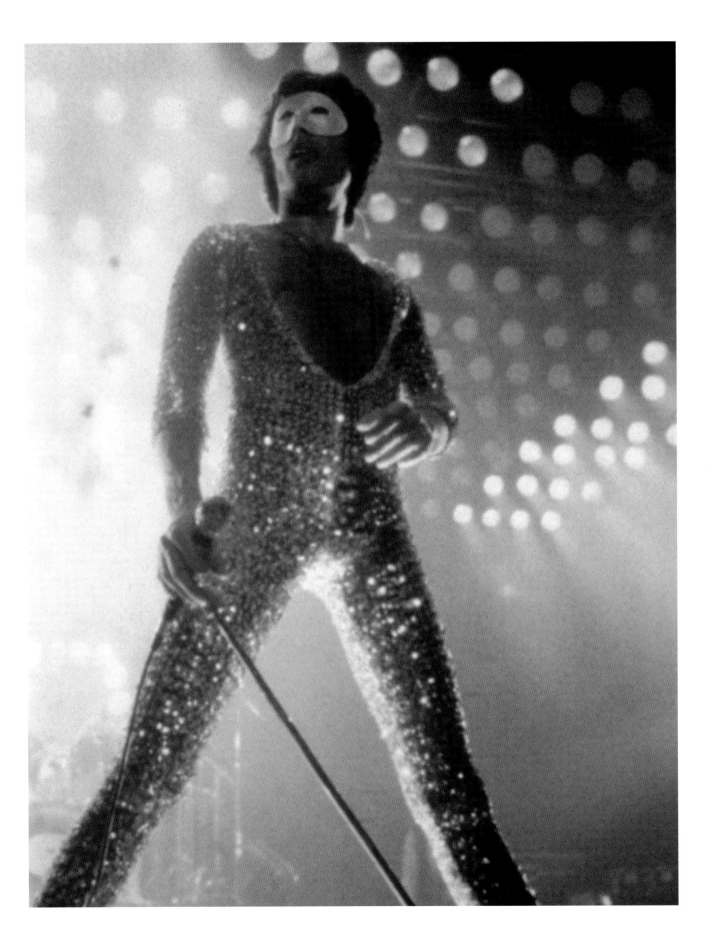

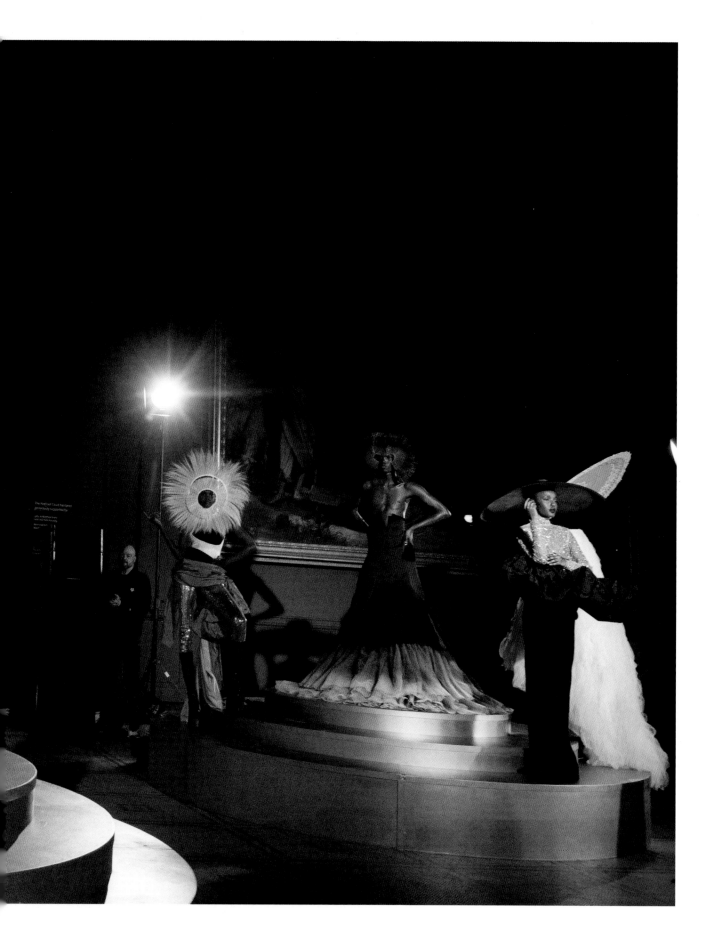

IN
VOGUE

There are certain fashion moments that have become touchstones for fluidity, moments that have moved the proverbial needle of nonbinary fashion, guided by bold individuals who have championed fluidity in the mainstream. Harry Styles has managed to do this both purposefully and gracefully in transitioning from front man of the ultimate boy band One Direction to chart-busting solo performer, actor, and fashion icon.

Letter from the Editor

Center Stage

IT'S NOT AS IF WE'VE NEVER HAD MEN on the cover of *Vogue.* They've simply played accompanying roles. Call them *Vogue*'s plus-ones: Richard Gere (with Cindy Crawford) in 1992, George Clooney (with Gisele) in 2000, Kanye (with Kim) in 2014, Justin (with Hailey) in 2019, to name a few. So Tyler Mitchell photographing the delightful Harry Styles going stag on our cover this month—in a dress, no less—is history in the making.

But dwelling on history risks sounding old-fashioned—and do we care so much about gender rules anymore? Certainly the 26-year-old is unconcerned with barriers and boundaries of all kinds. In his life, in his wardrobe, and in his soaring career, he believes instead in the fundamentals of play. As a musician, Harry has moved effortlessly from the boy-pop of One Direction to the '70s sun-drenched rock and roll of his solo career (and with "Watermelon Sugar" he managed to score a feel-good chart-topper in the midst of a feel-bad summer). As a muse and friend to Gucci's Alessandro Michele, he personifies a loose, insouciant, and extremely modern way of approaching fashion. As he tells Hamish Bowles, "When you take away 'There's clothes for men and there's clothes for women,' once you remove any barriers, obviously you open up the arena in which you can play."

Change is in the air this year, to say the least, and the house of Chanel has seen change on a monumental scale, with the loss of the irreplaceable Karl Lagerfeld and the ascension of his longtime colleague and collaborator Virginie Viard. As revealed in our profile this month—also written by Hamish (who, by the way, has become a model of multitasking, contributing to our video series *Good Morning Vogue,* hosting our new podcast, interviewing guests at the virtual event Forces of Fashion)—Virginie is quietly but unmistakably forging her own path at Chanel. What I've most admired about her is how incredibly unpretentious she is and how focused she can be on the key values in fashion: creativity, artistry, and craft, making clothes that matter and last. The way she has presented her collections reflects her personality and sensibility: Low-key, subtly elegant, romantic, and cool, Virginie's shows haven't tried to imitate the wild inventiveness of Karl's (no Chanel supermarkets or rockets inside the Grand Palais), but they feel utterly suited for our moment. I can't wait to see what she does next.

Amahitar.

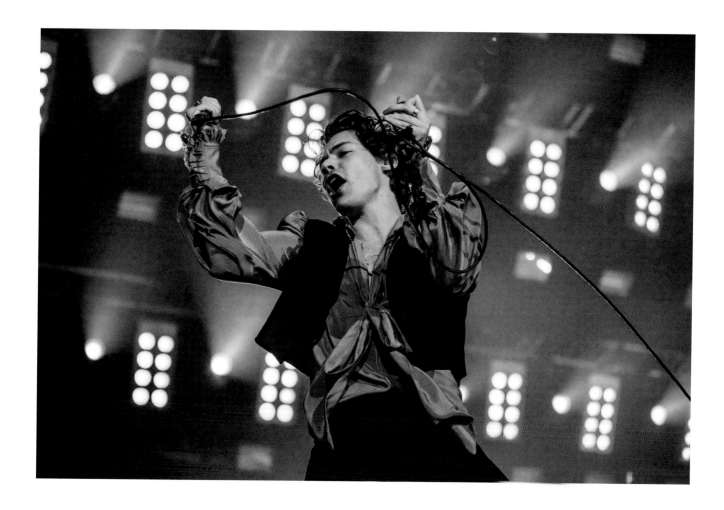

I met Harry when I was working on my first-year project at Central Saint Martins, which is the first time each designer creates something for a school runway show. I created an all-white outfit made entirely from white felt: a giant hat, a bustier jacket with frills, and matching flares with a frilly yolk in the back.

Harry Lambert, the prominent London stylist who became my patron saint, found that look from my then-fledgling Instagram account. In my second year at Central Saint Martins, I ended up working with Harry on multiple projects, including hats and custom blouses for his various projects. This led to his starting a conversation with me about creating something for Harry Styles; then, what would become the singer's signature style was just developing.

In conversation with Harry Lambert, I was given three references: David Bowie, Mick Jagger, and Jimi Hendrix, but he made it clear that he was very open to me creating what I saw in my mind. I began my typical hodgepodge research process—I like to fill sketchbooks with plenty of found images for inspiration. I began pulling images from the National Portrait Gallery

from the eighteenth century and cross-pollinating those with images of Jagger from the early Rolling Stones days. I liked the mix of Jagger's pizzazz alongside Hendrix's daring looks in furs; I then veered toward David Bowie for the way in which he created a new persona and played that out onstage. Alongside these visual references, I filled the margins of my sketchbook with strange doodles, stream-of-consciousness thoughts, and other ephemera—I let these guide me toward final designs, which I then present as beautifully drawn sketches on black parchment paper.

When I met with Harry Lambert, I brought both books with me, and Harry asked what was in my sketchbook. "Oh nothing," I said. "Just a scrapbook of things I incorporated into the final designs." When he asked to look inside, I cautioned that it was very messy and that only the final designs mattered. He leafed through the book, smiling. "Harry is going to love this," he said. He asked if he could show it to Harry, and of course I said he could.

Later, just before giving a presentation akin to my final exam at school, my phone rang. Harry Styles had looked at the sketches and wanted to meet me.

My teacher hated what I had done and ripped my presentation to pieces that same day. She went on and on about how I'd never be a successful designer, that I didn't understand the *rules* of design, that I'd amount to nothing more than some illustrator assistant. I nodded and smiled. "Well, okay, but I really have to go now because I have a meeting with my first client—it's Harry Styles and it's about doing clothes for his tour."

I dressed for the meeting in a long Prada jacket I had bought from a thrift shop on a weekend trip to Palm Springs, California, a plunging V chiffon top, and silver flares, topped off with a red fake fur. My look was Penny Lane in *Almost Famous*, right down to the glimmery eye shadow from Sephora.

There was a sea of people outside the arena, where overhead a huge billboard read: "Harry Styles—Two Nights Only—Sold Out." Fans stood in the freezing London evening, waiting for the off chance to catch of glimpse of Harry Styles. I've literally never heard people scream someone's name so loud.

I found a security guard, who gave me a "can I help you?" look. I told her I was there to see Harry Styles. She furrowed her brow. I told her that I was his designer—and with what I was wearing, who else could I be? I felt the fans looking at me, wondering, "Who is that girl? What is she doing?" The guard ushered me in.

Backstage, Harry's team greeted me with warm encouragement. They all loved my sketches. The fact that they had studied them so thoroughly made me realize this wasn't just about an outfit. The people who worked with Harry surrounded him with warmth and encouragement—they were more like a family than his team. It was clear Harry had created a world around him, one in which people

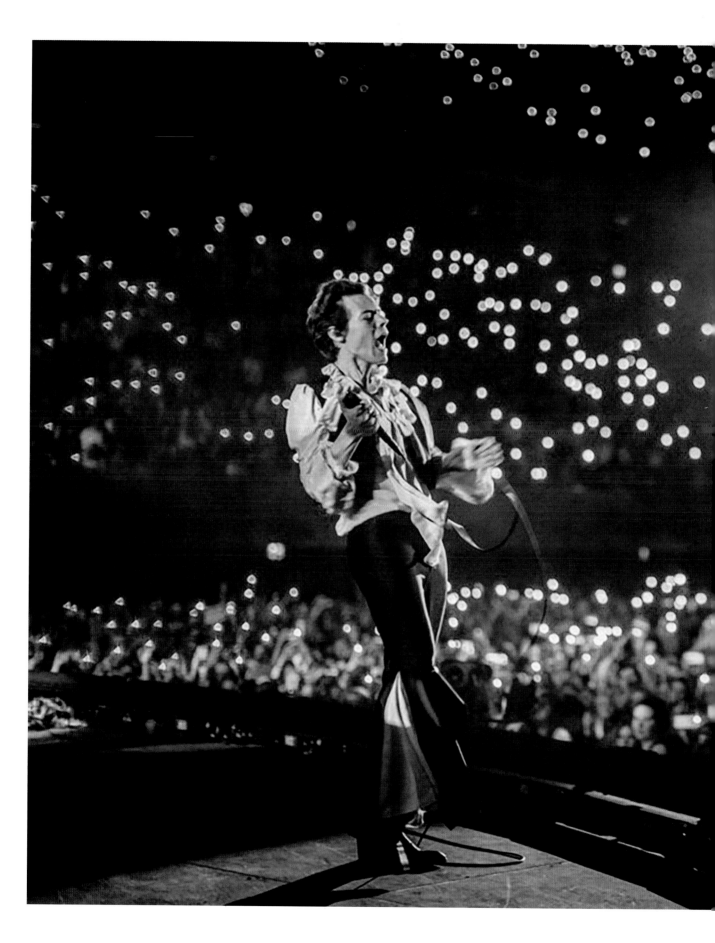

were treated equally, with kindness and inclusivity. It was an overwhelming—but very safe—space to enter.

I finally walked into Harry's dressing room and found myself shaking. I'm usually not starstruck, but this was my *first-ever* client. And this wasn't just any client. It was a person who was becoming a tastemaker for a new generation.

We went through the sketches one by one. A lot of what I had created were very silky, effeminate clothes reminiscent of centuries past, but interpreted with the modern, whimsical sensibility of the three rock icons. As we flipped through, Harry pointed at the things that he liked, and then I made a few revisions. Some of my ideas were very experimental, some very safe. We had a terrific dialogue about the sort of identity they aimed to create for Harry's next chapter, one that centered around him moving from side to side on the fluidity pendulum whether he did so consciously or not. At one point, I tried to erase a ruffle from a sketch, but Harry stopped me. "No, let's keep it," he said. For me, that small moment of trust in what I had done was incredible. I will never forget that.

Harry was very pleased with the way everything turned out, and I ended up working on the second half of his world tour. Around the world's stages he wore Saint Laurent, Gucci, Alexander McQueen, and Harris Reed, who was making everything by hand on the kitchen floor of his student flat with a used sewing machine, assisted by his best friend. Yes, it was surreal, but I was also beginning to feel that I had a purpose.

But by the fall of 2020, the ante went way up.

Anna Wintour's team reached out to me and told me that she needed something special for Harry to wear in *Vogue*'s December issue. Anna had always been encouraging of my vision for fluidity, but this ask took things to a whole new level. This was monumental: Harry would be the first-ever solo male on the cover of the world's premier women's fashion magazine. She wanted me to re-create a skirt that had been the opening look for my graduate collection, "Thriving in Our Outrage." She needed it in five days.

To say we had a lot of work to do would be an understatement . . . four of us holed up in a small hotel room, often spilling out into the hallway as we blasted Harry's first album on a loop and forewent sleep, working our fingertips raw. We remade the entire outfit from scratch using Venetian wool, duchesse satin, and a glue gun—a crinoline cage with a fuchsia pink exaggerated drape, a black jacket inspired by the Nutter suits of Savile Row with oversized black tuxedo trousers that were meant to look like a woman's skirt. I wanted the whole thing to be a bit tongue-in-cheek and have some British humor, so I put half an extraordinary ball gown atop half of a Savile Row–type suit with a 1970s shoulder.

We four worked in perfect synchronicity. Someone worked on the padding of the lapel, while someone else fastened the black grosgrain ribbon onto the steel boning of the crinoline cage, while someone else tacked down the fuchsia drape. We used a mannequin to attempt mimicking Harry's body for fit. It felt like we were constantly gyrating around this creation, almost the way Harry does onstage, trying to bring all these crazy components

together. The process itself was frenetic and often changing directions, kind of like Harry's sets.

The outfit was about showcasing Harry as a performer. When he goes onstage, he completely embodies who he is—he's shaking, he's spitting water, he's running around. I wanted to show that element of motion and drama while still creating juxtaposition. This design—and all my designs for Harry—was based in the idea of showcasing fluidity through movement. By exploring shape and how the clothes look in motion, I want them to express freedom and raw self-expression.

By the time we were done, I could not see straight. I literally walked into a wall while holding the crinoline skirt. The outfit was driven to the photo shoot, which took place on the Seven Sisters cliffs in Sussex. That afternoon, Harry sent me some wonderful texts thanking me for the outfit and acknowledging how big this moment was for both of us.

So much emotion went into the project on so many different levels. I was incredibly excited, but I can't say I felt lucky. My mother always told me that luck is when preparation meets opportunity. There was a certain satisfaction to reaching this point of professional achievement, and I had a real sense of how far I had come. I couldn't help but think about my days in school with pink streaks in my hair, carrying around *Vogue*, daydreaming of what it would be like to be in those pages. I was in a world far from the insecure and judgmental surroundings of those school days, a dream I could have never imagined had come true when I was only twenty-four. Had that little kid seen an image in *Vogue* of a man in a fabulous gown, it would have

given me much needed hope and promise for my life ahead. Maybe now another kid somewhere was flipping through the pages of that cover story, feeling acceptance in that moment.

In *Vogue*, Hamish Bowles called the outfit "a broad-shouldered Smoking jacket with high-waisted, wide-leg pants that have become a Styles signature . . . worn with a hoopskirt draped in festoons of hot-pink satin that somehow suggests Deborah Kerr asking Yul Brynner's King of Siam, 'Shall we dance?'" Sure! Now that you mention it, Hamish, that's exactly what I was going for.

Within hours of the magazine's publication, the gown became a symbol that transcended its parts. For some, it was a referendum on outdated gender norms. Those attached to the binary called for bringing back "manly men." For a few days, it was headline news. I knew there would be controversy, but still, in 2021, how could people be so outraged by a man in a dress?

While having a piece in a cover story in *Vogue* was surely a dream, it was even better to see it worn by an artist I so admire—especially as a champion of our shared aesthetic who has supported me from the very beginning. Harry talks a lot about his open-mindedness, having fun, and experimenting with clothes. This is exactly what fluidity is all about. He and I never had a conversation about gender or identity while working on this piece. While it was clear that gender was an unspoken undertone, what we were doing was going for a fashion moment. And we got it.

"What's really exciting is that all of these lines are just kind of crumbling away," Harry said in *Vogue*. "When you take away 'There's clothes

PAGE 95 Jammed in the small bathroom of the Standard hotel while making this look for *Vogue*

PREVIOUS Modeling the pieces to see how they look, how they fit, and how they flow . . .

FOLLOWING Harry Styles, the first-ever male to appear on the cover of *Vogue*, wears my creation in a photo taken by Tyler Mitchell at the Seven Sisters cliffs in Sussex, England.

for men and there's clothes for women,' once you remove any barriers, obviously you open up the arena in which you can play. I'll go in shops sometimes, and I just find myself looking at the women's clothes thinking they're amazing. It's like anything—anytime you're putting barriers up in your own life, you're just limiting yourself. There's so much joy to be had in playing with clothes. I've never really thought too much about what it means—it just becomes this extended part of creating something."

My collaborations with Harry since then have retained that organic back-and-forth process of our first meeting. This is especially true as Harry continues to push his stylistic perception into an entirely new chapter alongside Harry Lambert—long gone are the One Direction skinny jeans days. One of the signature pieces I designed for this new chapter was a blue moire two-piece suit that Harry wore in the "Lights Up" music video.

Every time we've collaborated, it has been about pushing that next boundary. Initially, I was surprised someone—and a man, no less—in the center of public attention would be bold enough to wear a bright lilac blouse with exotic flares and chiffon pouring out and rock out with a bare chest during an era when most other male singers wear hoodies and sneakers. But Harry's most comfortable when he's being unpredictable, and unpredictability and authenticity are what move fluidity forward.

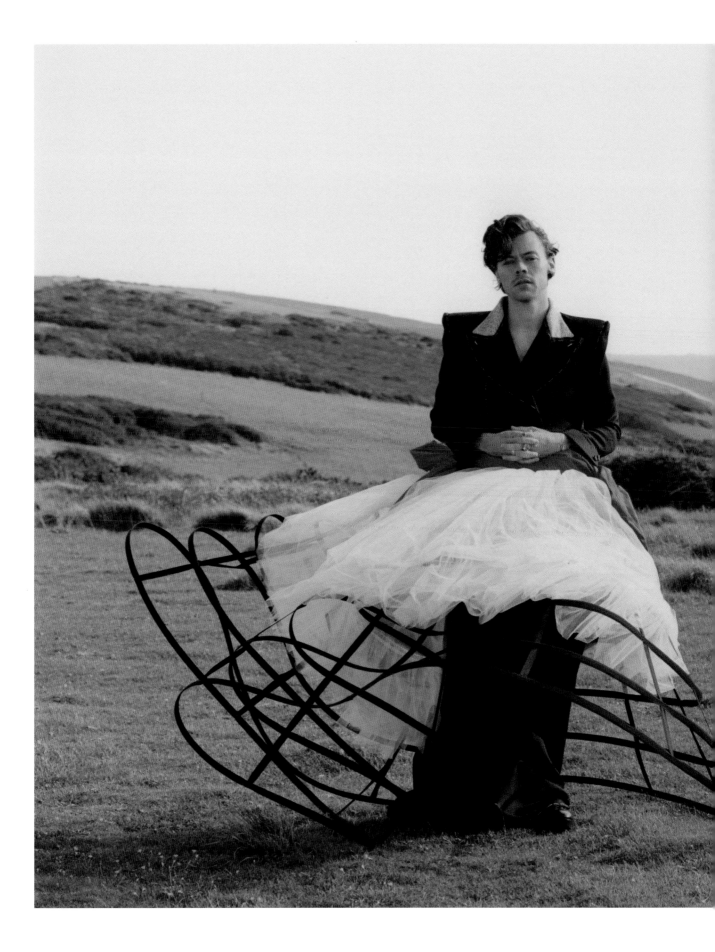

6

THE VERY BEST VERSION OF THEMSELVES

People often ask how dressing celebrities impacts the larger conversation about fluidity. Dressing some of fashion's modern-day trailblazers—Adele, Lil Nas X, Lizzo, Sam Smith, Iman, Selena Gomez, Beyoncé, Emma Watson, Solange, Harry Styles, Emma Corrin—helps center fluidity, not just in the world of fashion, but in mainstream culture. Celebrity broadens clothing's reach. They are tastemakers for a reason—people respect, admire, and covet them, and this causes what they wear to be more admired.

VOGUE

BRITISH

JULY
2022

Beyoncé

TURNS UP THE HEAT

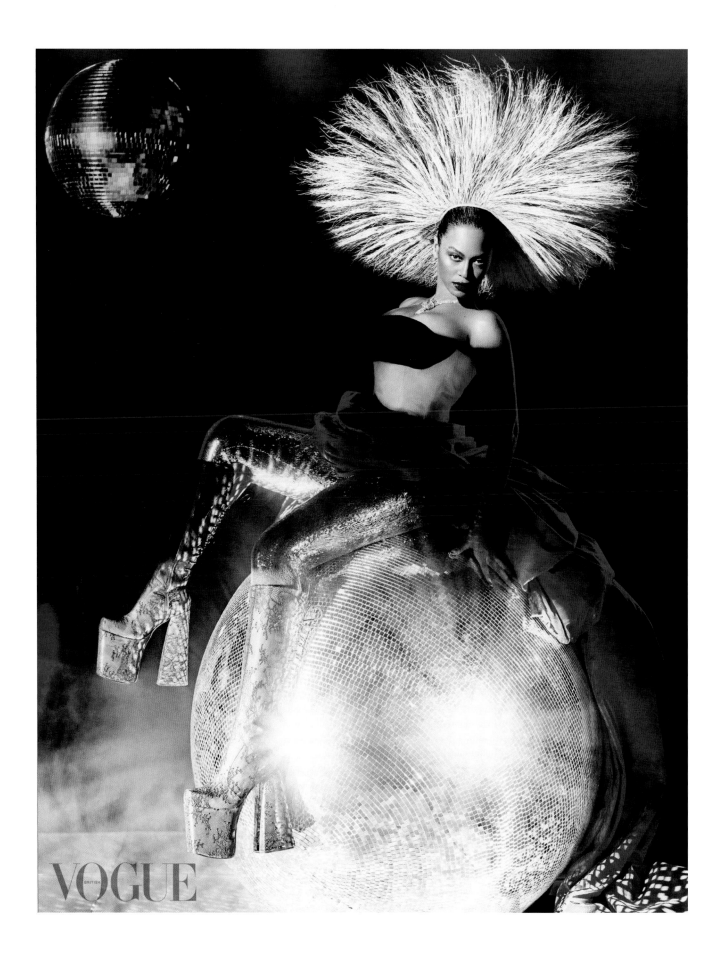

see my role as a designer to be a person who leads the star alongside their stylist on what they want to convey with their persona through their clothing. He/she/they are trusting me to craft a visual part of their message that delivers on what they envision. And, hopefully, I'll move that vision just a bit further than they imagined.

When I work with a performer, the most important aspect for me is mutual trust. Unlike other companies, which have paid partnerships or brand deals, my collaborations with talents come from an organic place of interest in my work and mission. They, too, want to be pioneering fluidity's ideals. When celebrities wear Harris Reed, it's because they believe in what it stands for; similarly, I work with someone because I believe in what they stand for and what they are trying to be or who they are. That's true collaboration.

It's important to understand that the Harris Reed team is fewer than ten people in total, and this allows us to personalize outfits to the wearer. My team is led by the incomparable—and I don't use that word lightly—Phoebe Briggs, who is my right hand. She runs the operation day to day and has helped me build the company. She had worked as an editorial director at *10 Magazine*, a British culture and fashion magazine, and we connected immediately. She has both an aesthetic sense that matches mine and a business acumen that exceeds mine. When Harry Lambert introduced her to me, he said, "This is a woman that's going to change your life and always be there for you." And he was right.

My other core pillar is Daisy Hoppen, my PR guru for the past four years. To say she has done an amazing job of broadcasting my brand and my message far and wide is a vast understatement. There have been a dozen magazine covers, numerous profiles, and stories about my collections and me, and more importantly, she fights for what I believe in.

Aside from Phoebe and Daisy, the team itself is fluid, moving and changing so we can find new ideas for each new line. I like the idea that my team is ever evolving. Each season, I bring on two or three interns, individuals who are diverse and bring varied life experiences and different points of view.

The one constant is that I love having strong women within the team. I call the women on my team "witches"—in a good way—because it's like there's a cauldron that I'm throwing upcycled sequins and lace and tulle into, and they stir it all together, making sure it comes out right. These women are always finding new ways of getting this little boy's dreams of huge, head-turning, gender-fluid creations where they need to go, a task that is probably harder than the creation of the garments themselves.

My team makes every garment made-to-measure, using sustainable fabrics whenever possible. I have the luxury of working on only a few projects at a time, which creates a more intimate and enriching personal relationship with each client.

PREVIOUS Beyoncé wearing a black feathered halo, a piece that I hold dear to my heart, in an image that represents everything I want the wearers of my clothes to be: fierce and unapologetic with their face front and center

OPPOSITE Beyoncé in fully custom Harris Reed from my "Sixty Years a Queen" collection, an outfit made from fabric that was repurposed from Italian upholstery fabric. Photographed by Rafael Pavarotti

My clothes haven't been whipped up in an atelier somewhere far away by people who have never met the artist. These are garments that I interact with them on, pin on them, and then have a conversation to get their feedback, almost like a deep therapy clothing session.

Take Adele, one of the most famous women in the world—for good reason. I met Adele's stylist, Jamie Mizrahi, in my first year at Central Saint Martins. Later on, she called me to say, "I think we need to put Adele in some Harris Reed." Hello, it's me!

They were preparing music video looks for Adele's new album, *30*, as well as her residency in Las Vegas. They wanted a look that was very Princess Diana–inspired: a sophisticated, established woman who's always being looked at, yet who feels timeless.

Adele's music has a very personal parallel to her life and where she is at that moment—hence titling her albums with her age at their creation. *Rolling Stone* said of her latest album: "She's never sounded more ferocious than she does on *30*—more alive to her own feelings, more virtuosic at shaping them into songs in the key of her own damn life." So, what to dress her in to express this?

I met with Adele at her home in Los Angeles with Jamie. It was a very inward process, one that was incredibly fun, full of laughs and real energy. We played dress-up in her closet with the looks that I brought. When I work with an artist, it's vital to have those familiar interactions, to be able to be in their personal space, whether that's a recording studio or their home. Experiencing their environments helps me better understand who the person is and what they're trying to say with fashion.

In Adele's case, she is an extremely private person. So being able to be in her home, I immediately understood how much faith she was putting in me as a designer.

Adele then invited me and my team to a friends and family concert in London. Watching her perform and actually seeing how she moves informed so much of where I took the silhouettes and the clothes' wearability. Harry Styles uses the entire stage, gyrating like a spinning top, while Adele mostly uses just her arms to highlight her vocals. That type of performance changes how the garment needs to be stretched, how it wears, and what it forecasts about the performer. What I designed for Adele needed to have fluid motion and be absolutely eye-catching.

I focused on how strongly she stands in her vulnerability. We have this in common: I always say that anyone wearing my clothing should feel a bit vulnerable, because to wear Harris Reed is to put yourself out there. Adele offers vulnerability with her lyrics; I do the same with fabric. It felt vital to explore that shared ideal.

In the video for "Oh My God," Adele wore a transparent pussy-bow blouse covered with polka dots that I made from scratch and gold, pearl drop earrings, and matching rings from my jewelry collection with Missoma. I also felt that the polka-dot sheer lace was a beautiful way of inviting viewers into a special moment. Adele is letting them see more of her, much the way her music invites people into her life. My hope was her doing this would allow the audience to look a little more closely at themselves.

She graciously gave me a big thank-you in the Instagram post of the video, which has more than ninety million views on YouTube. That type of reach causes some of those viewers, even if it's only a small fraction, to look at my Instagram and learn more about what I stand for, and there's no way I could achieve that on my own. *Vogue* wrote: "Adele's 'Oh My God' is a high fashion tour de force." High compliment accepted!

My job is to make these artists the ne plus ultra of themselves, to help them not only shine, but to bring something else deep from within outward through their clothes.

I don't take any of these collaborations lightly; every time I receive a request from someone with a certain level of influence, I know this will help the fluidity pendulum swing, and swing it does. Developing these relationships with people I've respected my entire life, those who dominate music, television, and media, has been a true dream come true—for both me and the movement. In addition to brand awareness, dressing these people of notoriety with large followings shows the validity of my work—not only from a conceptual standpoint, but from a commercial one, too. Fluidity is appealing as well as profitable.

Dressing these artists is a gateway, a path for exposure. When I design clothes for Adele, Sam Smith, Harry Styles, or Lizzo, and they post on Instagram, their followers stop and think, *Wow, what they are wearing is a lot, but it's amazing and I'm obsessed by it.* Or people comment, "I don't get it. Why is this person in this outfit?" I revel in these opposing reactions. Just as fluid fashion embraces the contradictions between men's and women's clothes, these conversations about fluidity also benefit from the friction that comes with dual perspectives.

This friction, these conversations, this exposure—all of it furthers the fluidity movement. It furthers the scope of what people think they can wear. It brings fluidity right into the public's homes, where they can start conversations across generations and with those who might otherwise be close-minded.

PREVIOUS Creating the look for Adele's "Oh My God," a fluid and fun pussy-bow polka-dot blouse, a signature sating bustier, a black satin fishtail pencil skirt, and jewelry from my Missoma line

OPPOSITE Lily Collins wearing head-to-toe Harris Reed for her *V* magazine cover story

PAGES 114–115 I felt this look for Ashley Graham for the 2023 Met Gala lived up to the gala's theme, "Karl Lagerfeld: A Line of Beauty."

PAGES 116–117 Watching Olly Alexander dancing on Sir Elton John's grand piano at the BRIT Awards on TV wearing a completely handcrafted outfit of mine was a gay dream come true.

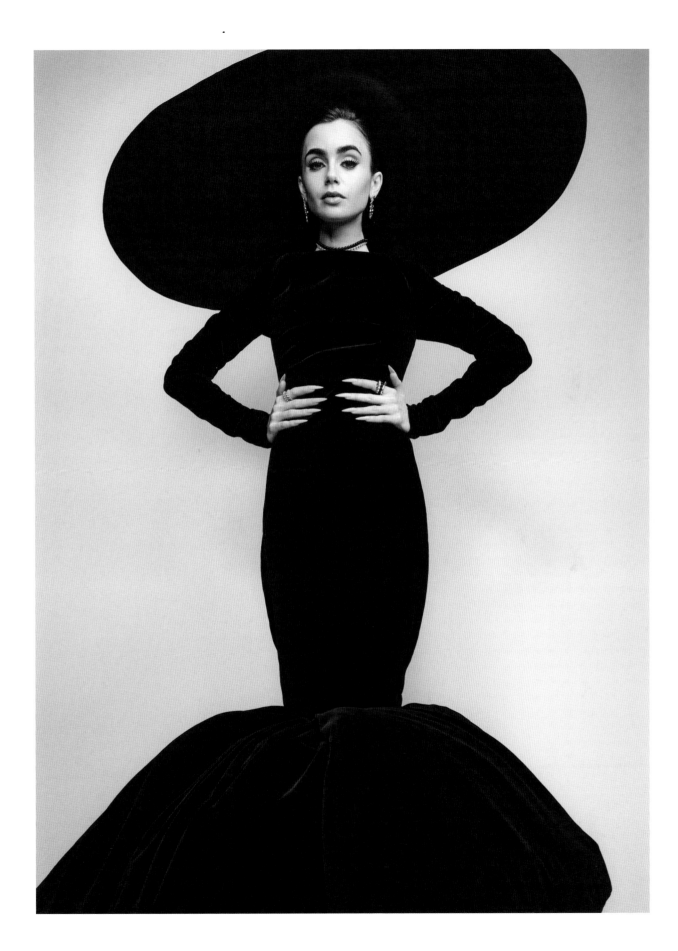

"To wear Harris's clothes is to be having fun," Harry Styles says. "Every frill is there to be played with, and an overwhelming sense of freedom shall rain down upon you."

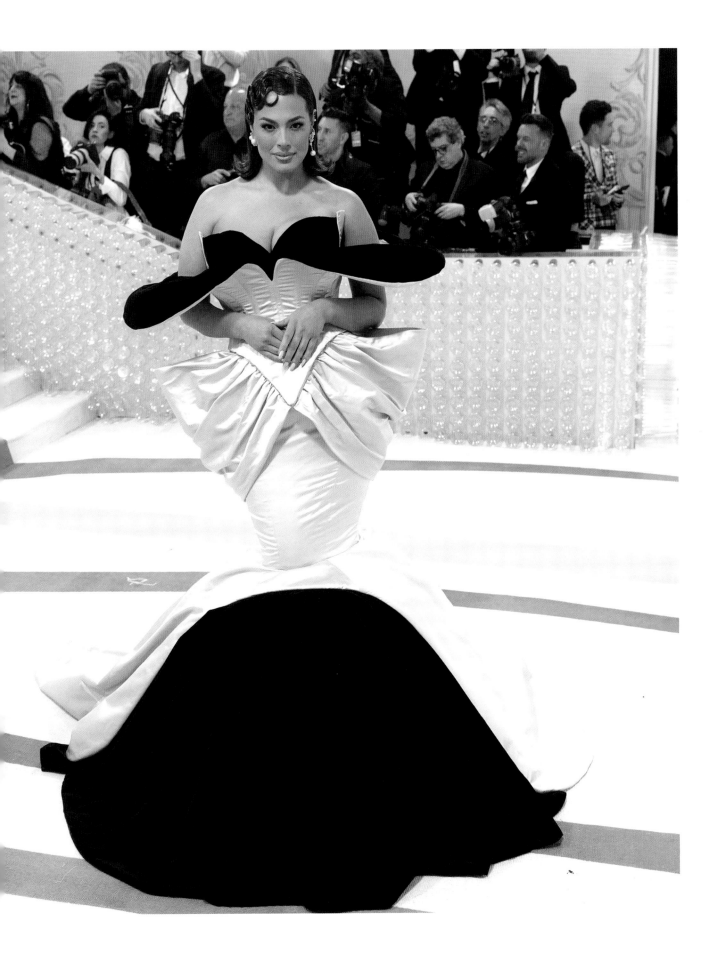

INDIVIDUALISM

What we wear allows our individualism to take center stage. From the first chance I had to pick out my own clothes, I felt this profound responsibility in choosing them wisely. My clothing truly is who I am. This, too, is how I design.

Funnily enough, when I think about clothes, I think about Barbie. Barbie serves as a prime example of what clothing can say about one's identity. There's pilot Barbie; painter Barbie; businesswoman Barbie—and she has a different outfit and a different look for each of these careers. Couldn't we have different outfits to best express every side of ourselves? Shouldn't we embrace dressing up to best show who we are and the life that we want to live? I think so.

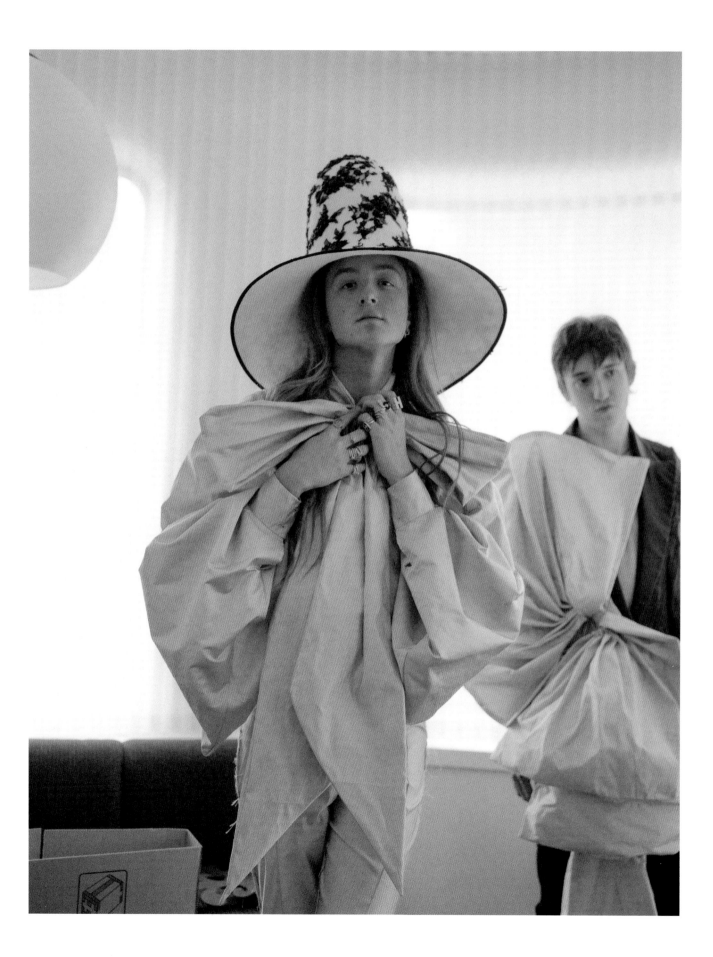

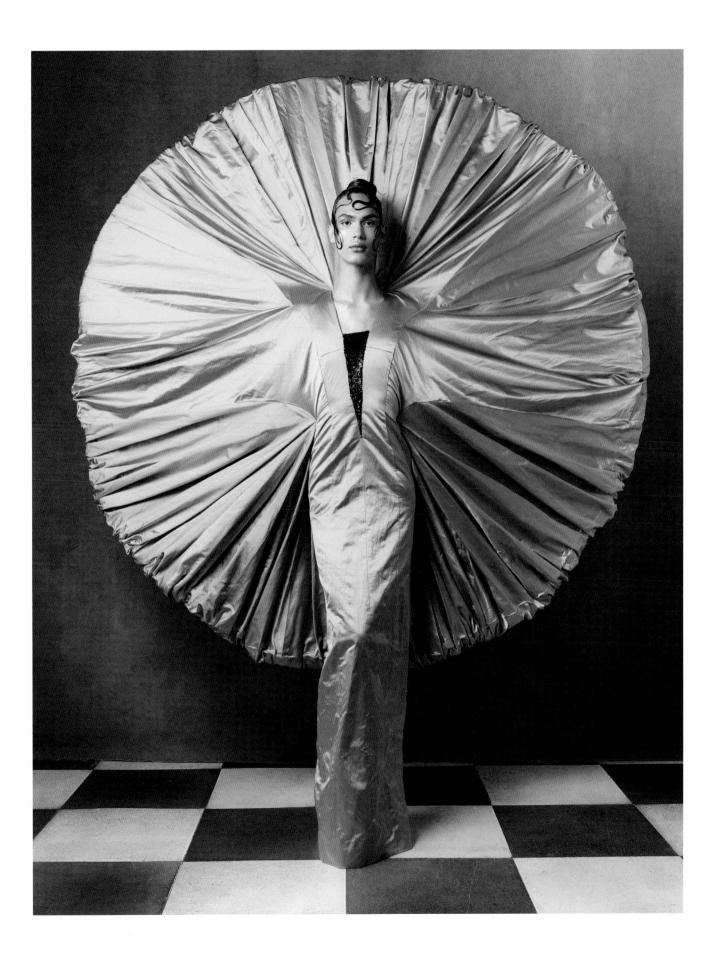

These questions are at the basis of my design process: How do I want to show up in this one life we have? What parts of me do I want people to see? I want my designs to alter the perception of the wearer *and* the viewer. My designs should change our understanding of gender and encourage absolute individual freedom. My designs should showcase *all* of our many identities, layers, shades, and colors—and clothes should reinforce that these facets are, indeed, fluid.

My designs are also a product of the world and my place in it. In 2020, I asked myself: "Do we express ourselves because we are angry? Does outrage breed the outrageous? Without outrage for change, where do we find our strength to make a difference?"

These questions birthed the title of that period's collection, "Thriving in Our Outrage." I was outraged because I had worked on this collection in an innovative, freeing, creative design school for five years, but just as we approached graduation and our first real show, the world shut down. As COVID-19 arrived, we were told we had two hours to leave school and go into isolation, with no idea what would happen next to our collections, our careers, or our lives. We left behind pieces we had spent five months working our fingers to the bone on, shells of outfits, patterns half cut and accessories half finished.

School had been an incredibly intimate experience that so many people participated in, from the leaders of the industry who visited to my teachers and amazing classmates. Nothing about this had been easy. It was a ruthless, cutthroat road. Day one began with the head of the school telling us that half of us wouldn't graduate—and she was right. But we were told that if we were willing to break the glass box around us, shoot for the stars, explore parts of ourselves we might not want to visit, and find visual and creative exploration in the crevices, cracks, and underbelly of who we were, we would put something extraordinary out into the world. And, more importantly, we would put out something that was true because it came from within. I arrived a naive queer kid with untapped potential and grew into an individual who knows who I am because of the people I was surrounded by—as a person and as a creator. And now I was being told that I couldn't collaborate with my classmates, my teachers, my peers, but that I now had to do this entirely on my own.

The entire process of creating "Thriving in Our Outrage" was intense because it was all done in lockdown. Thankfully, my roommate had moved out weeks before, allowing me to use the second room as a studio. My helper, Bella Thomas, moved into my apartment. We made a giant black-and-white hand-embroidered hat that was the size of my bedroom. When we steamed the layers of the hat and put them on the floor, they kept wrinkling and ruining the hours of work we put in. The only solution was to lay them out on the bed to maintain their shape, and so we ended up sleeping on the floor for several nights. I did my thirty minutes of exercise a day running around in glitter platform shoes, trying to break them in for an at-home photo shoot that was to come later as a final showcase of the outfits we were creating.

In the collection, I explored the idea of self-expression as a daily ritual that embodied feelings of romance, theatricality, and glamour. To do this, I relied on sequins and dramatic silhouette highlights to show that this was more than a personal, intimate journey; it was one that invited a conversation on fluidity by blurring preconceived fault lines on gender and sexuality and using showmanship as my tool to start a larger conversation. The clothes were neither masculine nor feminine, so it was up to the wearer or the observer to see them to assign their own meaning to them.

I also borrowed from the mild-mannered style of the 1950s, relying on the looks of mid-century debutantes and the dramatic charm of their outfits. This was the extreme of what men thought women should look like, with the massive gowns and UFO-sized hats. I was also inspired by the larger-than-life silhouettes of rock bands like the New York Dolls, who juxtaposed traditional stage-wear elements such as sequins, crystals, and feathers with 1970s masculine tailoring. The late British dancer Lindsay Kemp was also on my mind as I designed this collection. Kemp had an outrageous, over-the-top stage presence in both clothes and expression that I found to embody the ethos of my work: blurring lines of who one can become when they wear an outfit of mine.

With my influences washing over me as I went, I worked and worked. The collection came to be, one sequin, one crystal, one stitch at a time, ironic and cheeky in its designs, just the way I wanted it. But alas, there was no physical showcase for the clothes as the pandemic raged on. I went back and forth over how to showcase the clothes. Do I have a model come over, or do I just photograph the clothes with my phone and post them on Instagram? My classmates were using mannequins or showing them digitally. Instead, I had them photographed on me. They were my clothes, so I *should* be the one to show them. I did my own makeup, relying on a virtual tutorial from the legendary Terry Barber, one of my all-time favorite makeup artists and the director of makeup artistry at MAC Cosmetics. I put the clothes on and took the photos against a green screen while Bella and I tried not to trip over each other as we set up the shots in my small living room. We then placed Lukas Palumbo's sketches onto the green screen and had Lauren Deane Hunter animate the sketches to move. So we essentially did an entire fashion show remotely. In May 2020, I took a deep breath and posted the photos on Instagram to see whether the fashion world loved or hated my first fluid creations.

While the collection *was* a statement about who I am as a designer, it was also very much a statement about creativity—that even in the most troubling times creativity can't be quarantined. In fact, creativity can evolve under constraints and pressures.

The response to "Thriving in Our Outrage" was incredible. Celebrities like Kaia Gerber, Jodie Turner-Smith, Hari Nef, Kathryn Newton,

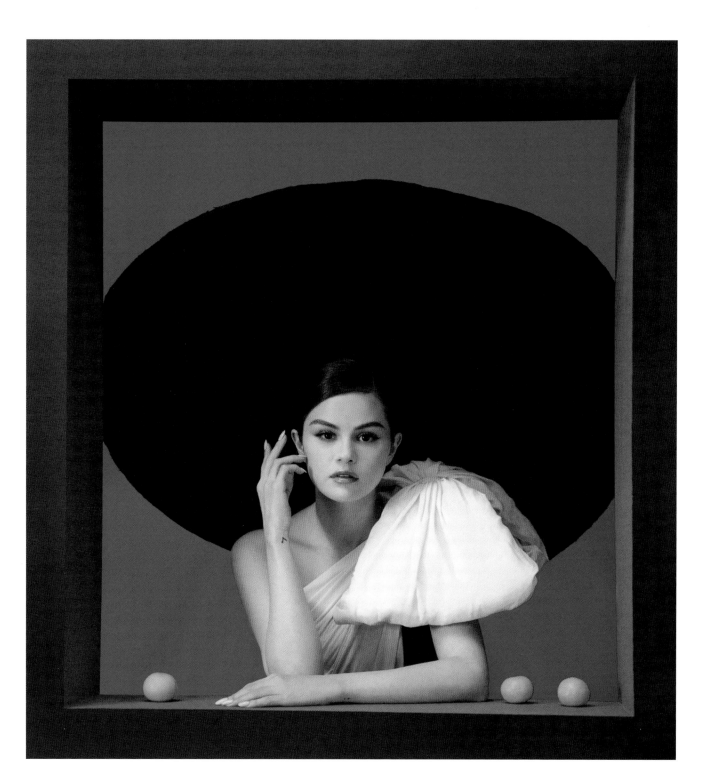

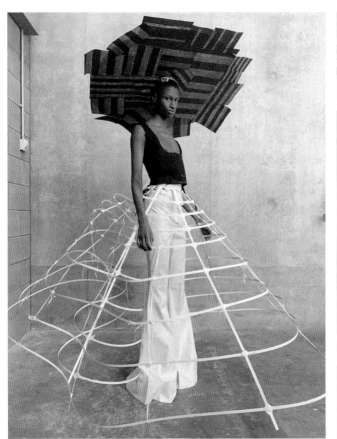

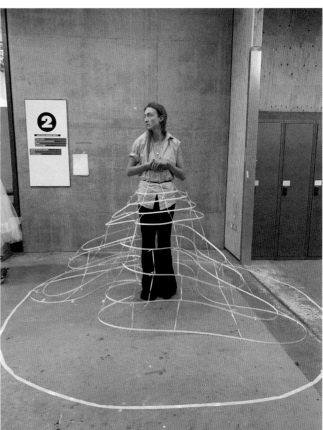

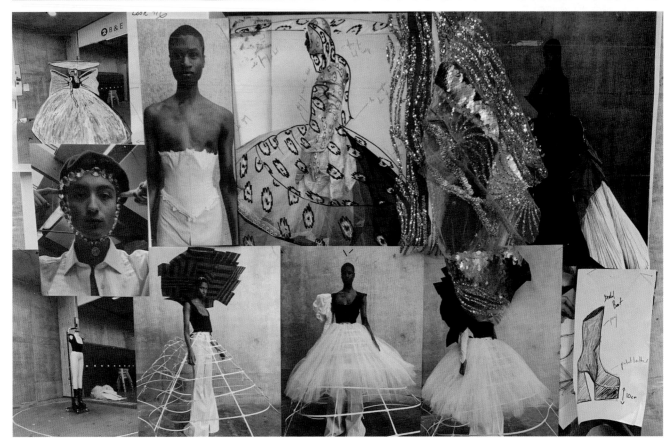

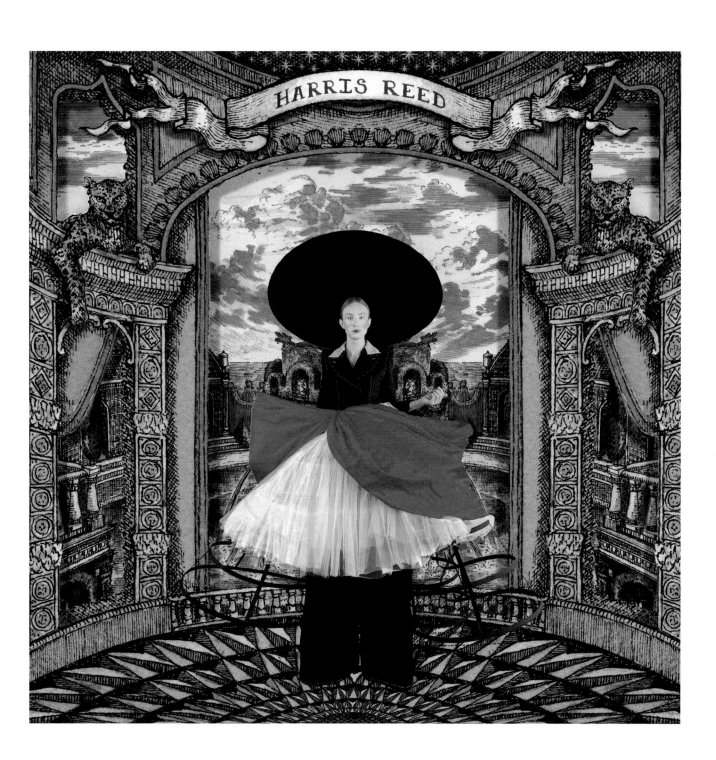

Kiernan Shipka, and many more swarmed my Instagram comments with praise. Then every *Vogue* online edition picked up the images, commenting on the collection's powerful impact. The widespread response showed that a fashion brand could have relevance during a time of immense challenges and pain.

The incredible Kate Young, who is Selena Gomez's stylist, engaged with the collection on Instagram and was very supportive with her comments. Kate is one of these stylists who has her hand on the pulse on what's happening next creatively. When they were working on the promotional campaign for Selena's Spanish-language album, *Revelación*, Kate thought of my hats and their larger-than-life silhouettes. She asked—and I said yes before she finished the question—if I could customize one of my black velvet hats from the collection. They used the hat, which also ended up on a billboard above Times Square and on Selena's Instagram feed, with its three hundred million–plus followers.

The response made one thing clear: we were on to something. And so I began to plan our next collection, despite the world continuing to conspire against us. With mandatory lockdowns being instituted in London, no one was renting or sharing space. Only essential services were functioning.

When designing my next collection, I was in a very rebellious state. The idea I kept returning to was that of being in a lockdown—feeling constrained and controlled. I didn't want to do a ready-to-wear collection. I wasn't even sure how wearable the clothes would be in a mainstream setting. And a bigger question was, what did fashion mean in the world we were living in? I wanted my creation to speak more to our current moment, to show fashion as high art, as a dream, as escapism.

I ended up getting a very lucky break, one of many in a series of breaks where someone became a patron at just the right moment. At a dinner months earlier, I had met Elli Jafari, the general manager of the Standard hotel. I was texting her during lockdown, and the question of where I could find a studio came up. "Darling," she wrote back, "just move into the hotel!" And so I did. I became the Standard's official "designer-in-residence," taking meetings and doing photo shoots in its public spaces and posting on social media about the hotel. Once the second lockdown kicked in, the hotel very kindly allowed us to stay on, and my small team and I were the only people in the hotel besides the security guard in the basement. I was Eloise at the Plaza—well, a queer version of that, anyway. It was the most eerie feeling to basically be creating light and noise—at least in terms of visual noise—in a space of darkness and uncertainty.

This collection, which I had not yet named, was fully made from room 122 at the Standard, with me and a small team of three, alongside my amazing brand director, Phoebe Briggs. Everything was a challenge. Because we couldn't buy the fabrics, let alone send them to Italy to be dyed, we had to hand-dye them in the hotel room's bathtub.

PREVIOUS, LEFT (TOP) Trey and me messing around with what later became the Harry Styles look for *Vogue*
PREVIOUS, LEFT (BOTTOM) My collage mood board with references of corsetry, nutter suits, and platform boots
PREVIOUS, RIGHT A self-portrait for my collection "Thriving in Our Outrage" that was digitally enhanced with illustration by Lukas Palumbo and animation by Lauren Hunter
OPPOSITE Behind-the-scenes images that led to my "For Now, Unexplained" collection

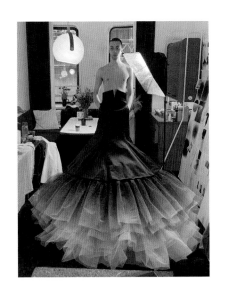

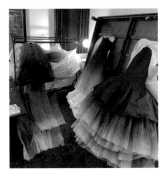
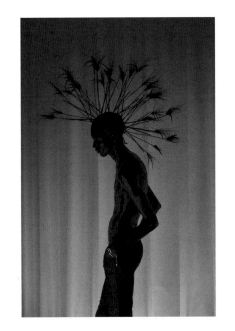

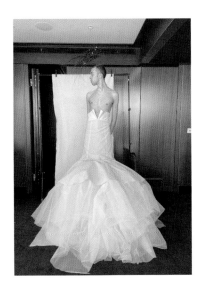

My friend Georgia had to take each piece of fabric and work her way down it by spray-painting it, as we couldn't buy dye because only essential stores were open. And so, the hardware store was our main supplier. The process was itself very fluid— the movement of fabric on liquid. She would swirl spray paint on the fabric, working her way from the middle down to the corners with each color. We then used the entire length of a hallway, which is probably half the length of a football field, to lay out the materials so we could hand-sew pleats. The whole line was glue gunned and hodgepodged together with love. My friend Callum, who worked at the Standard, was our fit model.

The collection conveys the hardships of its creation and shows that things can be created in the most unusual circumstances. It was made during a moment influenced—but not defined—by a journey into the unexplained and uncertain. And so I named the collection "For Now, Unexplained," because the abiding feeling was that we all, as a global society, had no idea what had happened or where we were going next.

For this six-look collection, I explored London's visual history, bringing together the anarchy of the punk movement with the debutantes and their dressmakers who define Britain's aristocratic past. I paired full-skirted tulle with menswear tailoring to create a new construction of a dress that is neither masculine nor feminine, but rather turns the focus on the body rather than on the garment itself. The palette is meant to evoke a spectrum of shades reminiscent of emotions and auras that showcase the feeling of the individual wearing the clothes.

The headpieces, which take their inspiration from punkish mohawks, are realized in peacock feather plumes. I always feel that more drama and a bigger silhouette around the face demands attention on our most important feature.

The custom knee-high H Boots made with Roker atelier are a very statuesque punk boot with a masculine demeanor; they contrast the clothing's romanticism. Their roots come from the days when I wanted to wear something that would raise me above the bullying and misunderstanding of who I was and put my already tall self above the hatred.

Heading into 2021, lockdown restrictions were easing, and so we scheduled a show for February. We made a video to accompany the collection and highlight its message. In the video, which was shot at an old studio that we found, set to the music of Honey Dijon, the models journey through lacquered corridors and draped rooms in which they are presented with different facets of themselves, each version with a different aura. They continue to walk through the darkness until they find their way to an infinity room, where they are met with all versions of themselves. They are honoring their journey and being proud of the different stages of their life. It ends with a model standing together with alternative versions of himself in the collection's six looks. To me, the collection is not just clothes. It's a raw mix of my emotions from that time period.

I wanted the video to capture this idea of progressing and facing all the different versions of ourselves. Facing our many identities can be immensely uncomfortable—and I wanted the video to showcase that discomfort. At that time, I felt as

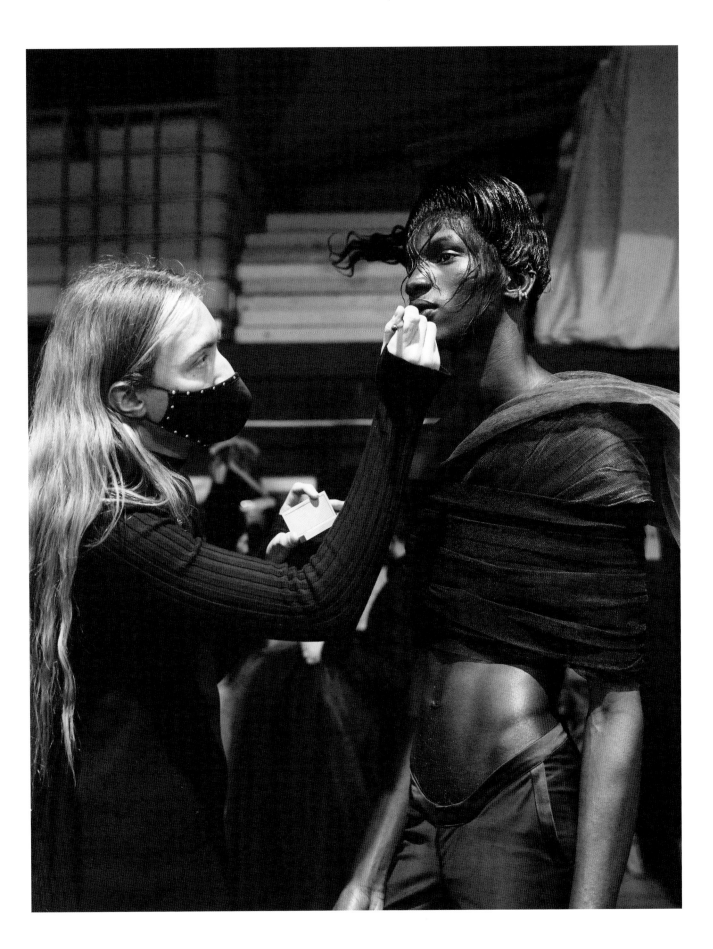

though I was looking to the horizon, facing the unknown with my rebel streak but allowing for growth in whatever form it brought. My feeling was, come whatever may come, but for now, this is how I exist.

Amazingly, my favorite hat from that collection is the one that Beyoncé wore on the cover of *British Vogue* in 2022 for a story on the launch of her album *Renaissance*. I grew up watching her videos, getting every dance move down to the best of my ability, and I blasted her music in my head-phones when the bullies berated me on the play-ground; she helped me escape to a safer world, a world where I was free to be me and express the most theatrical sense of myself. I wanted desper-ately to spread a tiny fraction of the light she sheds onto this world. My hats are for people stepping out into the world as nothing less than who they are—they turn heads by using fashion as the ulti-mate tool to provoke conversation, invoke change, and spread hope.

PREVIOUS Shooting "For Now, Unexplained"

OPPOSITE Florence Pugh modeling my "All the World's a Stage" collection. At the show, she came out and read a monologue setting forward a declaration for fluid fashion.

FOLLOWING SPREAD AND PAGE 137 Final images from "For Now, Unexplained" that are about enhancing the auras that individuals have by playing with blue to pink, to represent their different sides

PAGE 139 Momo doing the final walk across a watered lacquered floor for the "For Now, Unexplained" film

PAGES 140–141 Momo in an old wedding dress that we reimagined by adding an explosive purple hue for the "For Now, Unexplained" collection that later inspired the collection I did for Oxfam, in which I took upcycled wedding dresses and turned them into demi-couture pieces

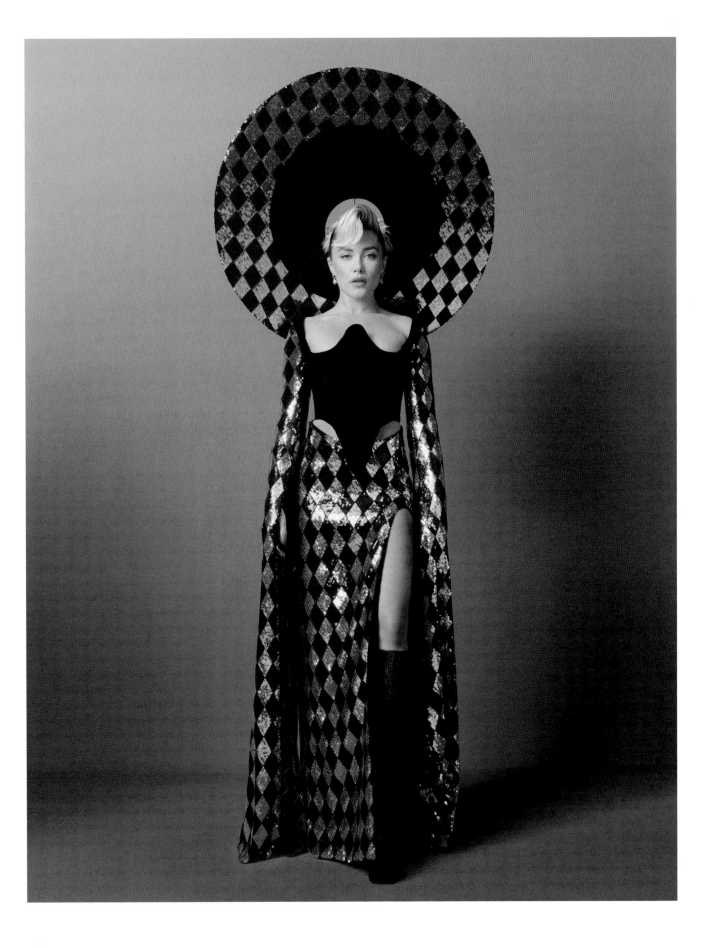

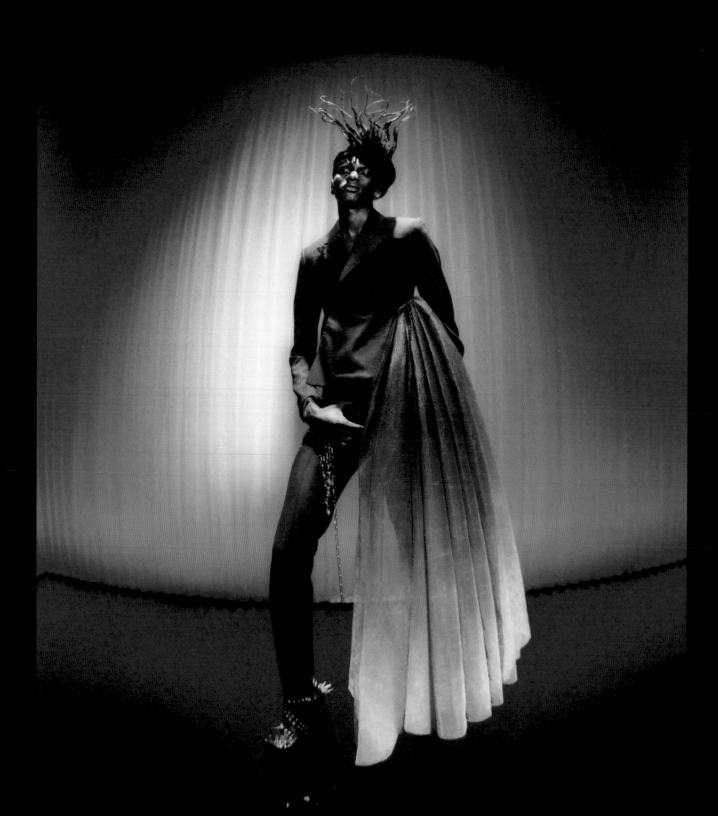

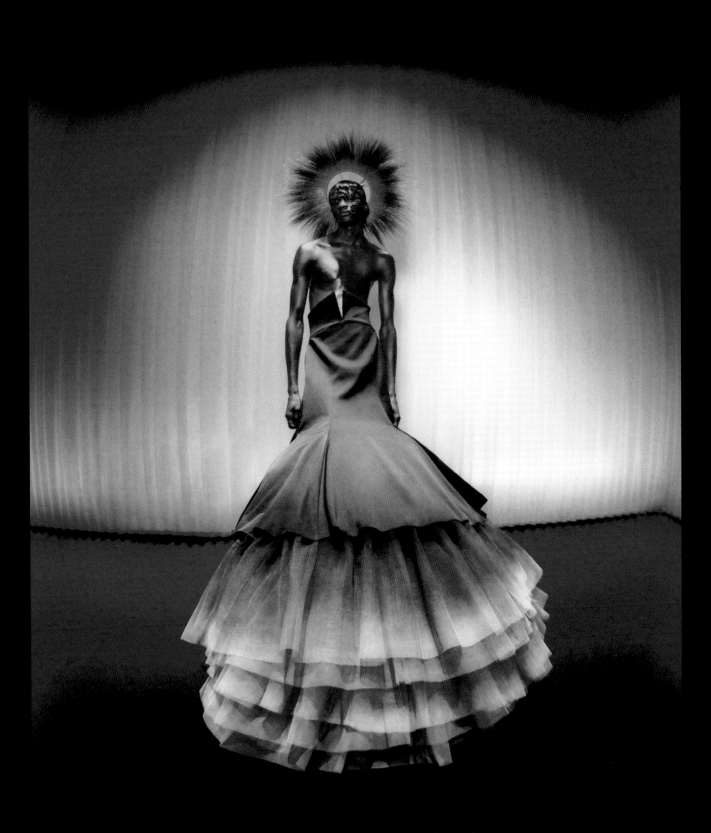

WOMEN'S WEAR DAILY

"Emerging designer Harris Reed is fast becoming one of fashion's favorite rebels . . . and giving London Fashion Week a much-needed jolt of optimism and energy . . . Indeed, at a time of low morale across London—prolonged lockdowns and the aftermath of Brexit are taking a toll—Reed's infectious energy, appetite for opulence and determination to spread the message of gender fluidity far and wide seems like the ultimate act of rebellion."

NEW YORK TIMES FASHION WRITER VANESSA FRIEDMAN WROTE

". . . I have just spent four days at our kitchen tables immersed in the 'gender-neutral fashion week' also known as London Fashion Week. Personally, I think gender-neutral is a misnomer. It suggests collections that focus on the hugely contemporary issue of gender identity, and how that is expressed through clothes—which is, after all, one of the historical battlegrounds of what is male and what is female. That would have been fascinating, if true, but as far as I could tell, only Harris Reed—he of Harry Styles-in-*Vogue*-in-a-ball-gown fame—actually addressed these questions, splicing tulle and suiting at the genetic level and forcing viewers to confront their own preconceptions and prejudices. All the other shows were primarily men's or women's (or men's and women's)."

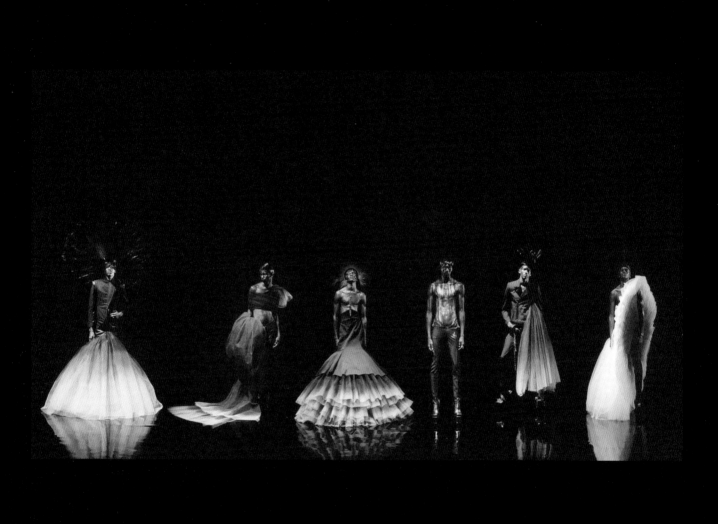

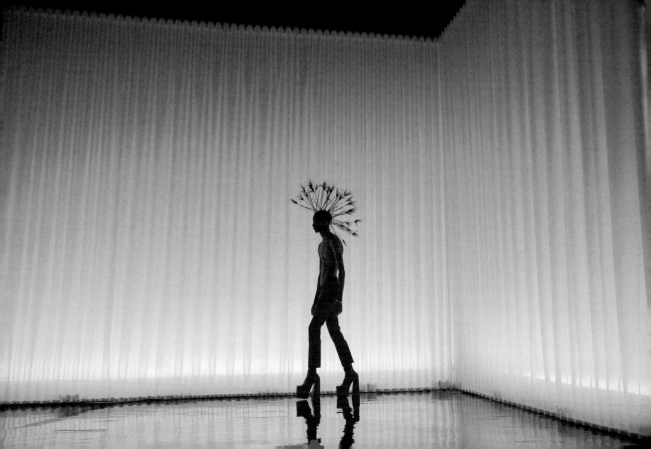

BRITISH VOGUE

"One of the next-generation stars of London's first-ever gender-fluid fashion week, Harris Reed's work is a stylistic fantasy and a beacon of change."

I-D

"A continued meditation on gender-fluid dressing and the malleable nature of identity that he began with ['Thriving in Our Outrage'], it's a collection that balances a sense of whimsical playfulness with technical rigour. Savile Row tailoring tropes are fused with flamboyant spans of ombré tulle, conveying feelings of fantasy and freedom that couldn't be more welcome right now."

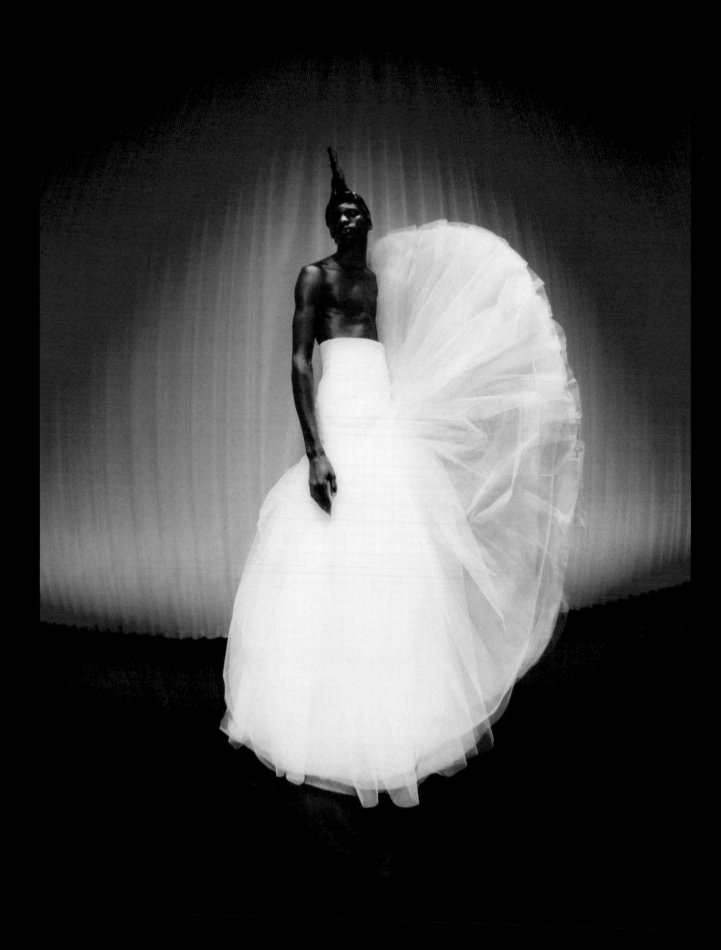

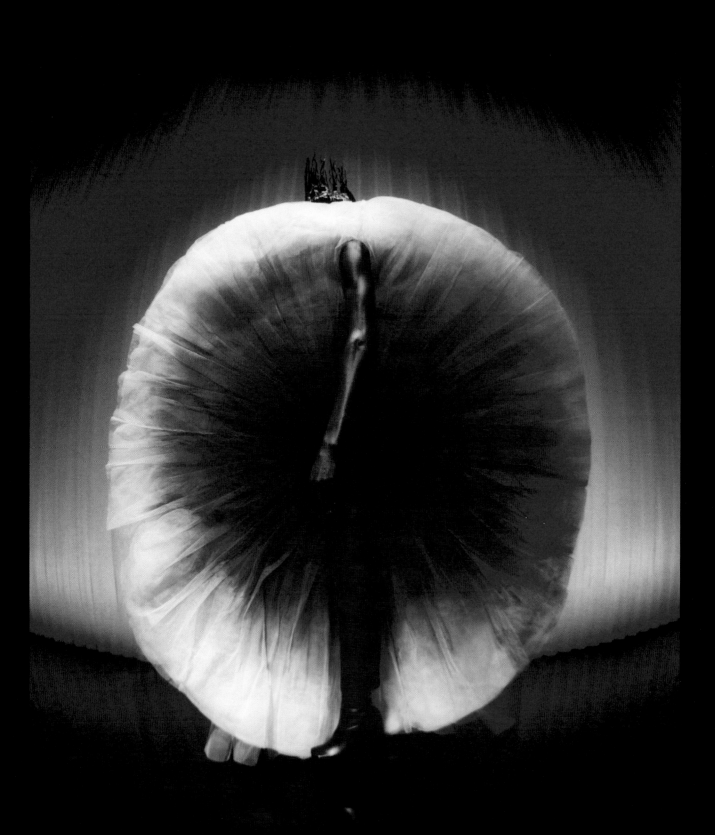

THE MET GALA

Dressing someone for the Met Gala, seeing them walk the iconic stairs of the Metropolitan Museum of Art in your clothing, is the pinnacle of an international fashion designer's career. In addition to being a profitable fundraiser for the museum, the yearly gala is the world's most prestigious fashion event and the industry's biggest night of the year.

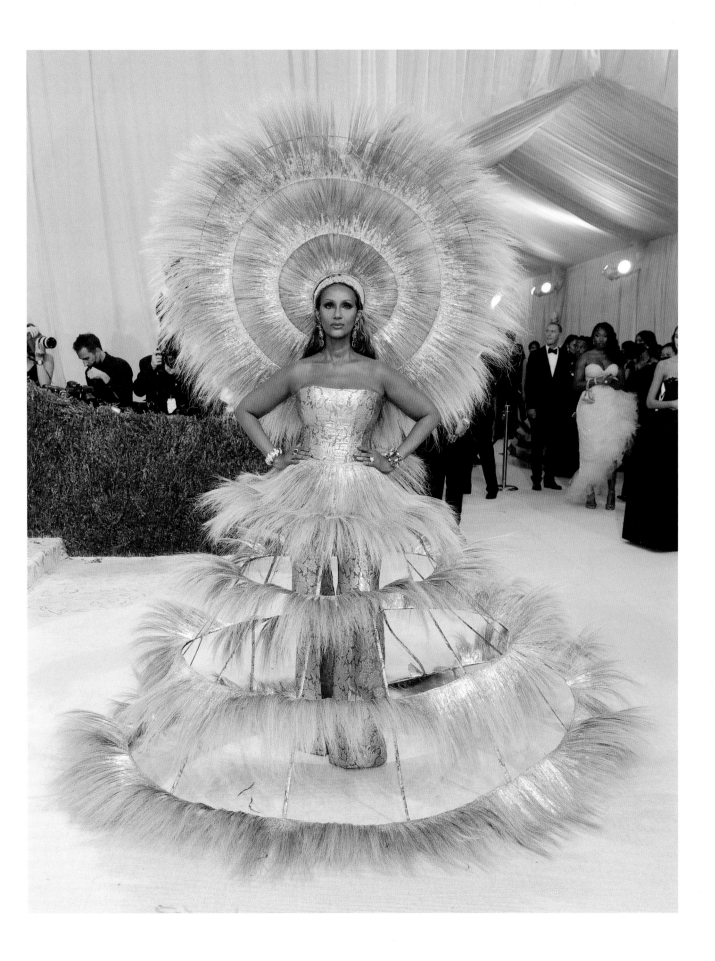

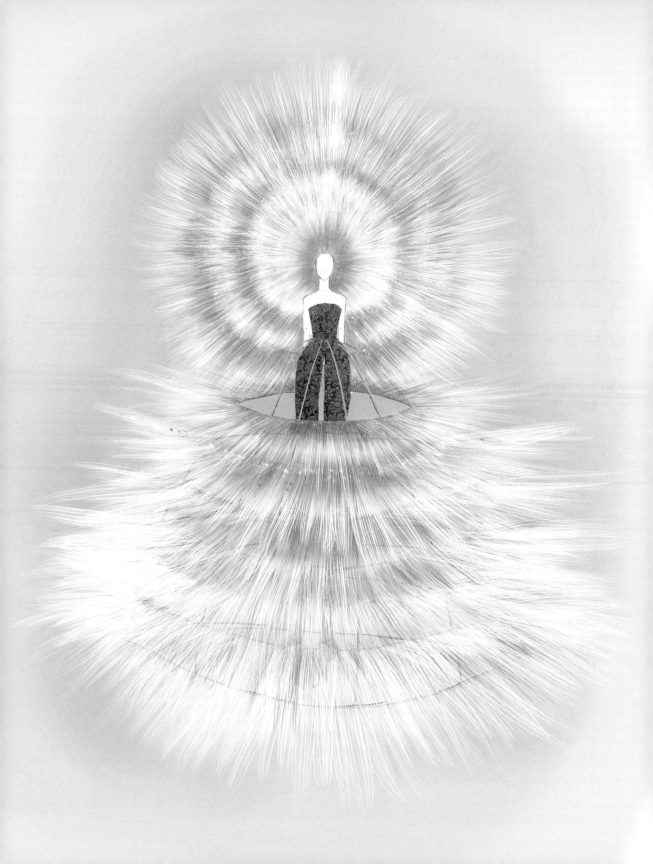

Celebrities in all arenas, from fashion, music, and movies, to sports, theater, and politics—as well as those who are famous for being famous—attend the evening's festivities alongside the designers of their garments. Having the designers attend with their celebrity clientele is unique—typically for designers, our work happens behind the scenes, out of the spotlight. It's one of the few nights when the designer becomes the center of attention and can shine alongside their work.

I'll never forget the feeling I had when I saw Sarah Jessica Parker wearing a one-shoulder tartan frock designed by Alexander McQueen, who posed beside her in a matching suit at the 2006 Met Gala. In that moment, McQueen was as much the face of his vision as his muse, which was eye-opening to me.

For fashion's biggest night, an invitation to dress an attendee is every designer's dream. Mine came with an invitation from *the* Anna Wintour, the doyenne of all that is fashion and the Met Gala's longtime chairperson. She asked me to create my biggest, most fluid vision to date.

There was initially some back-and-forth about who I would design for, which would be Anna's decision. I kept insisting on Iman. To me, Iman represents the strength of New York City. She was one of the first—if not the first—African supermodels.

I wanted to design an outfit that would be a standout among standouts, which, if you think about it, is kind of insane, because this is the Met Gala. I went straight into my whirlwind research process, looking at everything and anything that might spark the ultimate inspiration. My first thought was to create something with the grandeur of the old ballroom fashions that took up a space in the way that announced: "I deserve to be here, and I own it."

My team and I gathered in our London studio in room 122 of the Standard hotel and began pulling images off Pinterest and archive Instagram accounts. I came up with dazzling 1920s showgirl references from Fellini films, and someone else brought me images of old-school Parisian couturiers' work. Another assistant put forth a bizarre cage that was built for a chicken coop made by a farmer. While the inspirations were vast, what united them all was the idea of creating something big, very big, not just for the sake of being big but to own the space. We wanted to build on the idea of the New York ballroom scene, a historically safe space of expression for African Americans and queer people, as well as so many other people who felt like outcasts in mainstream society.

Though dressing the fearless Iman was a dream, it took a while for it to sink in that she would also be my date. An icon in her own right, she was also the wife of the late David Bowie, whose personal aesthetic and lifestyle were two of my biggest inspirations in cultivating my fluid aesthetic.

I wanted to use all of my inspirations to bring all the attention to the person in the outfit and magnify who they are by putting the focal point on the face. Being a queer kid meant that, for most of us, we had to hide ourselves to be safe. My idea with the sphere-like hat is that, rather than hiding

the wearer, it shows off who they are—their sexuality, their race, or otherwise. It shows them for who they are.

This outfit was about embracing what I was becoming known for: a larger-than-life idea and silhouette that puts the wearer at the forefront. The look had to be a true and utter moment of self-expression.

On the first Zoom call with Iman (me from London, her in New York), I showed her a sketch that was, at that point, little more than a dream. The idea was a jacquard jumpsuit, with flare or A-line trousers and a bustier—quite chic and quite refined. But then, on top of this would be a lightweight crinoline cage, some two meters around, lined with six rings of feathers and gold leaf. I wanted Iman to look like she was flying, and feathers helped represent that aspect. The literal topper would be a large feathered headpiece. One of my first recognizable pieces was a white circle hat—and if a headpiece is all about making the wearer's face a focal point, what better face than Iman's to draw everyone's eyes?

Iman loved the ideas, though she did ask how she would sit down at dinner with this massive cage around her. I laughed. Who can possibly eat at the Met Gala?

With Iman won over, I realized that we had only twenty-five days to make all of this, have it shipped to New York for a fitting, and then transported with her to the red carpet at the Met. The stakes were high, to say the least, not to mention

we still had to figure out what would look the most stunning while actually being wearable. Too much time down the wrong path and we would miss the deadline. Fabric choice for the trousers and bustier was also critical, because if we got it wrong, the outfit would miss the mark or fall apart altogether.

I knew that we couldn't use a flowy silk or a loose sequin fabric, because they wouldn't cling to her body correctly. The fabric needed to hug her, to look almost like it was a part of her. We settled on a previously unseen, archived Italian-made gold jacquard sourced from Italy. What I love about jacquard is its sculptural ability—it's flashy and fabulous but still strong.

The critical question was what to use to create the feather rings around the caged skirt to realize my vision of Iman radiating beams of light. We found a local supplier in London who had the exact amount of dead stock (almost unusable) peacock feathers. These were the last remaining stalks of peacock herls, the long, thin fibers that stick out from the stem of the tail feather and surround the colorful eyelike spots near the tips of the feathers.

Making the feathers stay straight was difficult. Working with my milliner, Vivienne Lake, and her team, we experimented with backing them with a metal paint, but they ended up being too heavy. We then concocted a mixture of a starching spray and a foiling glue to make our own glue-like mélange. We used paintbrushes to hand-appliqué this mixture to the feathers. After the feathers

PAGE 145 Iman wearing Harris Reed at the 2021 Met Gala, a most extraordinary moment for me

PREVIOUS The original sketch for Iman's Met Gala dress, playing up the queer culture of the New York ballroom scene, a historically safe space for African Americans and queer people. When I was sketching this outfit, Iman was the only name that came to me as someone who could carry this look with conviction.

OPPOSITE My mood board that started the design process for Iman's Met Gala dress

FOLLOWING Fittings to get ready for the Met Gala

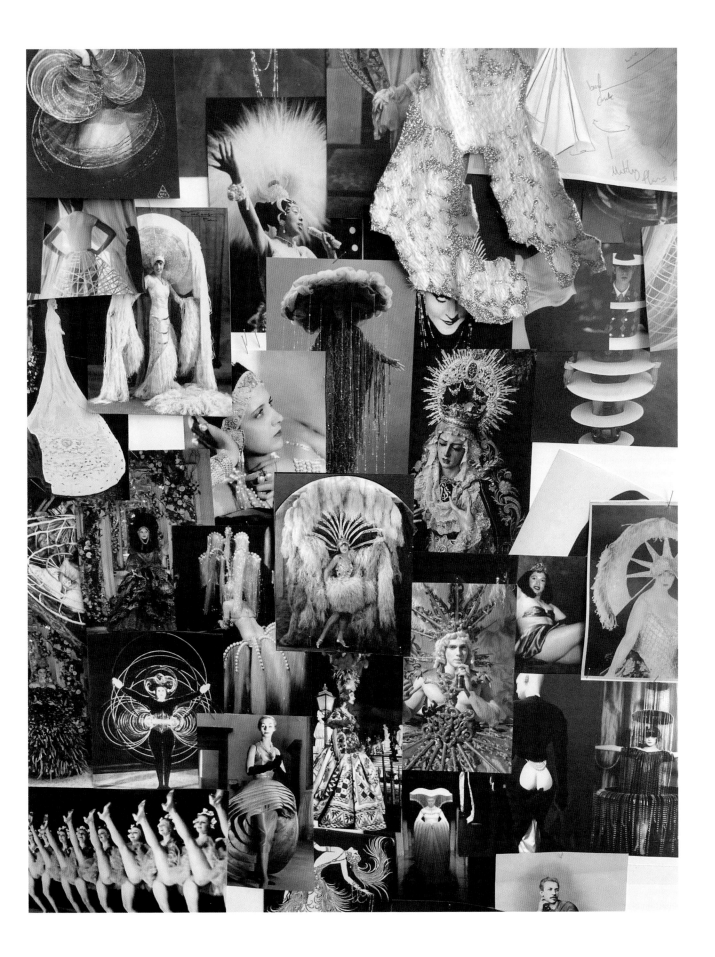

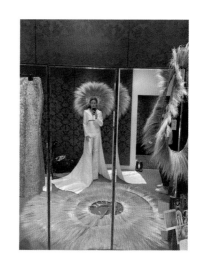

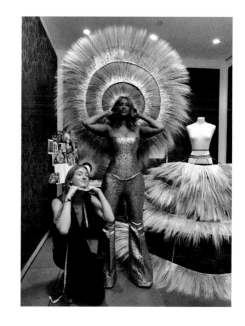

dried and hardened from this glue technique, we added the twenty-four-karat gold leafing using a stiff brush. The end result created a dégradé ombré effect, which is a gradient color effect where the hairs split into two contrasting color sections and visually blend from one hue to the other.

There were five feathered hoops in total. The bottom hoop was the biggest one, spanning some five and a half meters (eighteen feet). The layers were dense at the top and then thinned out toward the bottom, to mimic the natural drape of the feathers.

The hat would have three rings. One ring made it conversation worthy, two made it spectacular, but three would make it epic. As we tripled the size of the headpiece, the worry was that the rings would sag and obscure Iman's face. We had to make sure they had enough volume to keep them on an even plane. For days, Vivienne and I lived inside the headpiece trying to make it just right as she was the one who had to bring it together.

After three weeks, everything was done. But we had one more hurdle to consider: How would we transport the dress to New York? Phoebe, who is in charge of making the impossible possible, had to work on a creative solution for these very big, extremely delicate pieces without them being dissembled or crushed. She had to call the airlines to determine the maximum dimension of a crate that would fit in the baggage compartment. She tried all of our usual carriers, but the dimensions of the piece were greater than the usual dimensions allowed to be transported by plane. So she had to commission a specialist carrier to transport it. She also had custom boxes with a special soft insulation created for the piece, as it was too big for any existing boxes that could be bought— crazy as that sounds in our modern world, where anything can be shipped. Then she had to hire a moving van to transport the crates to the airport in London and from the airport in New York. And, of course, she purchased the maximum amount of insurance!

Finally we arrived at the fitting in New York. This was the moment of truth. If all the components didn't fit Iman properly, we were going to have to go full-blown *Project Runway* and work until the night of the gala—which, even with things going well, still happened.

Iman arrived to our first in-person meeting, statuesquely gorgeous and sweet and soft-hearted as can be. She took one look at the dress and said, "It's divine. It's beyond what I thought. The illustration doesn't do it justice." I smiled and nearly died from joy.

She first tried on the trousers, which needed a tweak. The most important thing on the red carpet is that the wearer feels secure within the piece and able to move around freely, so we needed comfort with structure. I quickly messed with the seams to make sure they were comfortable but still provided the necessary support.

The bustier was next.

"Too tight?" I asked through the curtain.

She laughed. "Never too tight."

She emerged, twirled, and studied herself in the mirror.

"I definitely don't want anything on my neck," she said, referring to the thin necklace she was wearing. "It's the only night I'm going to be

taking it off. This was made for me when David passed away, and I've been wearing it since. This is the only time it will stay home."

I just nodded. Even if she saw that decision in service of fashion, I felt that it was a high honor, a personal moment that she was sharing with me that went beyond trusting me to design her Met Gala dress.

We moved on to the cage. She wiggled her way inside, and we lifted it up off the ground to the proper height. Creating an outfit of this magnitude without any prior fittings, I knew we were going to have some work to do. Luckily the tweaks were minor, though still difficult because I was short-handed due to COVID travel issues. If the dress was not the challenge, the headpiece was. The Met Gala is not set up as a "step and repeat," which is where models walk a red carpet and stop at various backdrops to be photographed. Iman would be walking up literal steps as she posed with photographers screaming her name. She had been on the runway enough to know that she didn't want to be looking down while ascending. "It's going to test all forty-something years of my career," she joked. Iman had had foot surgery recently and couldn't wear heels even if she wanted to. So we bought these massive black creepers (thick-soled shoes with durable leather uppers) and painted them gold to give her the support to wear the outfit.

There was also the matter of dressing myself. My outfit was all about complementing Iman. I made a white tuxedo jacket with a train and a matching, smaller version of the headpiece. It was a nod to David Bowie's iconic white suit and, I thought, a fitting tribute to her late husband. I

wanted to look like a little angel walking next to a beautiful goddess and bask in her glow.

There's no feeling in fashion like the Met carpet. There I was, all of twenty-five years old. I remember thinking, *No one's going to know who I am.* But as we reached the red carpet, everyone started screaming my name. That's the power of social media, because I had never met most of these fashion reporters. Beyond the crowds, the stairs were a celebrity rush hour. There's Kaia Gerber. There's Billie Eilish. There's Timothée Chalamet. There's Grimes. There's Naomi Osaka. There's Rihanna. I felt like I was floating. And maybe I was, because I was wearing twenty-eight-centimeter platforms and a headpiece that probably brought me to about nine feet tall, if not more!

The walk up the stairs took all of four and a half minutes, but it felt like four hours. The photographers screamed for me to hold Iman's hand. But no, she needed to be the ray of light that went through the darkness, with me following. Thankfully I did follow her, because she almost tripped on one of those last stairs when the cage twisted a bit and got caught on a step. I pulled it free without anyone noticing, and on we went.

The fashion journalists loved the outfit. We stopped to talk to a very ebullient Emma Chamberlain, whom *Time* magazine named one of the twenty-five most influential people on the Internet in 2019. "This is the most beautiful thing I've ever seen!" she said.

"Thank you very much," Iman said.

"How much work went into this?" she asked.

Iman deferred to me. "I'd like to introduce you to Harris Reed," she said, inviting me to talk

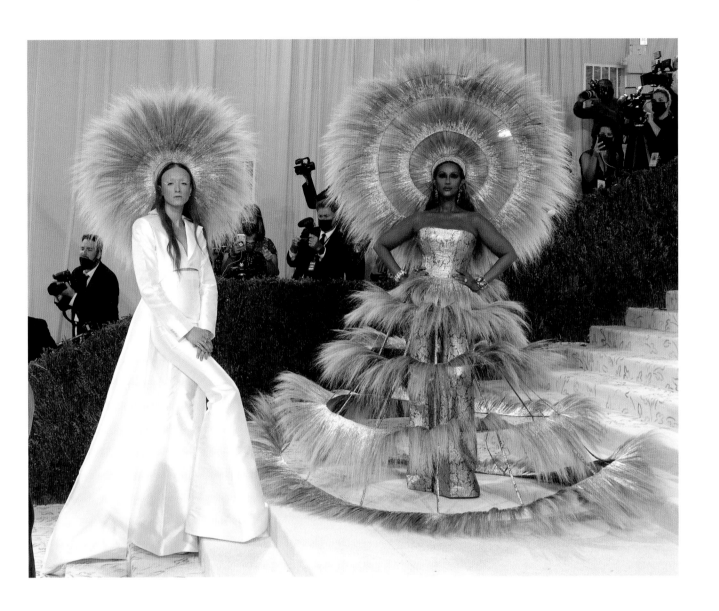

ABOVE With Iman on the magical stairs at the Met Gala

PAGE 157 Iman showing confidence, poise, and elegance in my epic headpiece.
(FYI, I made the headband the night before with a headband I bought at a pharmacy and wrapped in gold thread to make the fit better.)

about the outfit. Looking back, this was one of those rare moments when someone who should be in the spotlight gracefully shares it. That's class, and Iman is the high priestess in that department.

"Four hundred hours . . ." I said, probably sounding a little shell-shocked.

"Tell me more . . ."

"Hand tacking, hand gluing, hand embellishing, gold leafing, finessing, fittings, traveling from London to here," I managed, quickly adding: "It's been a fabulous process."

"But has been worth every second," Emma said. Turning to Iman, she said, "This is so gorgeous. How do you feel?"

"I feel great because the whole evening is about hope, a ray of light," Iman said.

"That's so true, and I love that," she said. "And I'm just in awe. I saw you walk in and I'm exhausted, but now I have energy suddenly. This was literal vitamin D pills for me. This was the best thing ever. You guys killed it. This is gorgeous . . . it's perfect. You follow behind her and it looks like just the sun coming through the Met Hall."

Wow.

As wonderful as the fashion moment was, I almost cried days later when I read a line in Carrie Goldberg's piece in *Harper's Bazaar* about the dress. She had asked me about the dress, and I said that fashion had a responsibility to spark conversation in relation to the injustices that were happening within society today. She wrote: "Iman, who famously faced down institutional racism as a model and founded a line of cosmetics for women of color in 1994, seemed the perfect fit to join the two brands in a collaborative, red carpet statement."

That is what fluidity in fashion is all about—coming together with others of different backgrounds and making a statement.

GRAZIA

"The sixty-six-year-old supermodel and entrepreneur [Iman] once again steals the show in a bold and beautiful custom back-tied jacquard bustier with rich silk ribbons, paired with flared trousers, which arguably makes a statement on its own. The fashion icon up'd the look with a feathered tiered skirt and statement headpiece. Iman dazzled as she walked up the steps hand and hand with the designer behind the jaw-dropping look, Harris Reed."

MANIFESTO

"THERE WAS TRULY ONLY ONE QUEEN AT THE MET GALA: Iman in Harris Reed . . . Iman, who is noted as one of the true trailblazers in modelling and Blackcellence, showed out in what can only be described as *Royalty Realness . . .* only a true queen could have pulled off this look with some serious aura. Consider us unworthy."

HARPER'S BAZAAR

"It's hard to stand out in a sea of celebrities wearing their most extravagant odes to American fashion, but at the Met Gala tonight, Iman stole the show."

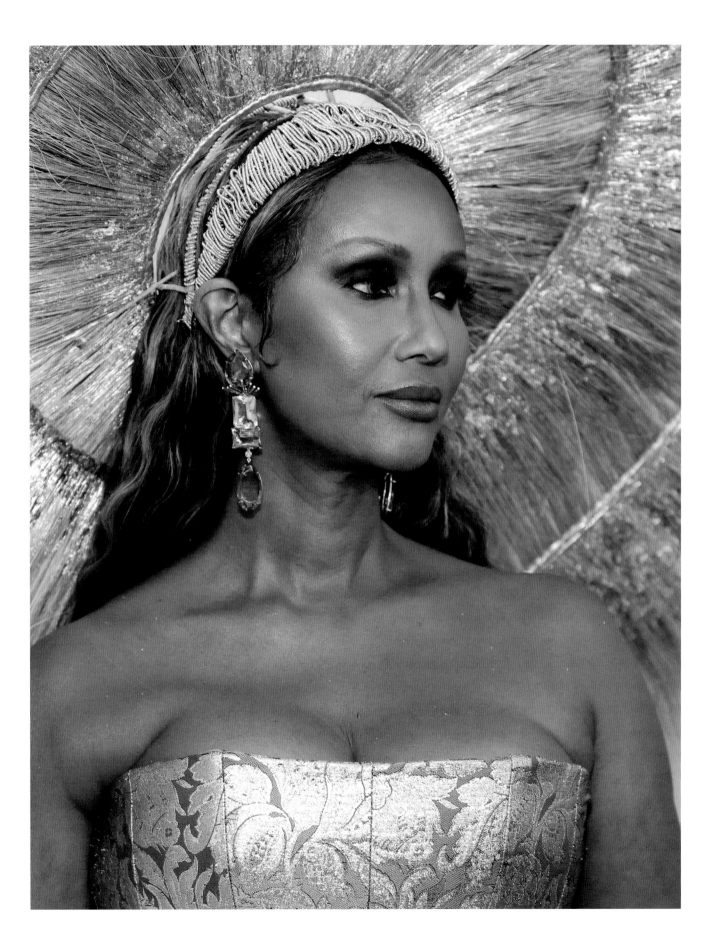

SARTORIAL SUSTAINABILITY

In fashion, it's one thing to try to bridge the classic and the zeitgeist, but it's quite another to work sustainably. I create demi-couture collections so that my clothes can be worn by the modern individual, and I try to use more upcycled and unconventional sustainable materials. Like haute couture, demi-couture garments are hand-crafted garments made specifically for the person who wears them, but they do not need the Fédération de la Haute Couture et de la Mode stamp of approval necessary to be deemed haute couture. Whether you're making demi- or haute couture, environmental sustainability in fashion is difficult to achieve. The industry is further behind in sustainability than others, for numerous and complicated reasons.

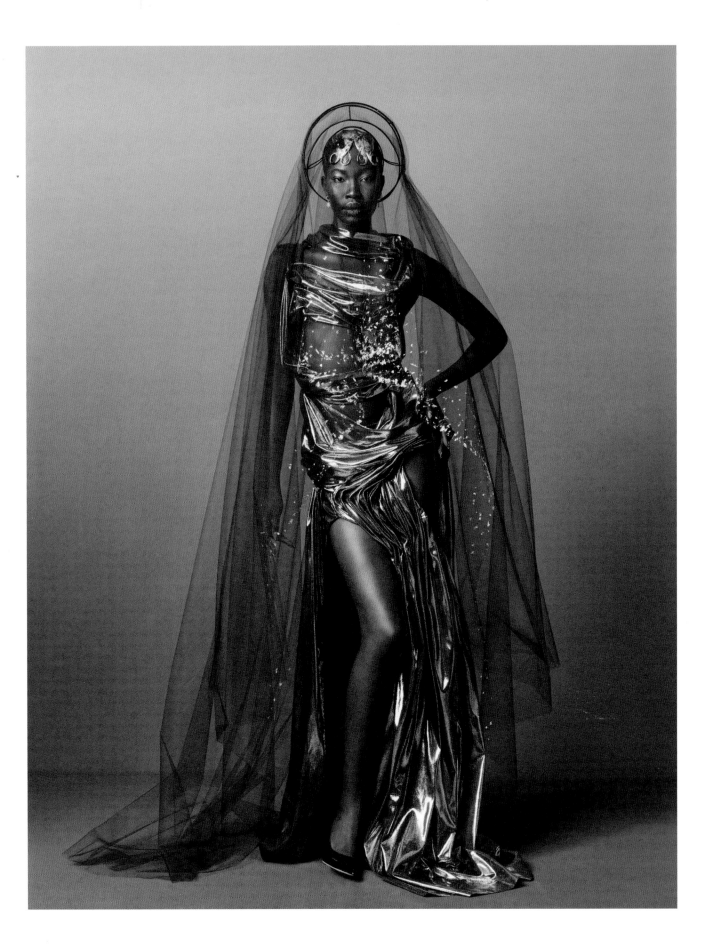

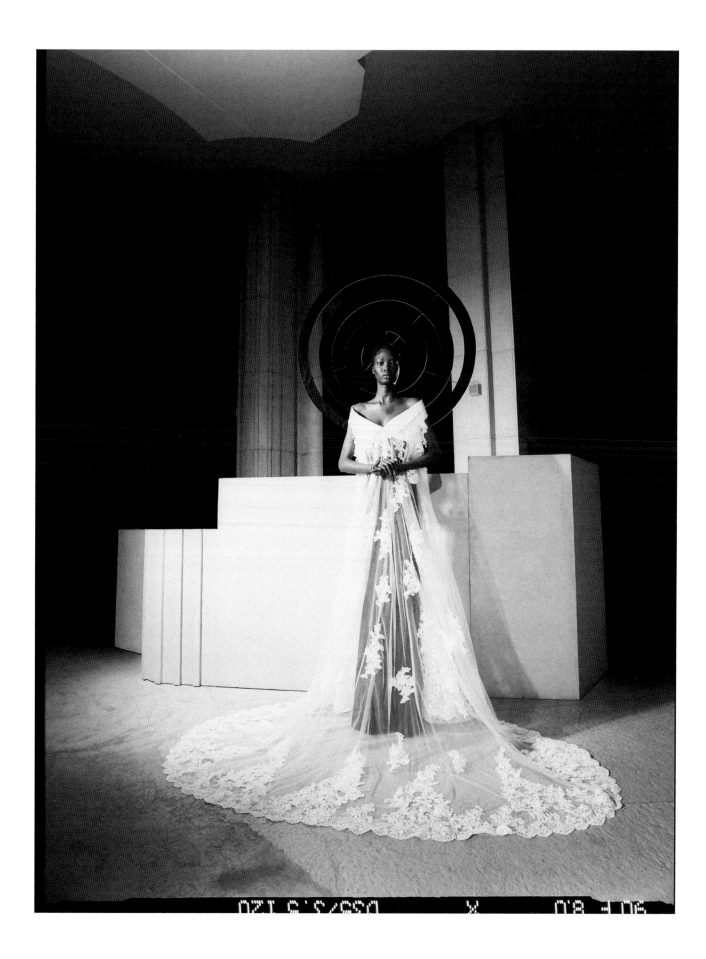

The fashion industry is a global business in which much of what is made is outsourced. Because very few brands own their factories, they can't directly control their production—not to mention material choices. In order to offer lower prices, mass-market fashion relies on fossil-fuel-based synthetic materials like polyester, which are far cheaper than natural materials. But just as fashion reflects culture, I believe it must lead culture. If part of my mission in the fashion world is being a leader in deconstructing gender divisions for clothes, my hope is to also help move us to a more environmentally sustainable place, too.

Fluidity is about caring—caring about the true you, caring about others, and caring about the world we live in. That's a big statement, but one I try to embody. A constant goal I have is ensuring that I'm using as much sustainable material and using old techniques that make as small of a carbon footprint as possible. The majority of my jewelry is made from upcycled silvers and golds and other metals. Fabrics are more difficult. I am always trying to find ways of using upcycled materials, dead stock fabrics, and locally sourced materials. This can be challenging, because many upcycled and local materials are cotton or hemp, which I don't use in my work. These are great fabrics, but they don't fit into the grandeur of my designs.

In September 2021, I decided to see if luxury could be done without sacrificing sustainability.

I named the collection "Found." The majority of materials used in the collection had already lived as a different garment and were purchased from Oxfam, a leading charity in fighting global poverty. Some of the pieces were off the rack. Others were hand-stitched by a loved one. All were given a new existence.

I love thrifting. There's something wonderful about discovering pieces that have had a past life. I also love wearing vintage clothing, mixing the old with the new, and giving things a second life. When the pandemic hit, one of the activities I missed most was going to thrift and vintage stores (as well as museums) in search of inspiration. These locales are where I fell in love with cuff details, ruffles, buttons, and even flipping old blazers inside out to study the lining. I love finding new ways of looking at things.

During peak pandemic, when I was restricted to hunting for inspiration on my laptop, I discovered oxfam.com. There was so much there—not just clothing. I started buying their vintage fashion books, like one from Fendi, and vintage records. Then one day I accidentally clicked the wrong key on my laptop and I stumbled upon the bridal section. I started scrolling through gowns that were priced from £30 to maybe £250 maximum. These gowns originally cost anywhere from the high hundreds to maybe £15,000. I was hooked.

As a designer and as someone who locally sources fabrics as much as I possibly can, seeing these fabrics and materials was wonderful. One dress was selling for £40, which was made with hand-beaded tulle and hand-beaded lace that would otherwise cost upward of £500 a meter. I started filling my virtual cart. Once the stay-at-home orders were lifted, I went back to shopping in their stores and bought several dresses. All the money from those purchases went to charity, and

I pledged to give them a finished dress to sell for charity, which they would put in their massive Selfridges window on Oxford Street in London.

For the fluid component of these designs, I wanted to subvert what we recognize as wedding day standards. By upending the conventions of the his-and-hers wedding wardrobe, I was able to liberate these pieces from the binary construct and move them into a fluid yet still romantic reality. I started by cutting a massive tulle train from the front of a very traditional women's wedding dress and added it to a men's suit. In this way, I hoped to deconstruct archetypes and add a streak of freshness and, in short, flip things on their head.

I also wanted to put on a unique show that was about challenging the norms. In the past five to ten years, the majority of designers have done typical up-and-down runaway shows. Music starts blasting and models all in a row walk up the runway, turn to show off the clothes, and then walk back down the runway. These shows typically seat five hundred people, many of whom are on their phones. I wanted to put on a more intimate show, for no more than seventy-five people, and in a special outdoor venue, and it was also important to have elements of everything my brand stands for, inclusiveness of gender and race and body.

We chose the Serpentine Gallery Pavilion in Hyde Park. The pavilion was designed by a dear friend of mine, Sumayya Vally, who is an incredible woman, and so for me it was also being held in a space that represented a lot of new beginnings. I used models of different ethnicities, genders, and sexualities, and I put boys in dresses and girls in traditionally tailored men's suits. Kelsey Lu, an extraordinary nonbinary singer with a heaven-sent voice, performed, serenading the audience in a private concert–like environment. Rather than having the models walk a runway, they took their places and only moved ever so slightly to the music.

The response was wonderful. It showed that my message could resonate, that my clothing had a tangible voice and purpose, that fluid—or even high—fashion can be sustainable, and that people want to be a part of it.

One of the looks went straight into the Selfridges × Oxfam space after the show. But this wasn't just one of the nice dresses that went into the shiny little store window. I actually rotated the dress so that the woman's breasts were exposed. It was displayed on a male mannequin turned backward with the chest out like it had been in my show. The design was done as a tongue-in-cheek nod to the idea that a wedding dress, which is often worn in a chapel, was reimagined to be vulnerable and more open (though we did make a sheer blouse to accompany it). Even people who liked the dress claimed that no woman was ever going to buy a wedding dress that didn't cover her chest. But within two days, someone bought it for £9,500, with all proceeds from the sale going to Oxfam.

Another dress was worn by Emma Watson for a purpose-driven red-carpet appearance. This was Emma's first red carpet in three years. From

PAGE 161 Adhel modeling a piece made from old gold lamé theater curtains for my "All the World's a Stage" collection
PREVIOUS My upcycled wedding dress collection, "FOUND," made from garments sourced from Oxfam
OPPOSITE Emma Watson wearing an upcycled wedding dress over a reworked old men's tuxedo trouser at the Earthshot Prize ceremony, showing people how beautiful discarded, reimagined clothing can be

the get-go, she was obsessed with the idea that at the awards show she was attending, everyone had to wear something that had already been worn. Emma Thompson wore a suit she had worn before, and Kate Middleton wore a dress that she had previously worn and been photographed in. But Emma wanted something cleverer.

Emma loved the idea of wearing looks from the "Found" collection. She wanted her back to be shown in a specific way, with the swoop of the back of the dress framing it, and to have it cropped on the sides to make it a bit more asymmetrical. She chose to wear these really cool, pre-worn Miu Miu shoes. To that, we added Harris Reed × Missoma jewelry, which was all made from recycled silver, gold, and other metals. She was an absolute dream to work with and fully embraced my clothes' mission—both in sustainability and fluidity.

Following on the heels of my sustainably made "Found" collection, I set out to expand my original limited-edition blouses, which are typically made with dead stock materials. I hoped to do this in a way that honored my belief in the beauty of recycled materials. Finding beauty in already-worn material is something that is very important to my brand because it lends a new way of looking at luxury fashion, not only in the way of gender and fluidity but also the idea of upcycling and the beauty behind it. Doing this allows people to see these old fabrics as something different—something new and fresh and relevant. The original blouses were one of a kind, with a very limited run of each style.

To push a combined message of fluidity with sustainability even further, I came up with an idea that seemed a bit crazy: partnering with the fashion house Etro on a line of blouses. "Easier said than done" was the refrain I heard. The naysayers didn't believe that Etro, or any other major fashion house, would want to use a previous season's fabrics to produce new garments, particularly since the fabrics did not have enough material to produce more than five or six blouses.

To truly break down barriers in fashion, a designer needs to establish a relationship with a French or Italian fashion house. The fact is, those houses—the Italian Gucci, Prada, Versace, Ferragamo, Zegna, and Etro and the French Dior, Louis Vuitton, Lanvin, Hermès, Chanel, and Nina Ricci—rule the world. They have wonderful points of view in their clothes, but they have not all been intimately involved in the conversation about expanding gender binaries—and they're only just getting started on establishing long-term sustainability.

I've always deeply respected the Etro brand and its legacy—not to mention all those bold colors and patterns. Etro was the ideal partner for this project because of their extensive archive of dead stock fabrics. But the company, which was formerly family-owned, had recently sold 60 percent interest to LVMH, which controls some seventy-five luxury brands, including Christian Dior, Fendi, Givenchy, Loro Piana, Celine, and Bulgari. It was unclear if the house would still be able to color outside the lines, but Etro has worked hard at maintaining its heritage and staying current. Their trademark paisley designs are very aristocratic but can also be seen as psychedelic and pop rock.

When I spoke to Veronica Etro, the daughter of the company's founder and the head of the house at the time, she loved the idea.

"I must say, I didn't have any doubts," the ever-graceful Veronica said in an interview with *Vogue*. "I remember when I received his message and thought, Wow! Why not? I think fashion, right now, is in a phase that is not about being self-referential, it's about really being open to new ideas and new people. What I like about Harris is that he's not taking fashion too seriously—that's important: to play with fashion but also have a care behind it. He has a message of inclusivity and this deep passion."

It was a dream come true for me as a young designer to collaborate with Etro, and especially with Veronica, who I remembered reading a profile on when I first moved to London about how she, too, had attended Central Saint Martins. It was a real, mutual collaboration, where we all rallied around an idea we loved. Veronica and her family allowed me to use Etro's luxurious paisleys, tulles, and Lurex jacquards from their dead stock archive. While these couldn't be used for a major run because there wasn't enough fabric, they were perfect to create three or six blouses from. All of Etro's wonderful fabric left on the cutting room floor was repurposed and given new life.

The result was a one-of-a-kind limited capsule collection of genderless silk blouses called "Harris Reed × Etro." Because we were using only two patterns with a very limited amount of dead stock fabric, they had to be blouses that could be worn by everyone. The challenge was creating a garment that transcended different body types. The blouses needed to cover women's breasts and also look natural over a flatter torso. To accentuate the genderlessness, we used transgender, male, and female models. The goal was for anyone who wore them to feel fabulous, regardless of their sex.

Traditionally, Italian fashion houses weren't involved in the conversation around pushing any limits of gender, but Veronica has been a bit of a trailblazer in this regard. While Harris Reed × Etro was a relatively small project, it felt like an important one for fluidity tying itself to a major fashion house and incorporating sustainability. The fashion industry will probably always struggle with sustainability—it's currently unrealistic for any large brand to create fully sustainable, carbon-neutral, all-natural clothes at scale. But my hope is that brands can start by making niche lines that are sustainable and build out from there. Fashion needs to lead.

PREVIOUS This look from my "All the World's a Stage" collection was all about playing with a sphere-like shape that draws attention to the individual.
OPPOSITE Marc Hibbert shot the amazing photos that bring my "All the World's a Stage" collection to life in print.
FOLLOWING Taking photos in the bathroom for my Etro × Harris Reed campaign that features blouses made from deadstock Etro fabrics
PAGE 172 A real honor to have Tom Craig take these two black-and-white photos before my show at the Serpentine Gallery
PAGES 174–175 Playing with the idea of jewelry for the "Mise en Scène" collection
PAGES 176–177 Theatrical images from my "All the World's a Stage" collection

V MAGAZINE

"When great designers come together, great fashion is manifested—and nothing quite exhibits this like Etro's limited edition capsule collection with Harris Reed does . . . The partnership is a combination of the legacy, influence and timelessness of both Veronica Etro and Harris Reed, pillars of the contemporary scene. Heritage of the Etro fashion house shines through in innovative fabrics, while Reed's creativity and craftsmanship at his demi couture brand make for a one-of-a-kind capsule."

VOGUE

"If you were to make a list of the most revolutionary fashion items of the 21st century, chances are the blouse would not rank in the top 10. Button it up, tie its collar, or let it loose; layer it or wear it on its own—the average 2021 blouse does not deliver a lot of pizzazz. Harris Reed and Etro intend to change that with their limited edition capsule collaboration, which is imbued with meaning and sensuality at every turn. Made from vintage Etro fabrics, the blouses rely on Reed's lexicon of blouson sleeves, long ties, and the freewheeling sexiness of rock stars like Jimi Hendrix (who would surely have been a Reed customer) to Harry Styles (who currently is)."

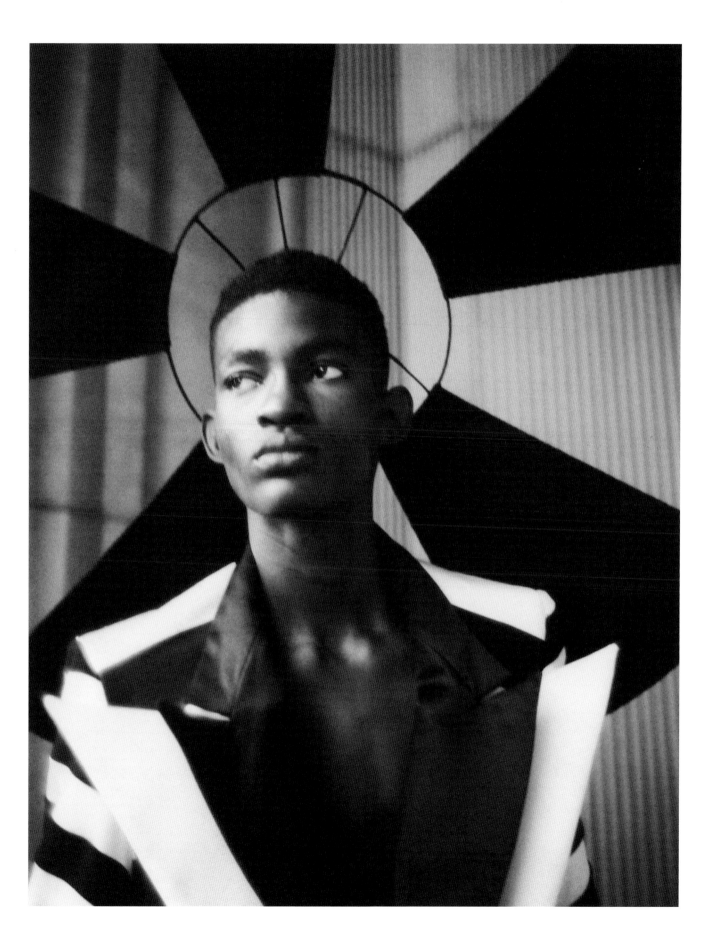

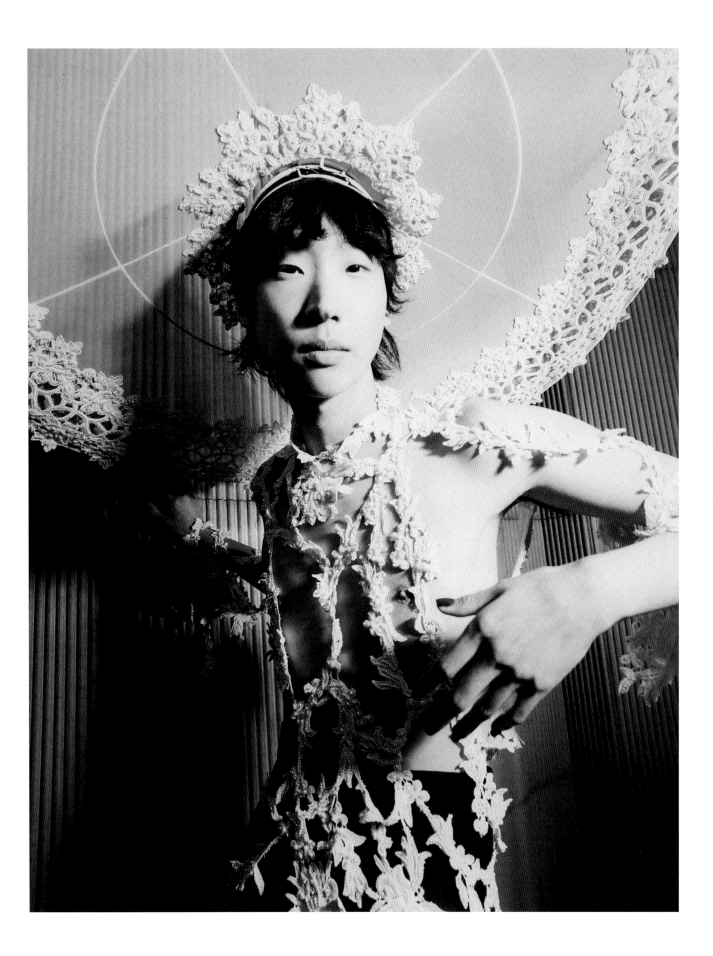

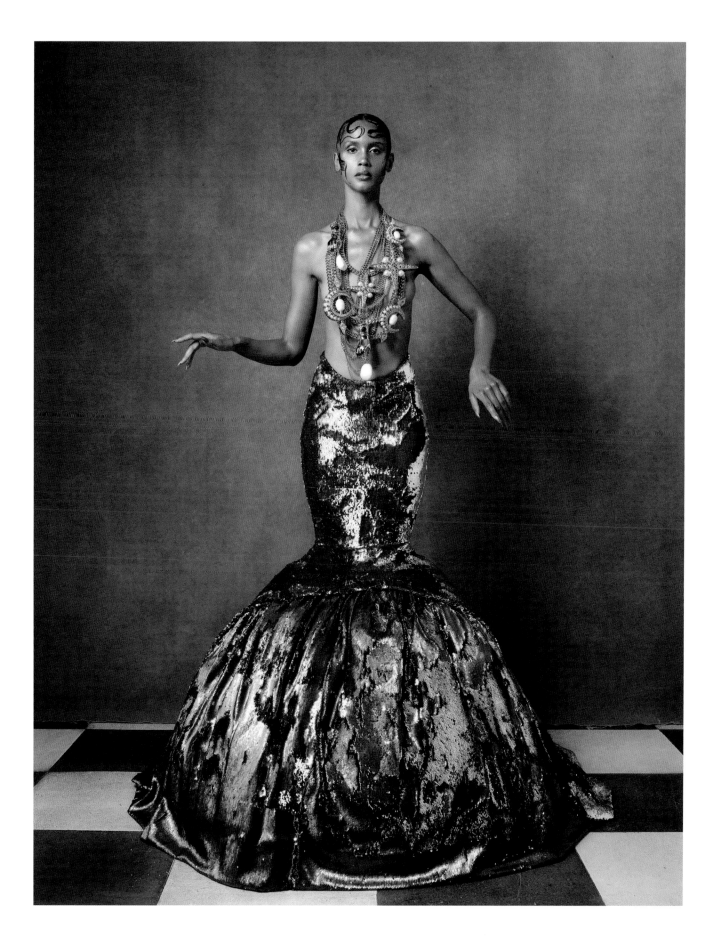

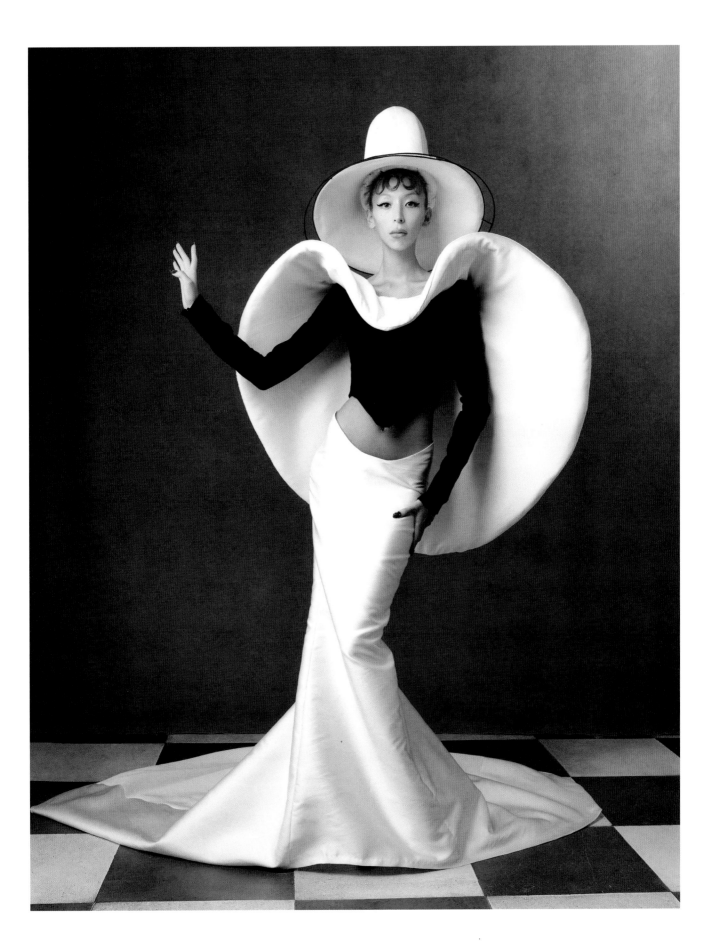

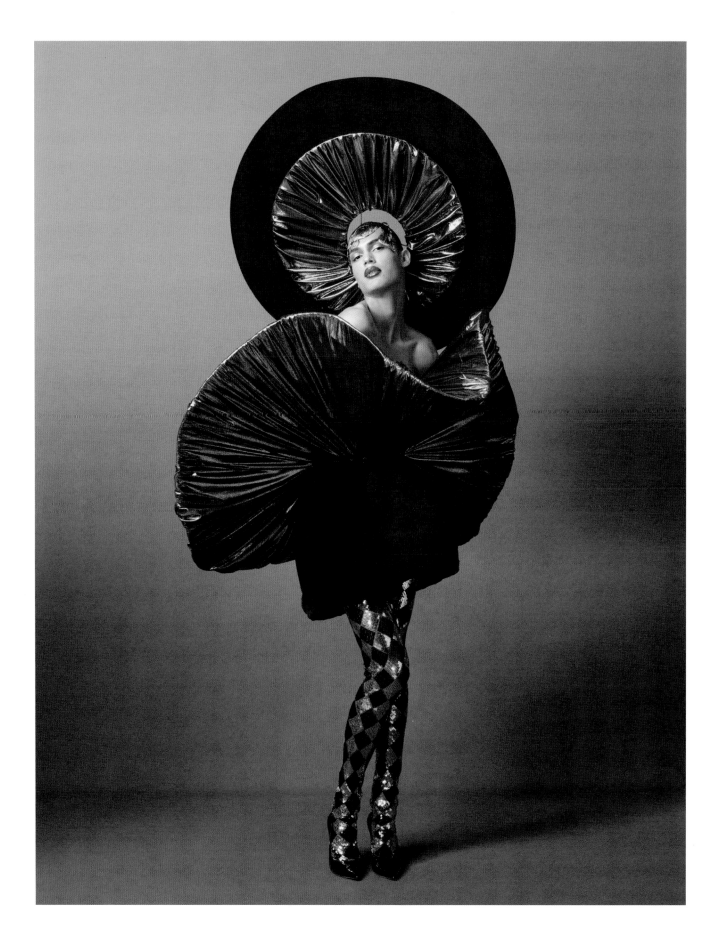

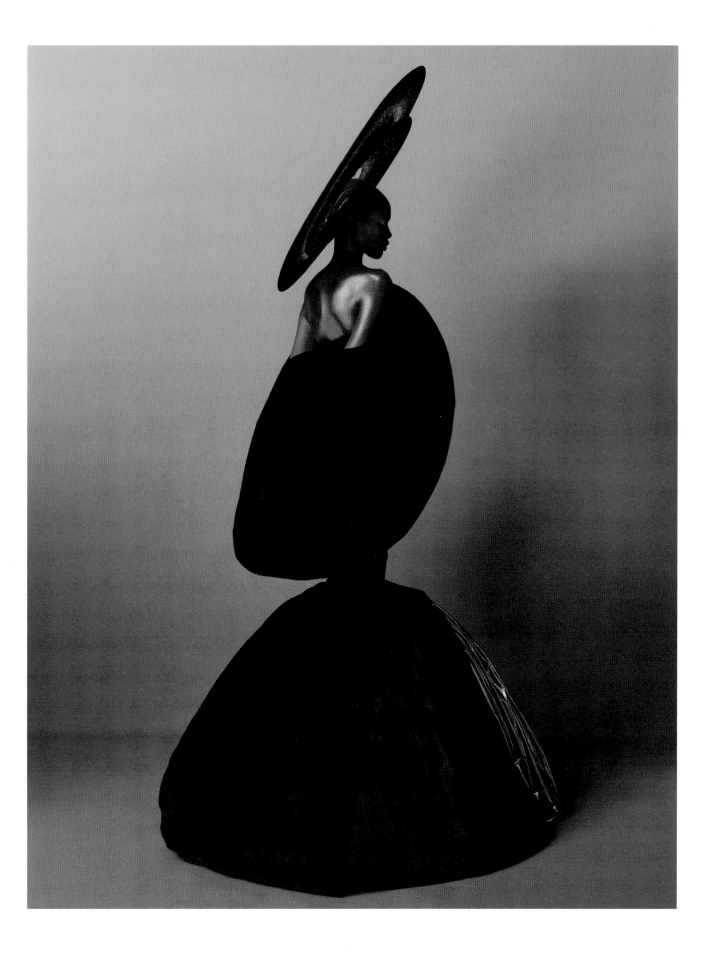

10

A FLUID
BRAND

Expanding fluidity in fashion isn't only about having more conversations around the gender binary in high-fashion spheres—it's also about making fluid fashion affordable and accessible for everyone. Knowing that the traditional business route for making my clothing wasn't possible, I had to explore other avenues that would really ring true to being a fluid brand. Fluidity doesn't have to be simply restricted to clothing; it can embody any product, any object, and anything you use to express yourself. This led me to collaborate with other brands who were also interested in progressing fluidity: brands like MAC and Harris Reed × Missoma jewelry, and to even create a line of candles.

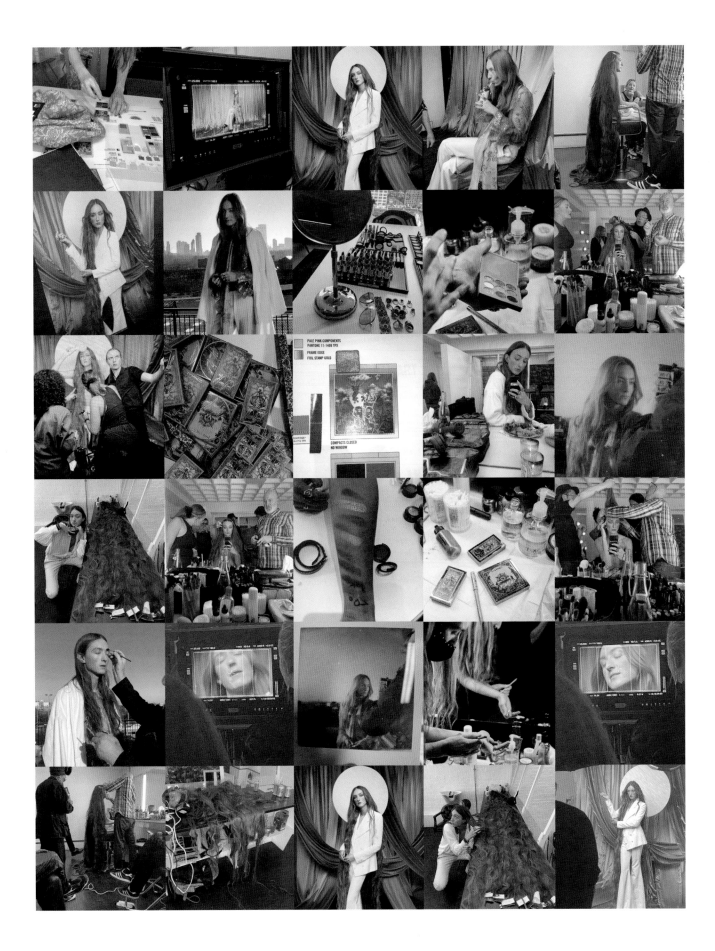

Often during interviews with major media publications, a reporter will suggest that because I've had only a few proper shows, expanding into other markets like home fragrance, makeup, and jewelry, where other luxury companies took decades to build their brands, I'm acting prematurely or in a way that isn't the norm. My response is always that fluidity is strong enough to be expanded into other markets because at the end of the day, it doesn't have one fixed area where it can exist. It is fluid.

Because I'm making up new rules as I go, I hope to go down the road of other designers who were forced to take out massive loans to grow new product lines and spending years and years of trying to play by the book. Yes, what I'm doing is unconventional. But nothing about the way I do my business, or my messaging, or my design, or myself, is conventional.

FLUID FOUNDATION

Makeup is used to enhance or alter appearances. It's been called war paint, concealer, pancake, and blusher, all of which describe how makeup can change our looks, ready us for taking on the world, and conceal or exaggerate. Using different shades and shines of blush, mascara, eye shadow, and lip liner is the easiest, quickest, and least expensive way of radically changing our appearance. Fluidity with makeup is playing around with the different aspect of one's complexion, such as a man wearing eyeliner or a woman using powder to make her face more angular and harsh.

When I moved into makeup, MAC was an ideal choice at the time. In addition to the quality of its products, I love that MAC, which is owned by Estée Lauder Companies, is a socially conscious company. The MAC AIDS Fund, which supports people affected by HIV/AIDS in impoverished countries, has raised more than $400 million through the sale of its products, according to the company. This philanthropic message was a truly important factor in deciding how to broaden what my own brand stands for and how it aligns itself with my own message.

In collaboration with MAC, I designed palettes of colors for the eye, cheek, and lips. It was MAC's first-ever gender-fluid collaboration. My inspiration for the line came from glam rock and Romanticism, boys, girls, in between, everyone just crossing paths and mixing the classical and the modern. For example, makeup in the 1950s was strictly marketed to women, and it was pink and sparkly. Then along came glam rock maximalism, which saw men rocking out in glittery makeup. Drawing on this shift, I wanted to use typically female colors like bright golds and emeralds and very shimmery textures in a way that men would be comfortable wearing, too. I also wanted to mix in darker colors and even the typical black, rock 'n' roller palettes, to create a juxtaposition with the feminine colors. The result is a mélange of colors that is not specifically male or female and serves a gender-fluid audience that is often left out of the

PREVIOUS Me for the Harris Reed × Missoma jewelry collection
OPPOSITE Behind the scenes of the making of my cosmetic line for MAC
FOLLOWING The global campaign shot for MAC × Harris Reed cosmetics

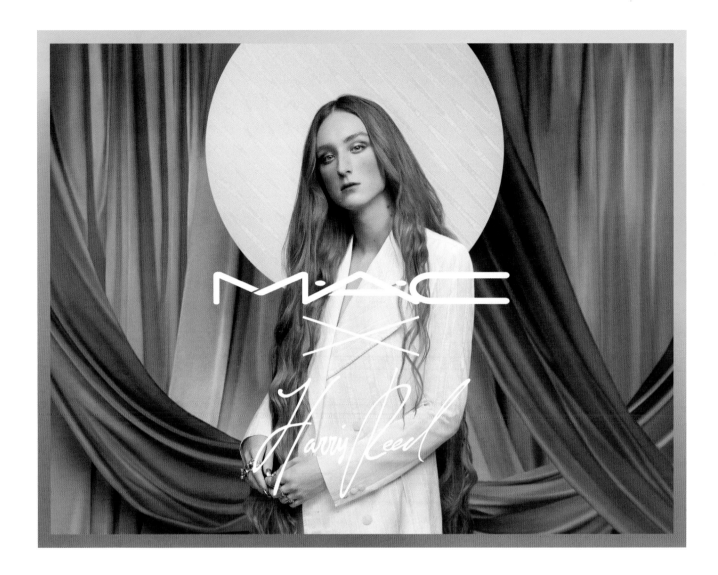

mainstream makeup market and marketing. It was also very tactile in the sense that you were encouraged to apply it with your hands rather than just using brushes.

The makeup line ended up both enhancing my demi-couture collections and playing into their inherent limitations. Because of the demi-couture price point, and because I refused to go the way of the more traditional large retailers, my designs weren't accessible to the younger audience I interact with on Instagram. I receive hundreds of comments and DMs daily from teenaged queer kids living everywhere from rural America to suburban London. In creating a gender-fluid makeup line, I was making a product that was financially accessible—something exciting and beautiful for buyers ranging from those teenaged queer kids to adults exploring their gender to any individual who wants to be seen.

SETTING FLUIDITY ON FIRE

Candles were an obvious next step in expanding the reach of fluidity into other products. I love fragrance, and I grew up surrounded by candles. My mother, Lynette, introduced me to candles as a baby. She always had soothing smells wafting through our house. Before I could even speak, I smelled these heavenly scents.

I remember walking into our kitchen every morning and there would be fifty vials of rose essential on the table. My mom would sit there and explain to me how each rose was different from another and emitted a specific note. Then she would combine a few to make a more complex scent.

She went on to found a candle company called Illume, and then had multiple companies after that. At one point, when money was tight, we actually *lived* in the warehouse for her candle business.

Everything I do is about building a world and a space in which you are transported. Nothing transports you more quickly than the power of smell. As a designer, I have always strived to make this world a fragrant place, if you will, because to make a true new world you need to activate all senses. My candle collection, "Thriving in Our Outrage," was created to inspire people to embrace their true inner fire, that light that sparks brightness and gives hope to us all. You can light a candle, let its scent fill the room, and then close your eyes and dream about what's on the horizon.

My candle collection had several scents, including Charred Rose, which I created in partnership with my mom. Charred Rose is a sexy, rich, and sensuous combination of dark rose, geranium, and patchouli, with hints of frankincense and vetiver, and it will truly transport you to a divine world of flamboyance and fluid fabulousness. The rose scent is for my mother, who always planted heaps of roses at our homes, and the bunches she picked overflowed from vases throughout the house.

FLUID ARMOR

Jewelry has always been an incredibly important part of me and my world. My love for jewelry goes back to my grandmother and my mother. I have a pair of clip-on earrings of my grandmother's that I wear to this day. When my mom was pregnant with me, she bought a ring at a Paris flea market. During those early years of exploring my identity, when I was coming out as queer in smaller circles, my mom gifted me that ring. The ring was symbolic of that exploration, as wearing a ring as a young boy was seen as feminine, or being different from the other boys. Although it's falling apart and has a few missing pieces now, I still wear it proudly. These pieces are part of who I am.

I've always believed that jewelry is the first step in shining new lights on ourselves. Jewelry builds up your fluid armor, allows you to explore different colors and textures, and of course adds a little bit of glamour. It is a beautiful way to start touching on who you are and how to best express yourself, and you can go step by step. To build up fluid armor, a man might start with a bracelet and then add a necklace. Maybe he then tries earrings.

With jewelry, you can be a minimalist or a maximalist. I've always piled jewelry on because

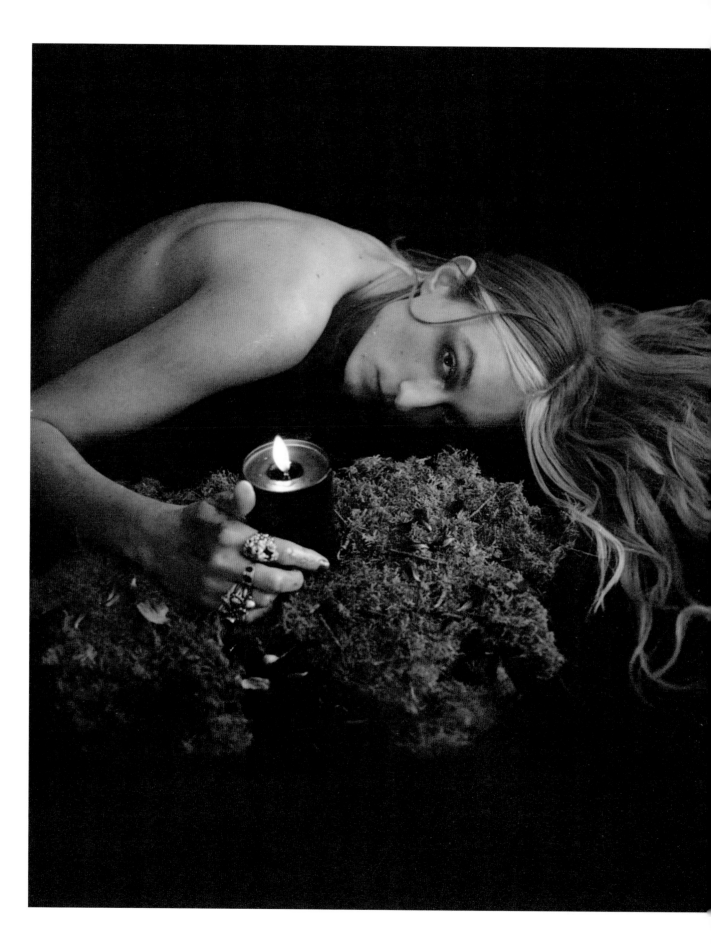

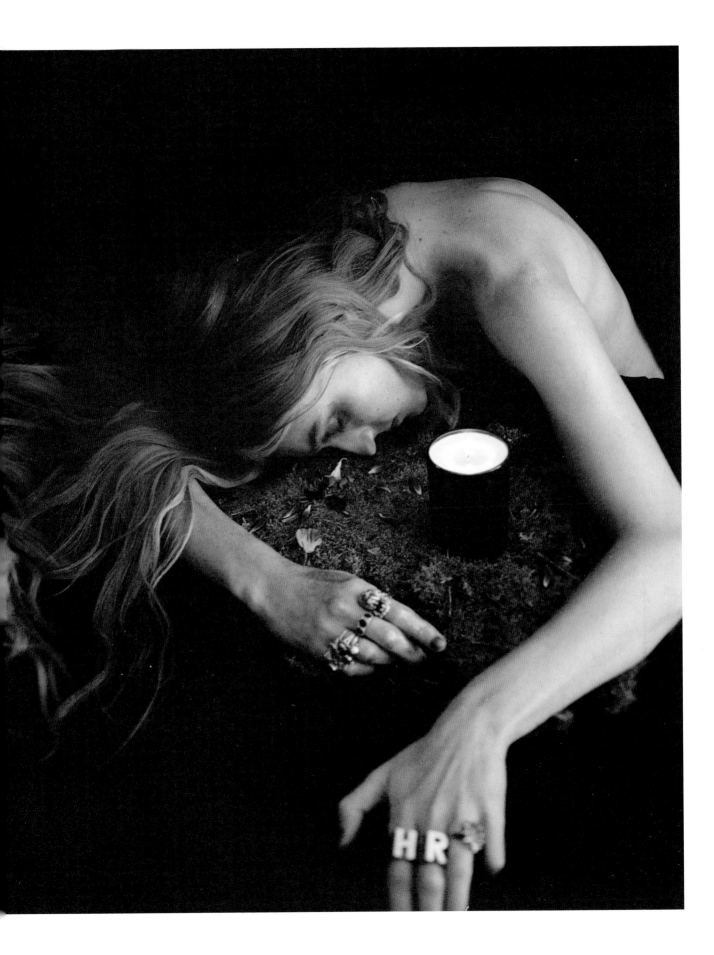

FLUID

that felt symbolic of myself: it allows for mixing and matching. Wearing jewelry is a low-stakes way of expressing the worlds within yourself. As with clothes, if you feel good, then you're doing it right— no matter what anyone else says.

When I met Marisa Hordern, the founder and CEO of Missoma, at a dinner party, we spent the entire time huddled à deux talking about the beauty of jewelry, its transformative power, and, more deeply, its meaning for our self-image. By the end of the meal, she asked me if I wanted to work with Missoma and create something that enhanced my message of fluidity and sustainability. "Fuck yeah!" was my exact response.

Missoma was an ideal partner. The company is known for quality at a reasonable price point—essentially "jewelry for everyone." The pieces I created were all sustainably handcrafted, made using recycled eighteen-carat gold vermeil and recycled sterling silver.

Every piece had a specific meaning. They weren't just about making pretty, wearable accents to your clothes—though that was important; the focus was on what elements each design represented so that the wearer could assign their own meaning.

That beloved flea market ring of my mom's inspired our Night Sky Pearl Cocktail Ring, which is the most successful piece of jewelry in the entire Harris Reed line.

The serpent earrings symbolize shedding the skin of our preconceptions—after shedding, we're reborn into who we aspire to be.

The butterfly necklace is based on the duality of gender—a butterfly is a transformative creature that embodies both genders and represents the

journey to accepting the true versions of yourself. The *Lexias pardalis* butterfly is also perfectly split down its middle, with male coloring on the left side of its body and wings and female coloring on its right. It is almost a flag for fluidity.

The earrings with a hand grasping a pearl represent a safeguard against that which would bring harm to us.

The earrings with hands clasped, influenced by Georgian jewelry, represent friendship and love, as linking hands raise each other up. It's the community coming together, grasping one another, and taking us all to new heights.

The dagger necklace represents the cutting away of ignorance and a symbol of strength that we can't live without.

Harris Reed × Missoma is a jewelry collaboration that encourages the wearer to celebrate every element of themselves by layering, stacking, and pairing pieces together in a way that is uniquely you. As *Vogue* noted: "Harris Reed ventures into jewelry with a dreamy Missoma collection for everyone." For *everyone*!

In a way, from a business point of view, what I'm doing is the new evolution of a start-up by embracing what technology allows us to do. Instagram has become my storefront and my primary means of communicating, and I am able to reach an astounding amount of people through it.

Creating these other products—expanding outside of just clothing—is an extension of my mission to create something new and accessible and still be 100 percent true to who I am and what my brand stands for. The fact that I am doing these other products is an extension of that thinking. It's

about leveraging, much the way many start-ups outside of fashion do, and about having makeup and jewelry that can truly be for everyone. Many fashion companies use technology purely to sell clothes, like Farfetch, Net-A-Porter, and Mytheresa. But mine is a bit of new business model, a way of thinking differently about the business of fashion and what my part in that business stands for.

I went into this business knowing I didn't want to do it like anyone else. I wanted to do what felt right—not just to me, but to my community. A lot of that came down to avoiding the traditional retail routes. It's a beautiful thing when you have a business that's truly reflective of who you are. I don't go into anything that doesn't reflect who I am and who my customer is. I go with what feels right.

Bringing fluidity to other products beyond clothing hasn't been a jump—it's been a deep plunge. We have a road map of where the brand is going, one that is always changing and updating itself. The goal is to continue to grow a queer, outspoken, fluid brand that is independently owned and specializes in demi-couture, being as sustainable as we can. In doing so, we're rewriting the fashion system to stand for inclusion at every level.

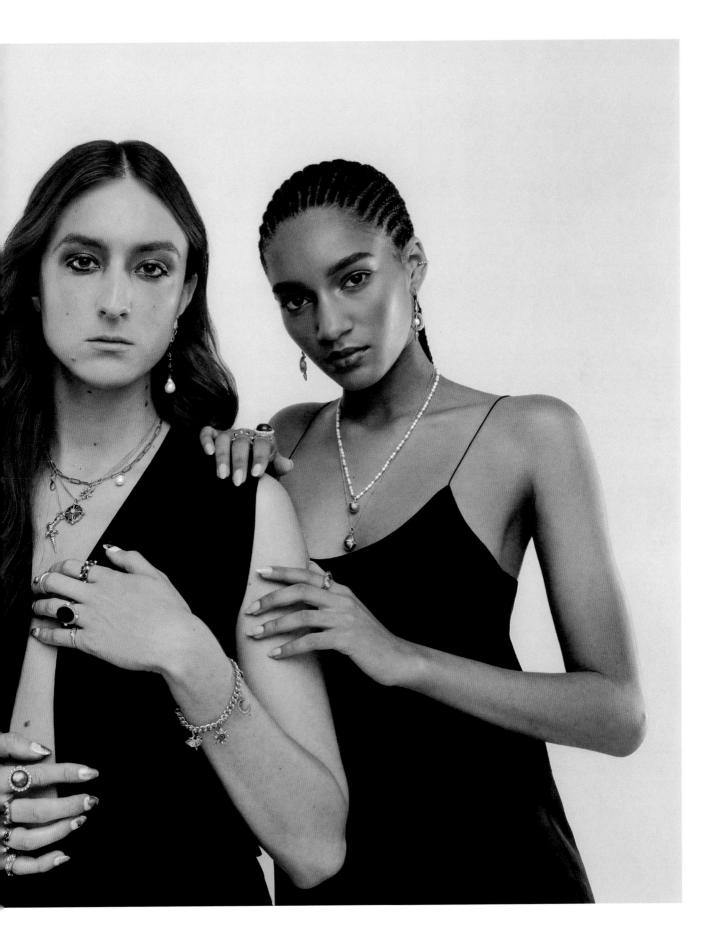

"SIXTY YEARS A QUEEN"

My February 2022 show had to be special. It had to be transportive. It had to top my previous shows. The fashion press had discovered me and were watching closely to see what I would do next. In 2021, my profile had risen inside of fashion, as I was awarded Breakthrough Designer of the Year by *GQ* magazine, and outside of fashion, as I was the subject of a profile in *The New Yorker.* But, pressure aside, as always, the show had to be quintessentially me.

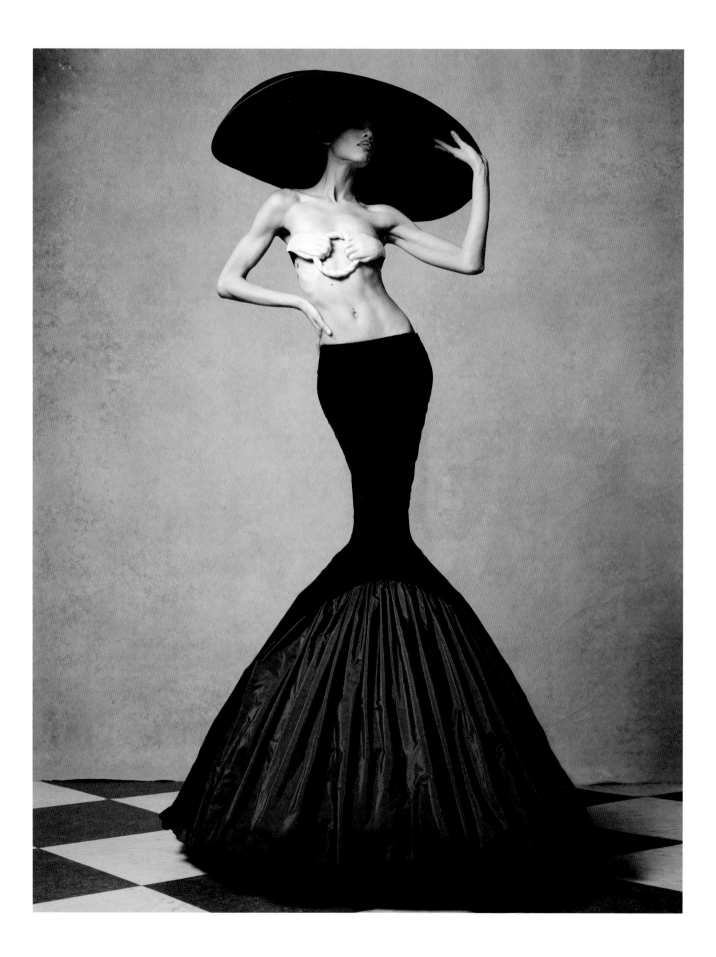

For this show, which I was somewhat boldly staging the night before London Fashion Week officially began, I wanted to stick to producing one-of-a-kind garments that shifted the focus back to fashion's true powers: making you think, making you dream, and making you question. Choosing to show the night before is also my way of being a bit of a disruptor.

A few months before the show, I had a random occurrence with a woman at a café in Bassano del Grappa in northern Italy. I admired her purse from across the café and could instantly tell, being the fabric fanatic that I am, that it must have been made from an upholstery fabric. It turned out her family was one of the biggest replica makers of Italian furniture and fabrications from back in the day. They had been instrumental in redoing the craftsmanship of the headboards, dining tables, and sofas, and bringing elegant Italian living to America, as well as other countries. She was intrigued by my desire to upcycle in clothing and ended up inviting me to the Bussandri family villa to view the fabrics.

The villa was a classic Italian renaissance structure the size of a small castle. The hidden treasures were in the villa's catacombs, which had several small, damp corridors filled with untouched materials like gold doorknobs, boxes of gold Medusa-esque medallions, and dresser drawer hardware. Inside the last room were rolls and rolls of velvets, moirés,

and silks, which, to my understanding, were unusable to them due to their age and condition. With their blessing, I repurposed these more than one-hundred-year-old fabrics into my fluid creations.

For my show, I wanted to embrace theatricality and create a moment no one would forget. I wanted my audience to be utterly immersed in this shared experience. This show was all about queer representation and louder-than-life showmanship. To achieve this, I needed someone who could captivate an audience completely.

And who better than the iconic performer and songwriter Sam Smith? Sam has long been outspoken about gender fluidity and inclusion, and damn, can they really put on a show. They are someone that has never shied away from expressing or sharing their personal journey of coming into their queer self.

"Yeah, right," most people said when they heard the idea. "Getting the Grammy, Oscar, AMA, and every other award winner to come to the show, much less to perform . . . good luck with that," they said.

I DMed Sam Smith on Instagram, and minutes later they got back with me with an all-caps "YES," saying that performing in the show would be an absolute pleasure. YES! They say life comes down to a few moments, and this was definitely one of them.

The stage was set, but not just any stage. We would hold the show in the atrium of St. John's

Smith Square, a church turned music hall, next to Big Ben, the night before the other London shows began.

For the designs, I took inspiration from the 1897 book *Sixty Years a Queen* about the reign of Queen Victoria. In my first year at Central Saint Martins, I literally tripped over the book in the library. The title of this old book was where inspiration struck.

What does it mean to be a queen? What does it mean to have reigned for sixty years? What does that reign look like at the end, as opposed to in its beginning? Then I began thinking of queen in terms of the queer scape, like nights out in Soho. I thought about how my queer community has taken on the word "queen," yet most of the world hears "queen" and thinks nobility. The two ideas began to merge, bringing forth the notion that we are all our own queens.

In the design process, I reimagined monarchic jewel tones, lace, and grand tails by uniting them with a glam-rock club scene vibe via a color palette of intense yellows, chartreuses, and royal pinks. There were also arrows that looked like they had been shot into the models in a nod to a queer St. Sebastian, and they were wearing giant feathered headpieces.

The show itself had a lot of moving parts. We had Sam Smith perform a divine seven-minute rendition of Des'ree's "Kissing You," one of the best-known songs from Baz Luhrmann's *Romeo and Juliet*. As they performed, models of different genders, sexual orientations, and ethnic backgrounds drifted through billowy eighteen-foot wooden clouds wearing the clothes made from the Bussandri family's century-old fabrics. What I always want to do is not just to create a fashion show, but to create a fashion moment. My goal—which some would say is overly ambitious—is to try to weave multiple singular events into one because this is the core aspect of a fluid show.

At Harris Reed, we all joke that people don't realize the level of thought that goes into making sure that what is important to me is in the show, starting with the models who wear my clothes. I want them to represent the best version of an inclusive, fluid world, but also to stand out as individuals.

Leading up to and during the show, I was a twisted ball of excitement and nerves; honestly, I was borderline freaking out. But then again, when am I not freaking out before a show? Would people be able to see the clothes well enough? Would people be able to hear Sam? Was Sam going to sit well within the clothes? Was the lighting going to be correct? Were the models going to be able to move? Would the models' identities be reflected in their styling and their chosen outfits? Was I presenting all the different, beautiful, and unique sides of fluidity and ensuring my models felt truly seen, heard, and represented? But whatever worries and fears were running through my head, I returned to the fact that I aspired to be a showman and I was there to inspire everyone around me to put on the best show I possibly could.

I wanted the models to feel confident onstage, where they would be moving their bodies but not their feet, embodying a character in a larger drama. I worked tirelessly with movement director Simon Donnellon to achieve this. The models didn't

GRAZIA

COULD A
WEDDING
REALLY BE
NEXT?

19
WAYS TO
REFRESH YOUR
WARDROBE

It's the
BIG
FASHION
ISSUE!

YOUR A-Z OF THE
SEASON AHEAD...

SWEATER DRESSES
SUPER SLEEVES
DISCO BOOTS
DENIM GOES DARK

PLUS
Get your coat!

EMMA
MANIA!
**WHAT NOW
FOR TENNIS'S
$1BN STAR**
*'She's making the
impossible possible'*

SURVIVOR STORY
'MY SECRET
ESCAPE FROM
AFGHANISTAN'

ZOE KRAVITZ
**SHARES HER
MAKE-UP
MUST-HAVES**
from £14

SMALL TALK'S BACK
HOW TO
SPARK UP
YOUR CHAT

STARRING
HARRIS REED
FASHION'S REBEL
WITH A CAUSE

4 OCTOBER 2021
£3.99 SPAIN €5.25 GREECE €5.99

ISSUE 813

38 >

9 771745 956990

walk like they would in a typical fashion show—rather than walking the runway one at a time, they were all placed onto the stage at once before the audience entered so that they shared the spotlight together. Doing this created an unrepeatable experience that might—just might—become part of a fashion revolution.

We were very much going for a fuck-off, old-school Alexander McQueen show. The early McQueen days were about performance, excitement, and artistry—pieces that made people think, not the kind that would be immediately stocked in a store after the show. He would sit backstage with his models and give them a narrative, treating them like actors in a film he was directing. He brought the performative nature to fashion. He made people see that fashion was high art that, at the base of it, has the power to change people's perceptions of how they see themselves and the world around them.

I've come to realize I am a showman/showwoman/showperson as much as I am a designer. I don't care if some people hate the result. I can't. What I care about is that moment of every show that you can't look away from. I want to rewrite the way fashion is seen. These are not clothes meant to sit listlessly and lifelessly on a boutique floor or in a store window; they are radical *actions* that are meant to be worn, celebrated, and inspiring.

OPPOSITE A fave look from "Sixty Years a Queen"

FOLLOWING These are two extraordinarily beautiful black-and-white photos of an amazing nonbinary model, representing energy and poetry. Shot by Jason Lloyd-Evans

PAGE 210 Stylist Harry Lambert and me, obsessing over every detail

PAGE 211 This is the look that the one and only Mrs. Beyoncé Knowles-Carter chose for a *British Vogue* cover shoot.

PAGES 212–213 Designs that use theatricality and beauty to show how clothing can have the power of transporting the wearer to a space of exhibitionism, what I call "moving and living art"

PAGE 214 A wonderfully campy image of nails, which I've always loved because I think they can play so much into the character that we build

PAGES 216–217 With Sam Smith after their extraordinary performance of Des'ree's "I'm Kissing You" that brought the entire audience to tears at my "Sixty Years a Queen" show

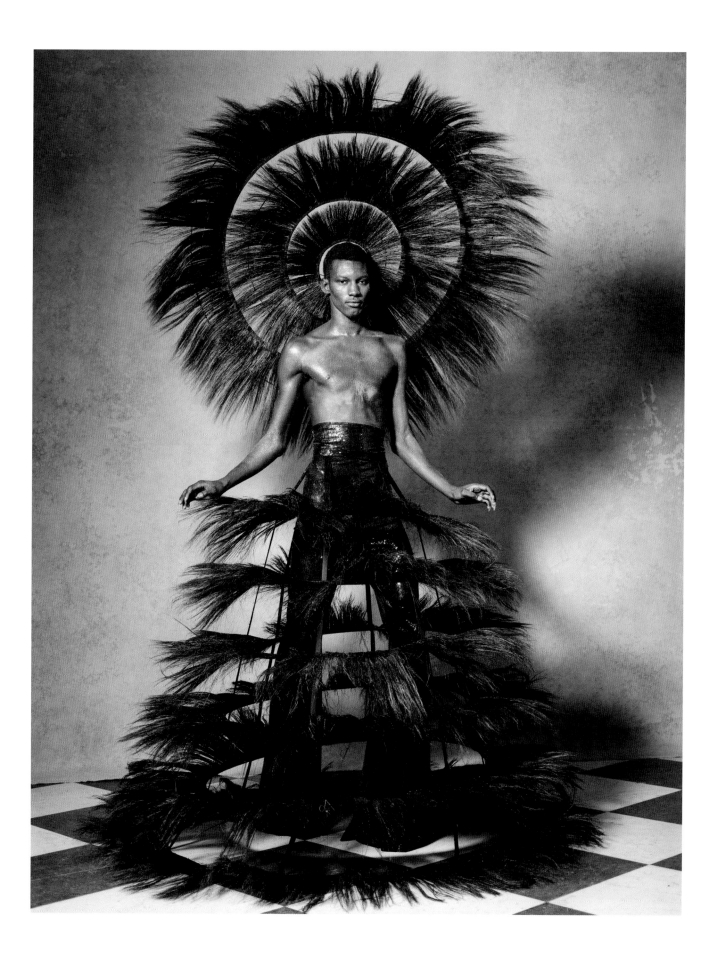

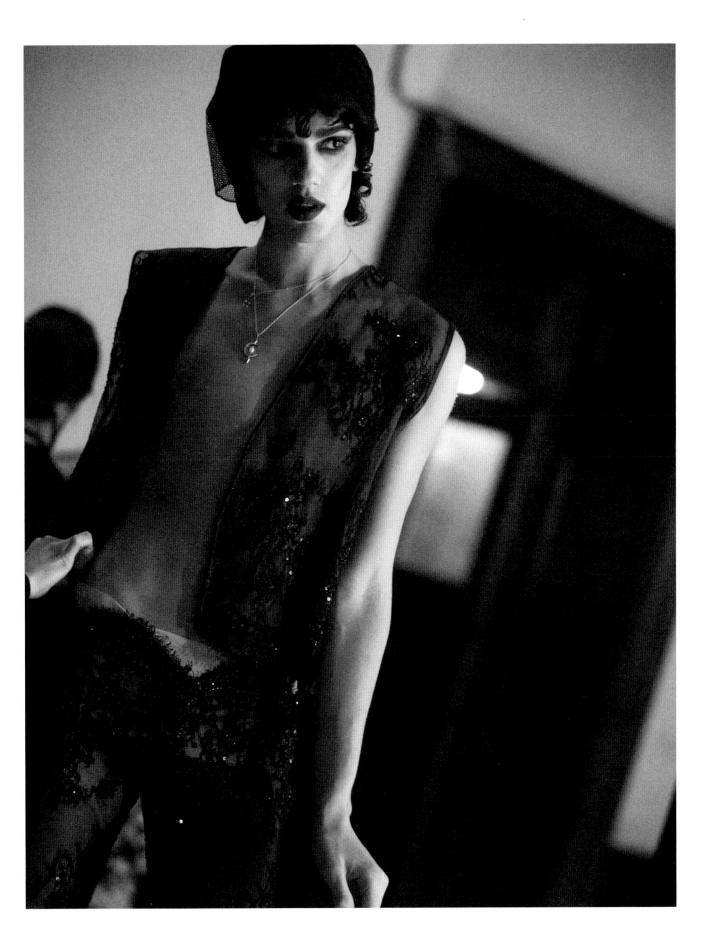

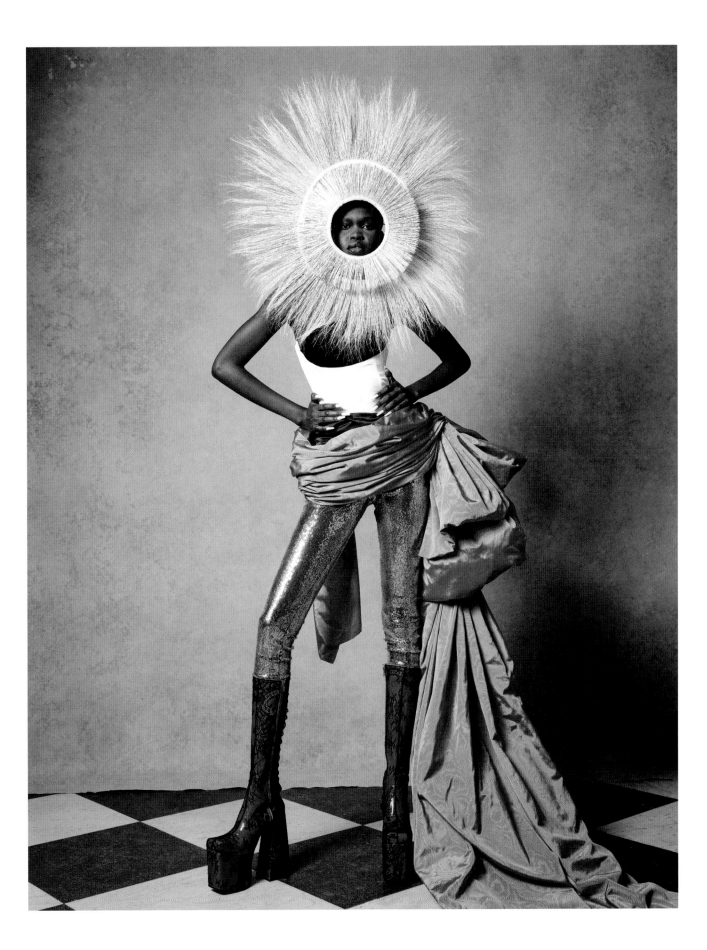

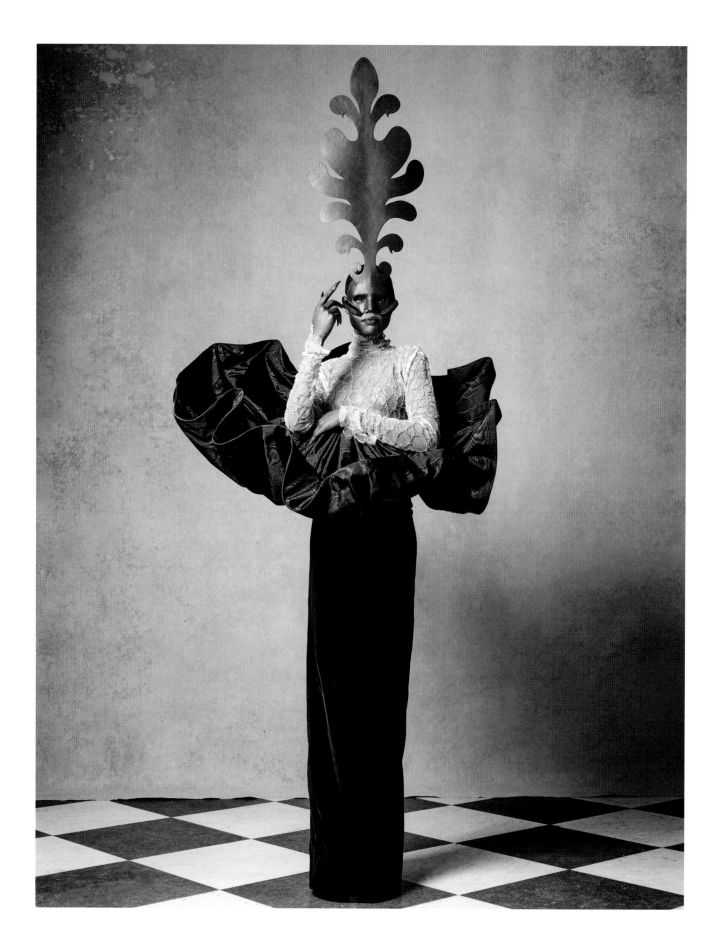

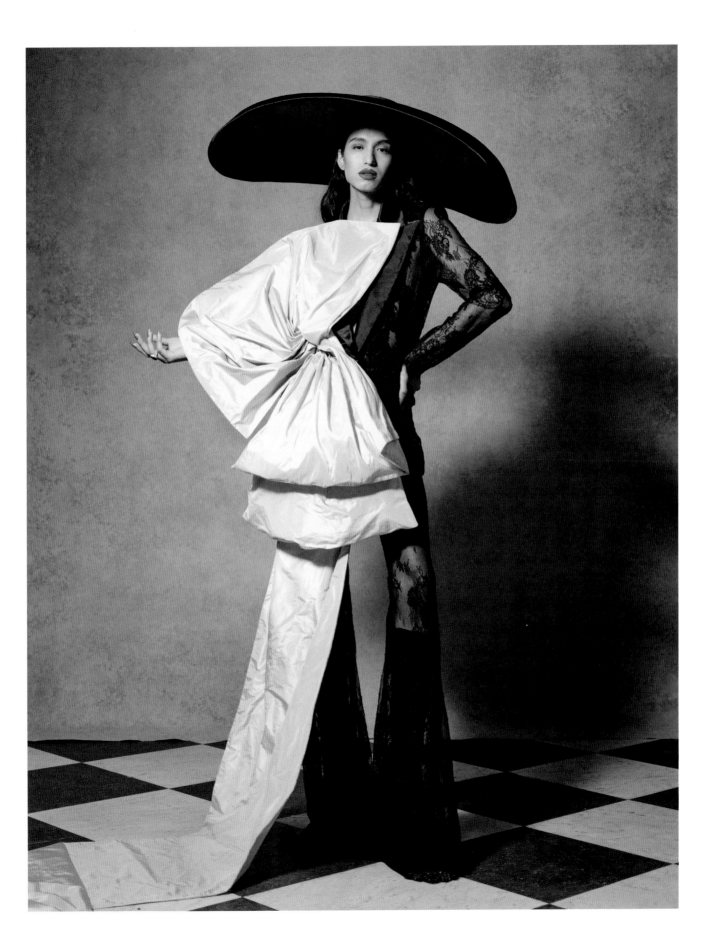

"The fashion industry has been in dire need of someone like Harris Reed, someone to shake things up and question the status quo. On Thursday night, Reed—with a little help from surprise show guest Sam Smith—proved that he's just the right person for the job. He dreamed up his '60 Years a Queen' performance show, held off-schedule, to bring emotion and theatricality back into the fashion show experience—and he succeeded by truly transporting his audience, even for a mere five minutes, to an alternate universe where gender is fluid, self-expression is unhindered and beauty knows no convention."

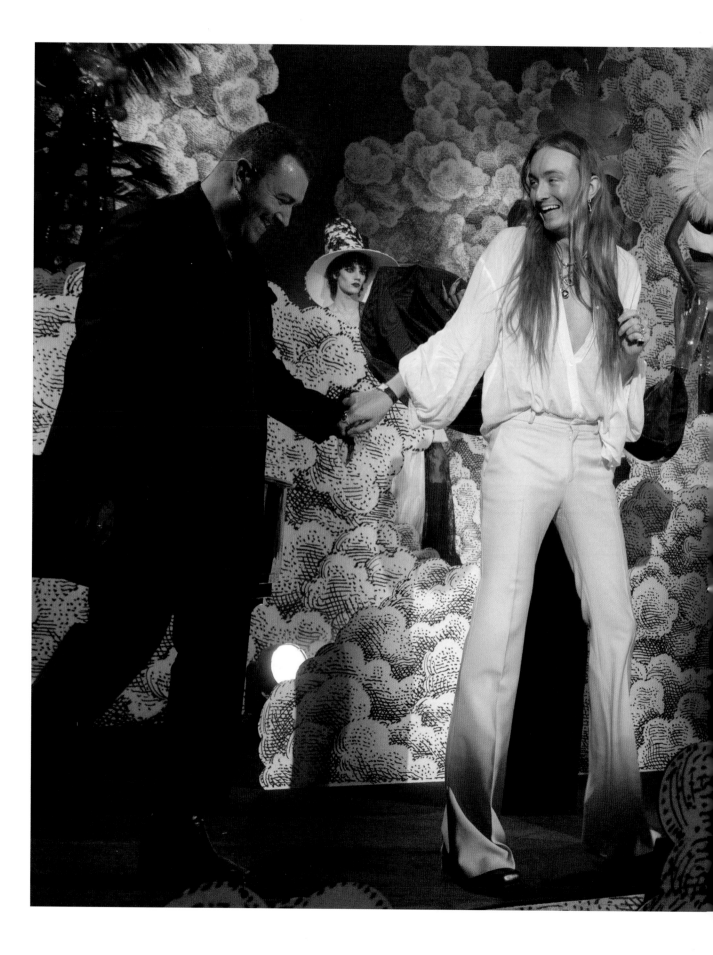

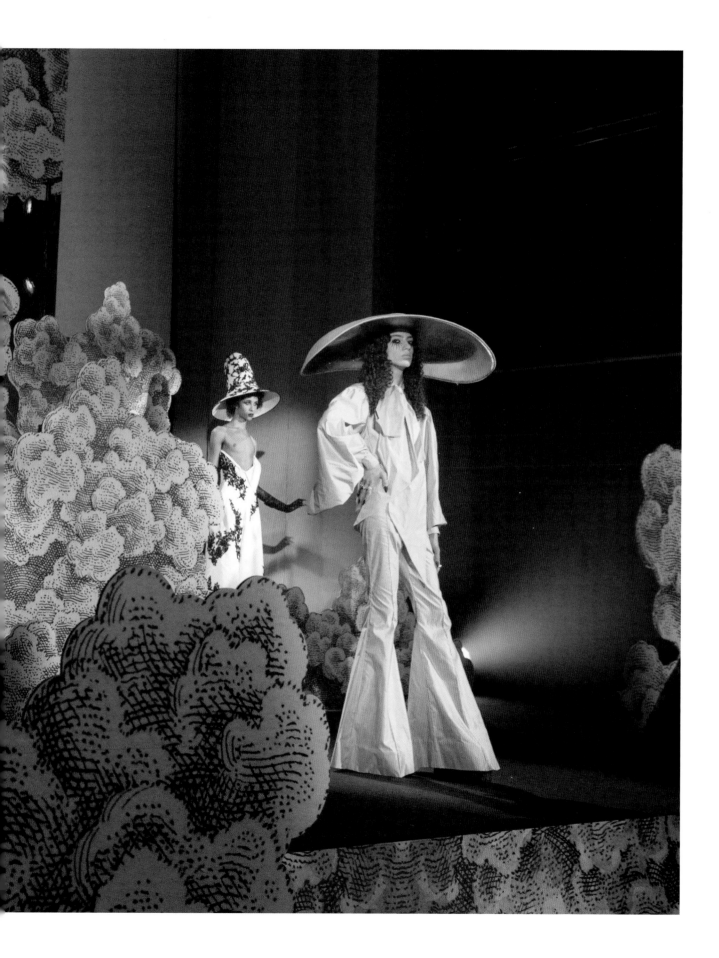

MAISON
NINA RICCI

"Mom, when I get older, I'm going to live in Paris, run a major fashion house, and create clothes that make me feel great and make others feel great," the nine-year-old dreamer in me declared.

In the fall of 2022, that dream came true. Nina Ricci named me creative director, making me the youngest person in history to take the helm of a venerable French fashion house. It was the most special moment in my career—and I've had many. In some way, it also solidified that my work and my mission are valid and may be able to work in the mainstream.

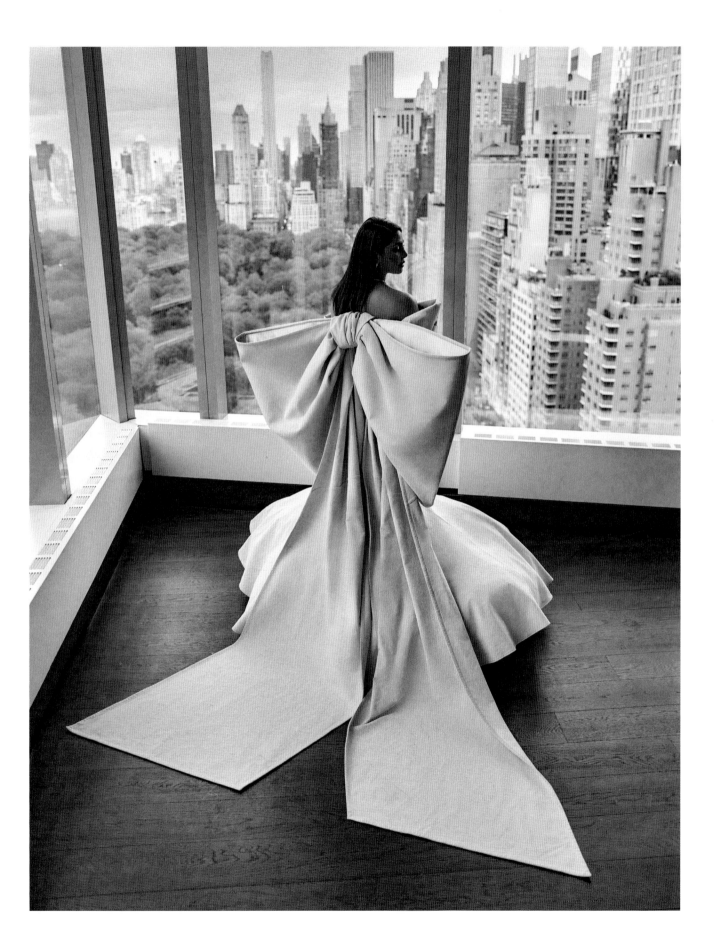

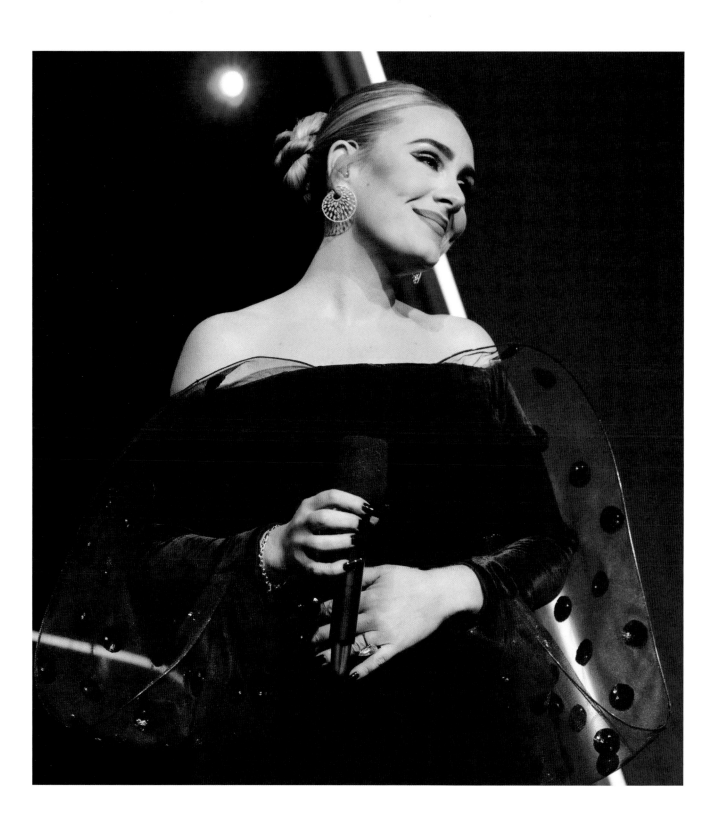

Nina Ricci has a wonderful history. The label was founded in Paris by Robert Ricci in 1932 as a gift for his mother, Maria, whose nickname was Nina. Since its inception, Nina Ricci has focused on serving women. The brand has represented bold and optimistic femininity and encouraged women to feel their best in refined, romantic clothes. A Nina Ricci woman has been empowered to reach her highest form of beauty by revealing her emotions, and even though its clothes were expensive, it was about accessibility.

Perfume has played a major role with Nina Ricci women, and I am honored to be overseeing the creative direction of the brand's scents as well. In 1946, they created their very first perfume, Coeur de Joie, followed by the iconic L'Air du Temps in 1948. "L'Air du Temps"—"the spirit of the times"—became the house's slogan.

The spirit of the times is now changing. This is the first time Nina Ricci has employed a designer whose focus is around fluidity. To be able to come to a brand and write my own rules of what femininity means and how femininity plays into fluidity is exciting and also a great responsibility. I will also be doing this in France, which has its own relationship with fluidity, as well as sexuality as a whole. In France, gender and sexuality are often seen as binary propositions. Nearly everyone I've met there assumes I'm a woman because of my appearance. In my initial interviews with the French press after the announcement, the reporters called me "madam." So,

with my arrival also comes a welcome opportunity to challenge a dated norm.

My goal at Nina Ricci is to pioneer what modern-day fluidity and femininity look like, together, hand-in-hand. I want to bring Nina Ricci to the forefront of changing what femininity looks like, not just in France but all over the world. I want to reimagine the label's traditional customers, because they won't be just women. Our customers will now include men, as well as nonbinary individuals and queer people. The goal is the idea that femininity can excite a customer of any gender, and the designs will have both traditionally male and traditionally female elements that will work together to convey gender. And I want to do all of this by showcasing diversity across genders, ethnicities, and races.

On a personal level, I believe that for people to see someone who looks like me at the helm of a multi-hundred-million-dollar French fashion house owned by a billion-dollar conglomerate affirms an increased impact in what I've been fighting for. You can bring on someone who stands for something bigger than fashion to run a commercial fashion house and hopefully . . . have success with it! Who knows? Maybe CEOs of businesses elsewhere, like in the world of tech or consumer products, will see a long-haired, fluid kid revitalizing Nina Ricci and spreading a broader message of acceptance and celebration of difference. Maybe they'll take notice and realize this is the future.

That is my new dream.

PREVIOUS The goddess Priyanka Chopra Jonas in a hotel suite overlooking Central Park wearing a Nina Ricci runway gown that was completely made out of bleached denim. When I took the job as creative director at Nina Ricci, my bosses asked if I would ever be able to design jeans. I told them yes, but in my own way . . . like this.

OPPOSITE Adele premieres one of my first looks for Nina Ricci at her sold-out 2022–2023 residency in Las Vegas. She debuted this idea of velvet and polka dots, which has inspired so much of the collection and helped set up the codes that we now live by under my creative directorship.

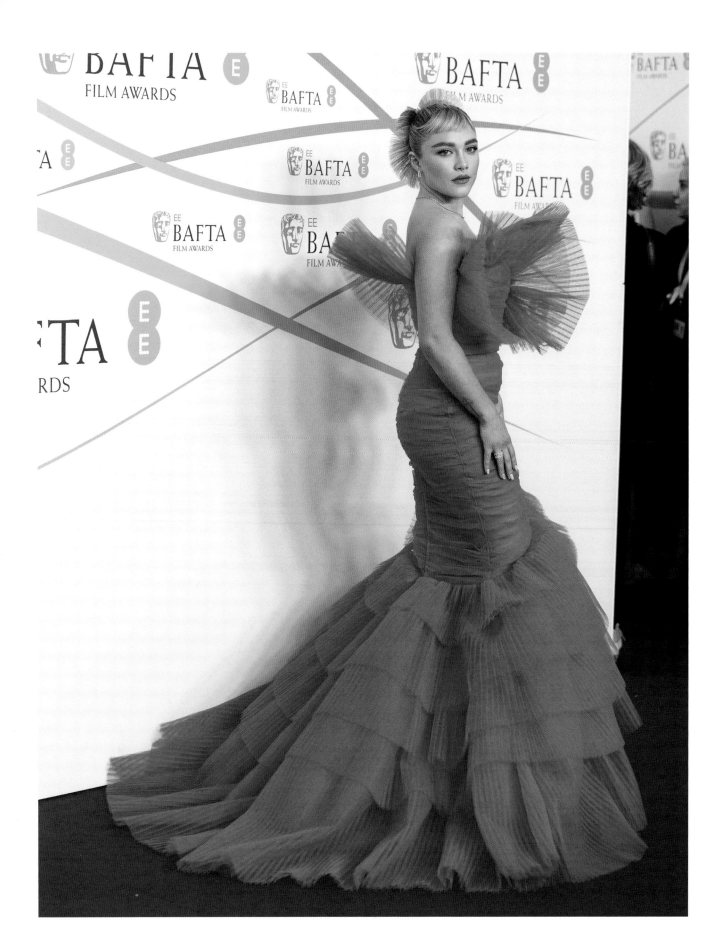

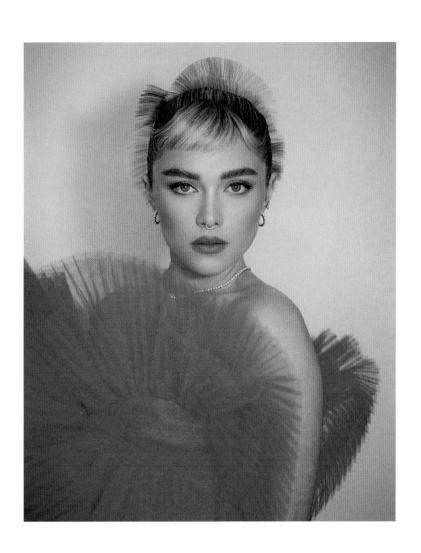

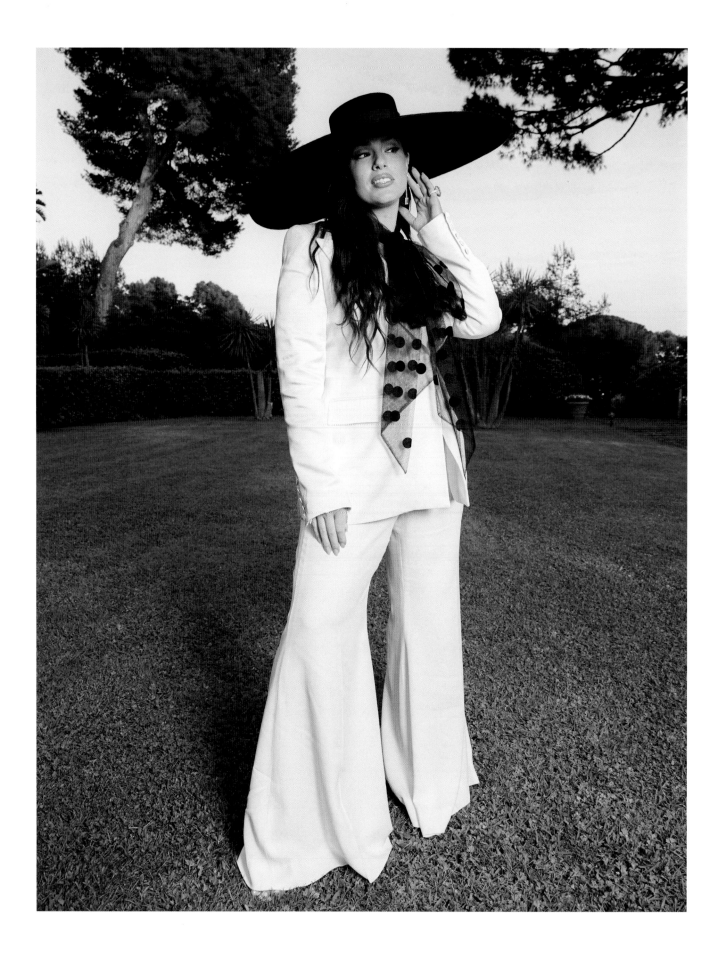

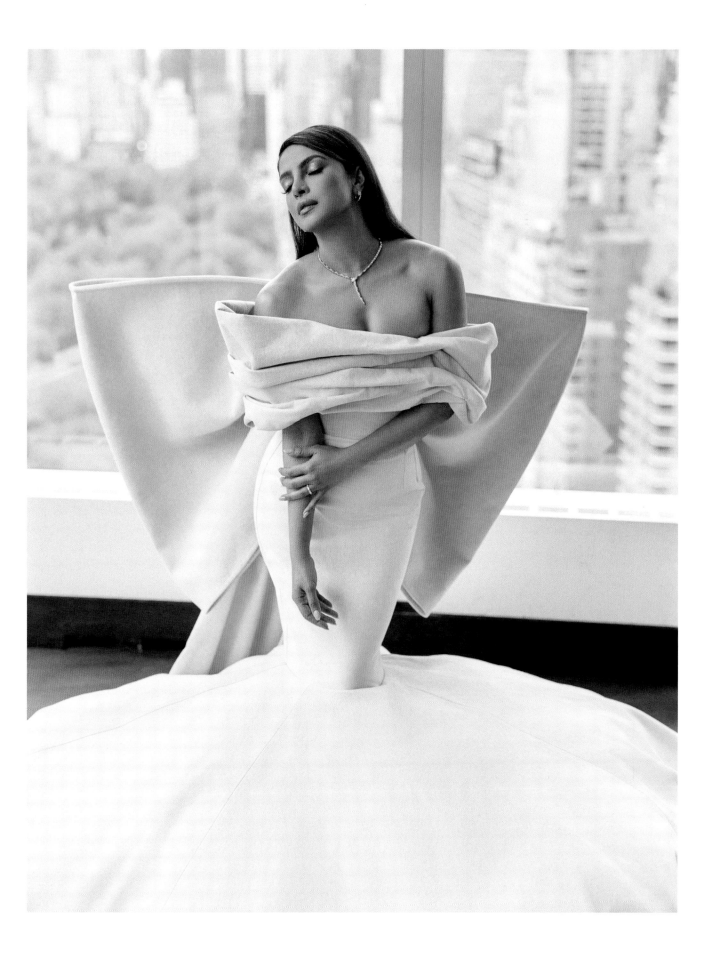

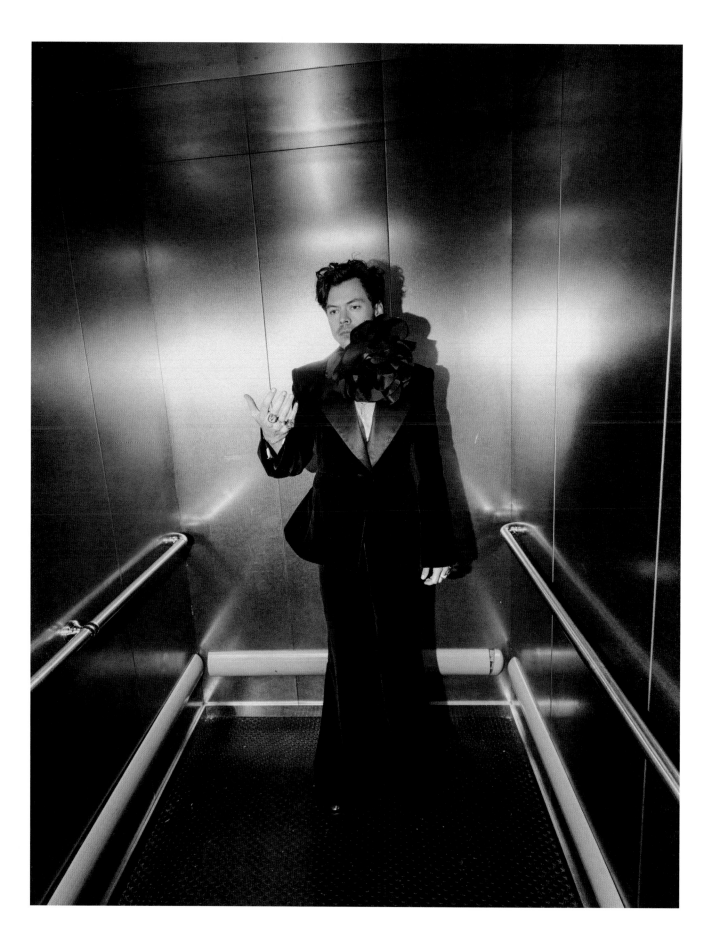

PHOTOGRAPH CREDITS

pp. 11, 12, 81, 122, 133, 161, 167, 169, 174–175, 176–177, 201, 207, 211–213: Marc Hibbert @Artworld

p. 14: Elliot Morgan

p. 17: Fiona Godiver

pp. 18, 80, 121: Buster Grey-Jung

pp. 19, 84, 208, 209, 210: Jason Lloyd-Evans

pp. 20, 21: Silvana Trevale

p. 24: Samuel Bradley

p. 25: Philip Sinden/Courtesy of Hearst Magazines UK

p. 28: WWD/Courtesy of Getty Images

pp. 29, 51: Nick Reed

p. 33: Luigi and Iango for *Vogue Japan*

pp. 34, 46–47, 58, 202, 214, 216–217, 230, 231: Jason Lloyd-Evans

pp. 36–37: Courtesy of Gucci

pp. 39, 52, 55, 81, 95–96, 108, 126, 131, 146, 149, 150, 170, 182, 196–197: Harris Reed

p. 40: Daniele Venturelli/Getty Images

p. 43: Ethan James Green/Trunk Archive

p. 45: Dia Dipasupil/Getty Images

pp. 56–57, 134–135, 137, 140–141: Jenny Brough

pp. 61, 186–187: Laura Allard-Fleischl

p. 64: Piczo

p. 65: Rob Rusling for *10 Magazine*

p. 69: Alamy

p. 70: The National Gallery, London

p. 75: Michael Ochs Archive/Getty Images

p. 78: The National Gallery of Ireland

p. 79: Giovanni Corabi @ MAP

p. 82: The Victoria and Albert Museum

p. 82: Ian Dickson/Redferns

p. 83: John Rodgers/Redferns

p. 89: Tyler Mitchell/Art Partner; Annie Leibovitz/Trunk Archive/ Anton Corbijn for *Vogue* courtesy of Condé Nast

pp. 90, 92–93: Hélène Pambrun

p. 100: Tyler Mitchell/Art Partner

pp. 105, 106: Rafael Pavarotti/Art + Commerce for *British Vogue*

p. 111: Nathaniel Goldberg/Trunk Archive

pp. 114–115: Sean Zanni/Patrick McMullan via Getty Images

pp. 116–117: JMEnternational/ JMEnternationship for BRIT Awards/Getty Images

p. 125: Camila Falquez

p. 127: Lukas Palumbo

pp. 129, 138: Ho Hai Tran

p. 145: Mike Coppola/Getty Images

p. 153: Taylor Hill/WireImage

p. 157: Arturo Holmes/MG21/Getty Images

pp. 162, 172–173: Tom Craig

p. 165: Karwai Tang/WireImage

pp. 181, 191, 194–195: Christina Ebenezer

p. 184: The Global M·A·C Cosmetics × Harris Reed campaign shot by Eddie Whelan

pp. 188–189: Ruth Hugben

p. 205: Alex Brummel/Grazia UK

pp. 221, 227: Nicolas Gerardin

p. 222: Raven B. Varona/Trunk Archives

p. 224: Mike Marsland/WireImage

p. 225: Peter Lux

p. 226: Pascal Le Segretain/ amfAR/Getty Images for amfAR

p. 228: Steve Granitz/FilmMagic

p. 229: Axelle/Bauer-Griffin/ FilmMagic

p. 233: Monica Feudi

p. 234: Anthony Pham

ACKNOWLEDGMENTS

Thank you to everyone who has supported me and shown so much love; my partner, my family, my team, my friends, and colleagues, you all mean the world. Eitan Senerman, Lynette Reed, Nick Reed, Harry Lambert, Phoebe Briggs, Daisy Hoppen, everyone at Harris Reed and Nina Ricci, Elli Jafari at the Standard, and Mark Wadhwa at 180 Studios. Thank you to Josh Young for bringing my voice to the pages. Thank you to Andrew Stuart, my agent. Thank you to the whole team at Abrams for making this project a dream come true: Zack Knoll, Rebecca Kaplan, Michael Sand, Holly Dolce, Kevin Callahan, Danielle Kolodkin, Gabby Fisher, Glenn Ramirez, Lisa Silverman, Denise LaCongo, Heesang Lee, Deb Wood, and Elisa Gonzalez and the Abrams sales team.

HARRIS REED is a prominent young fashion designer known for his innovative work marrying genres from fashion, film, beauty, culture, and the digital world through a gender-fluid lens. His influence has been chronicled in profiles in numerous publications, including *The New Yorker*, *GQ*, *Vogue*, *Harper's Bazaar*, and *ELLE*. He lives in London.

JOSH YOUNG is the author or cowriter of more than twenty books, including five *New York Times* bestsellers, two additional *Los Angeles Times* bestsellers, and five books that have been made into feature documentaries and series.

Editor: Zack Knoll
Designer: Heesang Lee
Managing Editors: Glenn Ramirez and Lisa Silverman
Production Manager: Denise LaCongo

Library of Congress Control Number: 2023933932

ISBN: 978-1-4197-6758-6
eISBN: 979-8-88707-002-5

ABRAMS The Art of Books
195 Broadway, New York, NY 10007
abramsbooks.com